Color in Townscape

Color in Townscape

Martina Düttmann
Friedrich Schmuck
Johannes Uhl

for Architects, Designers and Contractors
for City-Dwellers and Other Observant People

Translated from German by
John William Gabriel

W. H. Freeman and Company
San Francisco

First published in The United States in 1981 by
W. H. Freeman and Company, Publishers,
660 Market Street, San Francisco, CA 94104
ISBN 0-7167-1310-1

© 1980 by Archibook Verlagsgesellschaft mbH, Berlin
Typesetting: Buch und Fotosatz – Gabriele Krüger
GmbH, Berlin, and Richard Borek, Braunschweig
Reproduction: Carl Schütte & C. Behling, Berlin, and
La Cromolitho, Milan
Printing and Binding: L.E.G.O., Vicenza
Production: Rudolf Paul Gorbach, Gauting

Manufactured in Germany and Italy

Table of Contents

Rebirth of Color
Manifestos of the Twenties

Color in Architecture
by Fritz Schumacher

In recent years a craving for color has permeated our drab age, and now it has reached, and is beginning to change the face of architecture. After fighting to reinstate color in its rightful place in our interiors, architects have turned to the question of color on outside walls. *Der Kunstwart* has long advocated more colorful houses, pointing out how simply harmonic effects can be achieved through tinted plaster surfaces. Now and then one does meet with attempts to bring color to rendering—Dülfer in Munich bravely leads the field—and woodwork of lively hue has made a first appearance, most notably in the country houses of Schilling and Gräbner. It is truly a good sign that architects, turning to old farmhouses for inspiration, are helping to advance the cause of color, at least in the field of country house architecture.

But this is only a beginning: the country house is only the first witness in our case for color in architecture. And if today's architects, lacking the comfort and guide of a tested tradition, are unsure of their means even in this small area, how much more helpless must their chromatic experiments be when they are faced with architectural problems of high complexity.

There is a very simple reason for their hesitation—it is extremely hard to take a building which was not conceived with color in mind and, through choice of materials or pigments alone to create color effects after the fact. The entire aesthetic economy of a building should rightly include color as a prime element from the outset; barring the most primitive designs, one cannot hope to enrich a construction that has been conceived without a thought to color by tacking it on afterwards. No, the process of architectural design must itself be different if color effects are desired than if drab neutrality will suffice. This simple truth, I am afraid, is more accessible to instinctive good taste than to rational argument. Helpless as theory usually is when it comes to color, a word on the subject from a theoretical point of view might nevertheless be in place. It was John Ruskin, I believe, who first advanced the aesthetic axiom that, when put to decorative use, form and color were enemies and should therefore be set on essentially different paths. The highest intensity of color, in his view, should never coincide with the highest complexity of form. In other words, color can unfold its true effects only where form is simplest; and the artistic effect of form is impaired when we follow it with color—when used at the same point, these two basically independent artistic means do not mutually support but mutually weaken each other. He asks us to think of the capital of a column, richly sculptured with floral designs: painting would definitely not improve it, whereas the painted ornament on the smooth shape of an Egyptian capital is perfectly in place.

Ruskin views the independence of form and color in architecture as a general law, derived, as was his way, from an observation of nature. The irregular mottling of leaves, the patterns of an animal's fur, which do not follow the shapes of its body but obey a system of their own independent of the anatomical system—these being the sources of his principle, he would have us, at every point where form and color meet, treat them as separate systems, like the mottled marble of a column the streaks of which, rather than emphasizing the verticality of its lines cut across them at random intervals.

Thus, if we follow this view, it would be an error of aesthetics to see the congruence of highly articulated form with highly developed color as potentiating the artistic effect; or, more simply, what we actually get when we add *one good to another good* is, in this case anyway, *a worse.* If this fine observation put so dogmatically would seem to require detailed examples and notes to really convince, it nonetheless explains many phenomena in the applied arts that at first glance seem unnatural, and which many observers are thus tempted to label "decadent". Here, I believe, lies the reason why in much of our modern pottery of late, in which the play of colors has been allowed such a free hand, instinct has unfailingly led us to hold to primitive forms; here lies also the reason why, in designing the leading of our glowing stained-glass windows, we cleave to primitive styles of drawing although at our fingertips we have techniques which would allow us to create both perfection in design and perfection in coloring; here, finally, lies the key to the question of stylization in monumental painting—seen from this vantage point how clear it becomes why precisely the frescoes of the primitive masters, in their monumentality and decorative force, overshadow everything that other ages have produced which stood at the peak of artistic representation.

And here too we find central criteria for the use of color in architecture. The law that color and form should go separate paths in those areas where we wish them both to take effect, is the key reason why the call for more color in architecture is bound to lead to much more fundamental change than the

desire to make colorful what was once dull would, in its apparent simplicity, suggest. Yet I am not saying that this law should be accepted as valid for architecture by analogy only; a quite different train of thought has led me by a different path to the same results as Ruskin.

The chromatic effect of a building, first, does not stem alone from the actual pigments applied to its surfaces; the impression is at least equally as dependent on the presence of shadows, their massing and distribution over the building's facade. Shadows too possess color; they are never absolutely without it; and the more multifarious and interesting the chromatic play of shadow across the wall of a building is, the more careful one must be when adapting this primary effect to the secondary one of the actual paint or plaster tone, to insure that the two effects do not interfere with or even cancel one another out. A building with massed shapes whose painterly conception creates a wealth of shadow on its vertical surfaces can be made to appear very colorful by enlivening, say, only the roofs with an intense color, leaving its walls white or merely neutral in tone, and adding color elsewhere, in the wooden mouldings or in some other isolated area, to provide a fascinating accent. More true color in the masses could easily, in a case of this kind, ruin the harmony of the whole.

The same coloristic means applied to a simple, closed mass, on the other hand, could easily make the building look bare and lifeless, and only a touch of brilliant local color will produce the same effect of overall chromatic liveliness as in our first example. That is why strong colors show up to such good effect on the simple volumes of peasant houses; applied to a picturesque villa the same tones might well look garish and affected.

What holds for the building entire also holds for its details: wherever intricacy of shape gives an intricate play of shadow, color is unnecessary and under certain conditions may even be harmful, because it confuses the eye.—And thus by a devious path we have arrived at an explanation for the law Ruskin derived from looking at natural phenomena, namely the simple fact (to be taken with a grain of salt): *Shadow is color.* Since however shadow is inseparable from form, and since the more complex and projecting the shapes of a building are the more complex will the shadows they cast be, the degree of formal development in architecture sets a limit to the natural, aesthetic need for true color locally applied.

The practical consequence of this statement, however, is not: Be sparing of color if your main effects are produced by form, but—and this is the crux: Simplify your forms if you want to create successful color effects; throw all those empty, boring shapes overboard and use color in their place; and, above all, use color wherever the opportunity to create effects by means of formal articulation has been denied you for reasons beyond your control.

from: *Der Kunstwart,* Vol. 14, No. 20, 1901

Rebirth of Color
by Bruno Taut

We often speak of the things that surround us as having a certain aspect or character, like the human face. We speak of the face of the present, of the past, even of the future, and say that cities, buildings, works of art, everyday useful objects—in short, everything human beings make and do that adds to their material surroundings—constitutes the face of their times. To continue the metaphor, the face of recent times can be said to have been a pallid one, and indeed it still is, notwithstanding the efforts of a few small, minority movements to enliven it. There is really no danger of overstretching this metaphor: if our times, purely superficially speaking, have presented a pale and sickly aspect it is because they have lacked that most natural of all signs of life, color. The times were and still are today "sicklied o'er with the pale cast of thought". It will hardly be necessary to list evidence for this. Speaking purely intuitively the 19th Century, judging by its most prominent physiognomic features, was governed by thought, which, rather than being productive or life-giving, robbed its countenance of the glow of health and lined it with a livid grey...

To all appearances we find ourselves today at the beginning of a new style. Now, if we can apply to ourselves the judgement that art historians commonly make about the early period of any style, then to the objective observer our times will have a certain attraction. And I believe truly that the present is more interesting, unique, many-sided and abundant than any period in the past could ever be—even if all this means is that we are beginning to refocus our attention on ourselves, our needs and the content of our own lives, that we at long last have come to the realization that the *present* is all-important. Every new beginning is characterized by this concentration on what is elementary, basic. After delving into primitive cultures, which was a logical outgrowth of this attitude and which is now beginning to lose interest for us—luckily, since it had to remain archaeology in the end—we now have come back to simple, basic geometric shapes, are calling back to mind the very simplest, yes, even primitive formal effects, in order first to establish some basis from which we may then go on and develop new forms. And in this area machines have been a great help to us. Machines, formerly our masters, now serve us, making these simple shapes more cleanly and effortlessly and beautifully than any artisan ever could. This is the machine's intrinsic purpose. In the past, machines were used to imitate handwork, with unfortunate results, simply because these pro-

ducts were not original, and now they are. Clarity and cleanness of line, these characterize machine work for construction purposes as well as for transportation—I am thinking of ocean liners, locomotives, passenger coaches, yachts and automobiles—and thus machines make our buildings integral parts of modern life once more, link them into the chain of everything modern. To relate the lives we live in a natural, unforced way to the buildings we build—that is the valuable service that machines perform for us, those once so praised and then Oh so damned machines.

Forms of an elemental force are simple for that very reason! Let the academics pigeonhole the architecture of the past; we would rather build without architecture simply because we enjoy buildings for what they are, we enjoy their structure, their clarity of line, their unveiled and untrammelled force, and aesthetics only get in the way of our enjoyment. And the natural ally of clear, perhaps sometimes even brutal simplicity is color. Color stands, as Hans Poelzig once said, at the start of a new style, before the forms of that style gain in sophistication.

Yet at this point I have to mention one grave danger. Power and purity of tone, space, mass and color—by all means! Yet, though pure, brilliant color is wonderful, used wrongly it is far worse than none at all. Let's not even talk about those poisonous taffy tones or those 'harmonies' so beloved of certain types of interior decorator—they could convert any partisan of color into a hardbitten opponent overnight—not to mention those parlour painters' patterns, that kitsch that get-rich-quick companies would like to stencil all over our exteriors now. Nor (to complete the list of bungles while I'm at it) do I mean those gravy-like concoctions, those would-be interesting color combinations that are, in truth, nothing but paintbuckets full of the fear of color—or even of pure grey—that remind you of watered down ink, pink lemonade, country gravy, old leather and the things displayed in the show windows of soap shops. No—beyond all these horrifying productions of color's fellow travellers there is an old home truth that bears restating again and again, and that is that bright color combinations are not necessarily good coloring, just as little as loud notes necessarily make good music.

It is not a matter of using absolutely pure colors, though one can say that broken hues are not really in place on outside

walls. The effects of weather, dust, soot etc. make them milder anyway, quickly changing or even obliterating the original mixed tone. Then too, mixing alters the intrinsic structure of pigments, weakening their homogeneity, making them powerless to resist sun, wind, rain and snow because their backs, so to say, have been broken. This is one reason why pure, basic pigments are the most reliable ones for exterior use. Even green, being a mixed color, has to be used with caution, if for no other reason than that the green in nature calls for a countertone in architecture. Even the ancient Greeks, if my information is correct, used mainly blue, red and yellow (or gold) on their temples; some historians even maintain that the color green was entirely unknown to the Greeks. This observation is really sufficient in itself to show that the use of color has its natural limitations.

Any number of theories about color have been expostulated, perhaps the best known of which is Goethe's *Farbenlehre*. All of these theories have one fatal weakness in common, however, which is that they all consider chromatic phenomena in isolation and draw from these phenomena psychological conclusions of one sort or another. Goethe, for instance, declared red to be an advancing or aggressive color, whereas blue tends to pull back, recede from the eye. Now, this psychological interpretation is actually turned on its head by certain changes in lighting conditions. As twilight falls, for instance, red becomes darker and recedes while blue comes forward until finally it is the only color that still vibrates. Nor can the effects that combinations of color have on us be satisfactorily explained by theory. Those color charts with their stripes or spots arranged in certain ways ostensibly illustrate the basic laws of the color spectrum. In reality, however, by which I mean in practice, when colors are applied to the walls of a room or to a building's exterior —that is when the decisive factors come into play, these factors are simply not taken into account by the color charts. The relation between color and the form on which it is presented, the relation between areas of color of different size, and finally the relation between color areas on different walls ad infinitum—this chain of factors is not taken into account by any theory and is so endless that no law you could set up would ever do it justice. On the other hand, there are certain very general statements one could make, practical axioms, so to speak, such as that color must be seen in relation to light in some way or another, that it must express the properties of light, since of course color itself is a phenomenon that

is produced by light, one property of light. Perhaps the most important general statement we can make is that brightness is never color—bright color combinations can be even more colorless than a pure grey, and colors of lesser intensity, properly combined and distributed, can appear much more colorful than any number of loud tones used carelessly. Now, before anyone objects that all this is only a lot of hot air, let me give an example.

Among housepainters, especially the normal garden variety of interior decorator, the combination orange—violet—blue-green is very popular, simply because it has a great effect. Now used on a building, however, this combination must be about the wrongest one imaginable, maybe because all three of these colors are mixed tones and certainly because when they are applied to large areas the effect is loud, and one's natural instinct is to fight or flee. This is only one of a plethora of examples to show that lots of color, under certain conditions, can be worse than none at all. The beautiful sound of a piece of music has nothing at all to do with its having been composed or played fortissimo or pianissimo. And the same is true of color: purity of impression can arise from very delicate and reserved hues just as it can from strong and brilliant ones. Both lie along the same scale, and if someone is good at the first, he will also hit the right notes of the second. Whether this purity is best achieved with forceful color or with delicacy of tone is something that the purpose of the room or space, its inherent features, the position of the building and so forth must decide.

At the very top of the list, however, must stand the prime law of purity of color combination, so that this purity of color and of light will correspond to the purity of the other architectonic elements—space, mass and harmony *(Klang)*. Used purely in this sense color, as giving form to light, becomes one of these four basic elements, which are related directly to each other and which cannot be separated whatever you do. And since they are inseparable the development of the Chromatic Movement will be a measure of the development of architecture itself...

And thus our cogitations about color have spirited us out of the aesthetic realm into a different one, you might say that of ethics, yes, even morals. We often say about some person that he goes through life with open eyes, and about someone else that he is always half asleep. Well, this holds for

what people make, too. Someone who has his eyes open will probably be courageous enough to build his house in such a way that it expresses his open mind. The other fellow by contrast will very likely want to hold onto his dull, musty, stick-in-the-mud, sentimental, comfy cottage or whatever.

People's houses and apartments really do express their attitudes—courage on the one hand, narrow-mindedness and fear of change on the other. And it is perfectly logical that where courage is lacking—and be it the courage to break with the fashion that color just might become—that there this inner mustiness will be given a new coat of paint, so to speak, by way of compensation, as a woman who is afraid of growing old uses too much make-up. Streets, squares and whole cities, on the other hand, which are permeated more and more with new signs of their openness and courage—these cities and scenes will create an ever greater impression of joy, carefreeness and clarity, they will catch the sun even on cloudy days since they themselves will give shape to light—for color is light.

Everything in this world of ours has to have some color or other. All of nature is colorful, and even the grey of dust or soot, even the most depressing and melancholy places always have their own typical colors. Wherever light is, there color must be. All we as human beings have to do is give these physical phenomena, like everything else we touch, form, and as soon as we do it even the darkest corners are bathed in the resplendence of sunlight. And since every object in nature has its color, everything human beings create must be thought through in terms of color, too. So there is really no reason that I can see to deny that a colorful solution can be found for even the oldest and shabbiest buildings and cities. No matter how depressing and desolate a street may be, no matter how ugly the shapes of its buildings are, color will brighten them up and make the people who live there a little happier. This effect of color on the emotions has been tested many times in past years, and there can be absolutely no doubt that it exists.

Sensitive aesthetic souls always begin to wonder out loud at this point whether it is justifiable to underline the ugly shapes of ugly buildings by giving them a coat of bright paint. I would reply that this job is not an aesthetic one, it is a moral one—that it is a matter of bringing just a modest little bit of joy into the lives of even those unfortunates who have to live in the rottenest tenements and on the saddest airshafts. I would even go so far as to say that color can improve any building, no matter how horrible. Now, I know that you can paint certain things to death, by bringing whatever structure they may have into high relief; but you can also give them a completely new face with very modest means. The point is that you must avoid all prejudices and preconceptions. I know of no line and verse to say that you must always separate two colors at an edge, for instance, or that one building's facade must be painted in an identical way to the next, or that every wall of a room has to be the same color. There is even a law that speaks against this—a cube, for example, is heightened in its 'cubic' nature if you paint each of its sides a different color, while a monochrome treatment will suppress its edges and weaken this effect. The same is true of the four walls, ceiling and floor of a room—walls painted all the same tone do not take the function of the door, windows or even closets into account. This is blind aesthetic dogma and has not the slightest trace of binding force. Hence color can give old buildings—especially ugly ones—a new face, and what is more important, it increases people's desire to see all the horrors that surround us disappear forever. Painting an old house renews people's interest in it, they start complaining that it isn't even prettier than it is, and what could be more logical than the thought: Why in the world do we have to put up with this kind of thing any longer? ...

Throw out old junk, and you throw your cares out with it! And this is true not only of overstuffed apartments like the ones you may have seen in my book *Die neue Wohnung*. It is just as true of color, particularly, as I remember, when the first glints of it began to brighten up the dull streets of Magdeburg. One time the police even had to step in—the chief himself led a platoon to Breite Weg to keep traffic from breaking down completely, because of the huge crowd that had collected in front of Barrasch Department Store to look at the pretty new colors. The streetcar even stopped at another place, where it wasn't supposed to, in front of a blue building, and why? because its driver wanted to see the new paintjob. People flocked in droves to look at every new color scheme, innocuous as they were, usually to make fun of them—but there were always a few smarter ones in the crowd who shared the last laugh with that fellow behind the scenes who let Till Eulenspiegel shake his cap and bells again in his old haunt.

With these personal remarks I merely wish to illustrate my hypothesis that this spirit of fun—which color as a property of light definitely contributes to—that this spirit of fun has a cleansing and basically a more serious effect than even the most ostensibly serious things can ever have, simply because it makes pathos, that long, officially worried face and tragically furrowed brow, impossible...

Among all the cultural developments that we see around us today, the Chromatic Movement is the one significant and indeed indispensable way to make peace with our times. The somewhat violent side-effects that this movement could not help but cause in its early stages are a thing of the past; now we can stand back and look at all these experiments with a critical and objective eye because it is no longer necessary to fight for the cause itself. Not the What is important to us, not whether to go for color or do without it, but only the How, by which I mean not only how color is used to create effects on the eye, the nerves and the mind but also its technical perfection...

Our age is beginning to find itself; its blood is flowing a little quicker than before, its face is growing young again and happy and its cheeks are flushed with joy. Color is reborn.

from: "Farbe am Hause", 1. Dt. Farbentag Hamburg, Berlin, Bauweltverlag 1925, excerpted from a lecture

The Role of Modern Art in Architecture
by Bart van der Leck

Modern artists wish to overcome the isolation of their art, in both the literal and more profound sense. More than in any previous age artists are beginning to realize that art has no other aim than to create—to give form, not to fuzzy ideas or sentimental notions or passing fancies, not used here and there in isolation to illustrate or beautify or decorate but to shape reality.

Through the ages art gradually divorced itself from architecture and developed along its own lines until the present, when, through experiment and by destroying the natural and the outmoded, art began to come into its own in both an intellectual and a formal sense. Art always requires flat surfaces, however, and artists will always be interested in using the (admittedly practical) plane surfaces that come into being whenever a building is put up. What is more, as art continues to proceed from the special to the general it will claim, as its true domain, the entire color composition of buildings and even those aspects of their formal composition that rightly belong to painting. If architects are always on the look-out for artists who can do the pictures they need, artists are just as much on the look-out for architects who are willing to provide the conditions which can bring creative cooperation and unity of expression. What we ask of architects is self-restraint, because they have to deal with so many things which, at bottom, are outside the art of building and which have to be conceived and executed in a very different way than architects are trained to do.
Building is, in essence, a very different activity than painting; it stands in a very different relation to the infinite. Here are five pointers on the difference between the arts of building and painting—painting, again, as it is in essence:

1. Modern painting destroys naturalistic representation, as opposed to architecture, which is a nature-like, constructive activity.
2. Modern painting stands in opposition to the limiting, enclosing quality of architecture.
3. Modern painting is color and creates space, as opposed to architecture, which is colorless, planar.
4. Modern painting is design in spatial planarity—extension as opposed to the space-limiting planarity of architecture.
5. Modern painting is plastically balanced as opposed to the structural balance of architecture (loads and load-bearing elements).

Modern painting translates the corporeal into the planar and at the same time, by being conceived spatially, destroys the usual naturalistic representation in two dimensions to achieve spatial relations. The art of building is constructive and creates organic corporeality, encloses space; the architectonic plane sets limits to both light and space.

In modern painting color is the representation of light; and primary color is the immediate representation of light. Color is the visual shape of light. Modern painting gives the innumerable relations that exist in space immediate, concrete shape. Light and spatial description equal color and relation. If architecture delimits space, then color and the expression of spatial relations complete architecture by lending it a cosmic dimension.

Buildings, like the earth itself, are "shapes in space" and to be plastically complete require light to give them form and relate them to the surrounding space.
And this is the positive result that the destructive character of modern painting has—it adds to the image of visual reality in all its poignancy the cosmic values of space, light and relation, values in which all terrestrial objects, as individual cases, are contained and on which they are predicated.

from: *de Stijl,* Vol. 1, 1917-1918

Plastic Means
by Piet Mondrian

- □ + = R₄
De Stijl Manifest 1923

1 Plastic means shall be defined as plane surfaces or right-angled volumes in the primary colors red, blue and yellow and in the non-colors white, black and grey. In architecture empty space counts as a non-color; mass may be thought of as color.

2 An equilibrium of all plastic means should be our goal. Even if they differ in terms of dimension or color they will have to be of equal value. In general, equilibrium will require large areas of non-color and comparatively small areas of color or mass.

3 Dualistic opposition of plastic means is likewise a requisite of composition.

4 True equilibrium is achieved by positioning, and its basically oppositional character is expressed by the straight line (the demarcation of each plastic means).

5 Equilibrium, which neutralizes and synthesizes the plastic means, arises out of the proportional relationships established between them, out of which in turn arises vital rhythm. These are the five neo-plastic laws which define pure plastic means and determine their use.

from: *de Stijl,* Commemorative Issue, 1923-1925

I

Working together we have studied architecture as a plastic unity of all the arts (not including technology and industry) and found that our conclusions led us to a new style.

II

We have investigated the laws of space and their infinite variations (spatial contrasts, spatial dissonances, spatial complementarities etc.) and found that all these spatial variations can be mastered to create a balanced whole.

III

We have investigated the laws of color in space and time and found that the relationship between these elements, brought into equilibrium, leads to a new and positive plastic art.

IV

We have studied the relationship between space and time and found that the plastic expression of these two elements can be given a new dimension through color.

V

We have studied the interrelationships of dimension, proportion, space, time and materials and found the definitive method of constructing them to form a unity.

VI

By breaking through closed surfaces (walls) we have abolished the duality between inside and out.

VII

We have pointed out the correct place of color in architecture and declare that painting which is divorced from architectonic structure (i. e. easel-painting) no longer has a raison d'être.

VIII

The age of destruction is over for good. A new age is beginning—*The Great Age of Construction.*

from: *de Stijl*, Vol. 6, 1923-1925

Erstes Augustheft 1896.

The Chromatic Controversy:
Contemporary Views of the Twenties
selected by
Franziska Bollerey and Kristiana Hartmann

Cultural Despair
Reformers
The Use of Color

Critics of the industrial cities around the turn of the century may have been concerned primarily with social reform, but beneath the surface of their arguments there almost invariably runs a current of aesthetic revulsion. To reformers of the Wilhelmine Era in Germany the drab residential barracks of Berlin were the quintessence of both social and architectural horror. Some fled the cities; others stayed to try to change them.

Men like Alfred Lichtwark, Ferdinand Avenarius, Paul Schultze-Naumburg and the *Kunstwart* circle placed their hope for an urban renascence in traditional country styles of building, from peasant cottages to the bourgeois manor house. What they saw as the degeneration of urban culture might still be stopped with a strong shot of bucolic vaccine.

"Only simple people like the fishermen and sailors of the Baltic and North Sea coasts", wrote Alfred Lichtwark, *"have not lost their native enjoyment of color and have kept up the old custom of painting their window-sashes blue, green or some other brilliant hue."* (1)

Color in architecture had soon become almost an article of faith and a flood of pamphlets and proclamations began pouring out of the believers' camp. Ferdinand Avenarius, publisher of *Der Kunstwart*, scolded the unenlightened for their *Fear of Color* in these colorful terms:

"...(ours) was a general confession of taste in the aesthetic wilderness that stretched from the ruins of a tradition destroyed by bogus antiquarianism all the way into our own century. Our masters and journeymen have not yet realized that we have, thank God, left this wilderness behind, that artists and friends of art now value color as highly as it has been valued by all epochs of good taste and by all healthy peoples in the past. No, I am not putting down our artisans —many of them know this well. It is only that their hands are tied—they are not allowed to 'jump into the paintpot'. From the little landlord all the way up to the most high and mighty authority, everyone has his own petty regulations to make. The value of color as a means to enliven our streets and

country prospects is something that has still not entered the heads of our most glorious and powerful patrons... That a healthy cheerful color is more cheering and healthful than a sick anaemic one, nobody would deny; in practice, however, we hear nothing but reasonable 'ifs' and 'buts'. Pastel tones are more 'tasteful', 'garish' ones are not 'cultivated', 'people' do not do things like that, 'bright beads are for dazzling the natives' etc. etc.''. (2)

Five years later, for the same journal, Fritz Schumacher wrote his now-famous essay *Farbige Architektur,* the first part of which we have translated at the beginning of this volume. Less emotional than dispassionately analytic, Schumacher's ideas about the mutual influence of form and color in architecture are as convincing today as they were then:

"The practical consequence of this statement, however, is not: Be sparing of color if your main effects are produced by form, but—and this is the crux: Simplify your form if you want to create good color effects..." (3)

Bruno Taut
Garden City

The dictum that the success of color depended upon the simplicity of architectural form was one which Bruno Taut applied to the letter in his garden suburbs, Reform near Magdeburg and Falkenberg near Grünau, on the outskirts of Berlin. Taut began his career by designing interiors for the Munich architect Theodor Fischer and, like Behrens, Pankok, Olbrich and other painter-architects of the day, at first could not seem to decide which of the two callings to devote himself to. Within a few short years, however, he had become the pioneer of unbroken color on exterior walls.

Taut devised his color scheme for the Falkenberg project before the First World War, while still an employee of the German Garden City Society. Falkenberg was such a popular success that it was flattered with a nickname: *Paintbox Settlement,* the people who lived there called it. Some of the people who visited it went even further in their flattery— Adolf Behne, for instance, reiterated a common theme of the time to the effect that color is a means of visual articulation capable of expressing, at one and the same time, the ideas of settlement, street, neighborhood, and one's own house

Farbige Architektur.

Die Sehnsucht nach Farbe, die neuerdings durch unsere graue Zeit hindurch geht, beginnt auch an der Thür der Architektur zu rütteln. Nachdem man zuerst im Innern unserer Häuser die Farbe wieder in ihre Herrschaftsrechte einzusetzen bemüht war, fängt man jetzt auch an, die Frage nach Farbe in der Außenarchitektur aufzuwerfen. Der Kunstwart ruft schon längst nach farbigen Häusern und weist hin auf die einfache Art, wie man durch getönte Putzflächen farbige Wirkungen erreichen kann. Man sieht auch hin und wieder Versuche, dem Putz koloristische Reize abzugewinnen: Dülfer in München ist hier mutig vorausgegangen, — man sieht Anläufe, das Holzwerk lebendig zu tönen: Schilling und Gräbner unter anderen thun das neuerdings meistens an ihren Villen, — und es ist schon ein großer Vorteil, daß man auf dem Gebiete der ländlichen Villa, anknüpfend an das Bauernhaus, den Farbenmut etwas in Fluß gebracht hat.

Aber damit ist die Aufgabe noch nicht erschöpft; diese ländliche Villa ist der einfachste Fall, der uns in der Frage nach farbiger Architektur entgegentritt, und wenn hier schon manchmal der heutige Architekt mangels einer sicher erprobten Ueberlieferung schwankend werden kann, so ist er noch weit hilfloser aufs Experimentieren gestellt, wenn er in komplizierteren architektonischen Zusammenhängen seinem Farbenbedürfnis Ausdruck geben will.

Diese Ratlosigkeit hat einen sehr einfachen Grund: es ist sehr schwer, ein Gebäude, das nicht von Anbeginn an auf Farbe berechnet ist, sozusagen hinterher durch Wahl des Materials oder durch Tönung farbig zu machen. Die ganze ästhetische Oekonomie eines Gebäudes müßte von vornherein auf Farbe angelegt sein; man kann mit einem Worte — außer bei ganz primitiven Anlagen — die Art des Bauens, die sich ohne Farbe entwickelt hat, dadurch nicht ohne weiteres bereichern, daß

and personal freedom. Then Behne described these wonder-working colors:

"The colors that Taut used in his Berlin garden suburb of Falkenberg of 1913 are, besides a basic white, mainly a light red, a dull olive green, a strong blue and a bright yellow-brown. They are distributed such that when one enters the court one faces a brilliant white house across the way; the two houses at either corner on the avenue are light red and olive green. Between these poles the rows of semi-detached dwellings recede into the distance... The colors of the walls are heightened wonderfully by a brilliant white on window-frames, sashes and shutters, cornices, verandas and wooden balcony railings, while the doors and trellises are most often a dark color. White appears again on the chimneys and arbors...
Color used in the way Taut had shown it could be used in residential architecture seems ideally suited to bridge two contrary demands: ...the standardized housing units that we have to build for economic reasons can be individualized by varying their color. This is really a very practical way of avoiding the danger of uniformity. And varying the colors of a prescribed number of housing units seems to me to perfectly express the liberty of these garden city residents —not the arbitrary liberty of private houseowners but the self-determination of members of a social organism!" (4)

Contemporary observers saw the task of color very much in terms of liberation, whether it was a matter of freeing workingmen's housing from *the tyranny of refined and alien forms* (5) or, as Taut himself put it, of liberating architecture as a whole from *the straitjacket of muddy grey styles and materials and all that high-flown junk.* (6) The 19th Century revivals, in other words, were the enemy, and they had to be fought as much for ideological and social as for aesthetic reasons. The bright colors of the new garden towns were meant to open the eyes of their residents in the hope that a closer emotional bond between them and their everyday surroundings would follow. If the affectionate nickname *Paintbox Settlement* for Taut's garden suburb in Berlin and the rather more militant *Red Castle* for his Magdeburg development are any indication, Taut was the first architect in Germany to succeed in using color to augment social identification—and communication.

As architects began simplifying shapes and stripping surfaces of anything that looked vaguely historical, they often expected color to serve in place of ornament. Many of them thought the entire question of decoration in architecture needed rethinking, and they were not willing to give Adolf Loos, who damned all ornament, the last word. The discussion got underway, but as it grew more substantial color soon found itself carrying social connotations that were a little too heavy for it to bear—many architects of the time, without going to the trouble of trying to prove it, attributed to color a healing power. This comes out in Taut's description of an inspection tour he made to the Glass Pavilion he had designed for the 1914 Werkbund Exhibition in Köln:

"In the domed room where the light was scattered by reflecting panes, rain or shine, the mood was never depressing. There was always a diffused glow, in colors that began with a deep blue at the bottom and progressed upwards through moss-green and golden yellow to the peak, where they culminated in brilliant creamy white. Their vivifying effect on the nerves was generally felt, as was a more concentrating, calming effect in the lower cascade room, where the ceilings and walls led through all the hues of the spectrum from red, gold and silver-painted surfaces to polychrome tiles to the ever-changing kaleidoscope of the deep violet niche, all of the colors collected and focussed by the bright yellow glow of the cascade, trickling like golden water." (7)

A similar sentiment was expressed by Paul Scheerbart:

"Bliss through color only in glass culture"—*"Stained glass diffuses hate."*

The outspoken poet-planner added a note of what must have been welcome irony to the rapidly polarizing debate.

The Labor Council for Art
A Call for Polychrome Architecture

In 1918 the war came to an end, revolution spread through Germany, the Kaiser abdicated his throne and the Republic was proclaimed. The long-awaited social and political turning was at hand; for Germany's architects it meant a new public challenge. The Berlin *Arbeitsrat für Kunst*, a group of progressive artists called together by Walter Gropius, Bruno Taut and Adolf Behne, responded in the Spring of 1919 by making a survey of its members and associates. One of the

questions they asked on this survey concerned the use of color in the urban setting—architects and artists, the Council said, ought to begin thinking about how public buildings, apartment houses and private homes should look in terms of color.

The answers were published under the title *Ja, Stimmen des Arbeitsrats für Kunst.* (8) Georg Tappert and Karl Schmidt-Rottluff argued that all the stucco should be knocked off the buildings that lined the country's opulent *Gründerzeit* avenues and the facades be painted in gay colors. César Klein by contrast would rather have seen color limited to suburbs and quarters of the city still in the planning stage. Klein submitted a sketch of a utopian seaside city the lower section of which (his drawing was not too precise on this point) would contain harbor, offices, banks and businesses and whose upper section, built on a cliff, was to be residential, a true *polychrome town* with green, red, blue and yellow blocks. Crowning the whole he envisaged a cathedral to an unknown god, a dizzyingly sharp and jagged pyramid of glass. Schmidt-Rottluff too submitted an ideal environment along similar lines. The debate about color in architecture during those post-war years was shot through with social commitment and utopian proposals.

In the late summer of 1919 *Bauwelt* magazine published *A Call for Color in Building.* (9) The same year saw Adolf Behne, the Berlin art historian, proclaim in his book *Wiederkehr der Kunst* that art was alive and well:

"Color! If there is anything that typifies today's educated philistine, it is his fear of color. Pearl grey or white, those are nice colors. Blue, however, is vulgar, red is pushy, green is gross... Colorlessness is the mark of education, white like the Europeans' skin! Civilized people of our climes look down on chromatic art and chromatic architecture as they look down on colored human bodies—with a kind of horrified shudder.
And where does this fear of color come from? Your philistine senses in color the presence of something immediate, unclothed... I know educated people turn up their Greek noses at such things. They would rather have their chaste bowers, stamped out by modern functional cookie-cutter à la Professor Peter Behrens."
"We're not going to get anywhere as Europeans," Behne wrote. *"Where European-ness ends, that's where the beauty (the color) of the world begins."* (5)

DIE BAUWELT
Zeitschrift für das gesamte Bauwesen
Bautennachweis, Verdingungs= und V 'teigerungsanzeiger

Bezugspreis: vierteljährlich Mark 4,— Hauptvertrieb: Berlin SW68, Kochstr. 22=26	18. September 1919 Erscheint jeden Donnerstag	Anzeigen: 30 Pf. die 5 gespalt. Millimeter= höhe. Umschlagseiten nach Sondertarif.
10. Jahrgang	Manuskriptsendungen an die Schriftleitung der „Bauwelt", Berlin SW68, Kochstraße 22=26 Drahtmeldung: „Ullsteinhaus-Bauwelt, Berlin" — Fernspr.: Amt Moritzpl. 11800 bis 11850	Heft 38

Inhalt: Aufruf zum farbigen Bauen / Beobachtungen über Farbenwirkung aus meiner Praxis / Neue Aufgaben im Bauwesen / Kleinsiedlungen der Stadt Breslau, illustr. / Wirtschaftliches / Grundstücks- und Hypothekenmarkt / Baustoffmarkt / Arbeitsmarkt / Verbände und Vereine / Persönliches / Dienstanweisungen für Arbeiterkontrolläre auf Bauten / Auskunftei / Wer liefert, / Geschäftliche Mitteilungen / Handelsregister.
Inhalt des Bauweltregisters: Bautennachweis / Versteigerungsanzeiger.

Aufruf zum farbigen Bauen!

Die vergangenen Jahrzehnte haben durch ihre rein technische und wissenschaftliche Betonung die optische Sinnenfreude getötet. Grau in graue Steinkästen traten an die Stelle farbiger und bemalter Häuser. Die durch Jahrhunderte gepflegte Tradition der Farbe versank in dem Begriff einer „Vornehmheit", der aber nichts anderes ist, als Mattheit und Unfähigkeit, das neben der Form wesentlichste Kunstmittel im Bauen, nämlich die Farbe, anzuwenden. Das Publikum hat heute Angst vor dem farbigen Haus und vergißt, daß die Zeit nicht so lange her ist, in der die Architekten keine schmutzigen Häuser bauen durften und in der man kein Haus verschmutzen ließ. Wir Unterzeichneten bekennen uns zur farbigen Architektur. Wir wollen keine freudlosen Häuser mehr bauen und erbaut sehen und wollen durch dieses geschlossene Bekenntnis dem Bauherren, dem Siedler wieder Mut zur Farbenfreude am Äußeren und Inneren des Hauses geben, damit er uns in unserm Wollen unterstützt. Farbe ist nicht teuer, wie Dekoration mit Gesimsen und Plastiken, aber Farbe ist Lebensfreude und, weil sie mit geringen Mitteln zu geben ist, deshalb müssen wir gerade in der Zeit der heutigen Not bei allen Bauten, die nun einmal aufgeführt werden müssen, auf sie dringen, bei jedem einfachsten Siedlerhaus, beim Barackendorf im Wiederaufbaugebiet usw. Wir verwerfen den Verzicht auf die Farbe ganz und gar, wo ein Haus in der Natur steht. Nicht allein die grüne Sommerlandschaft, sondern gerade die Schneelandschaft des Winters verlangt dringend nach der Farbe. An Stelle des schmutziggrauen Hauses im Freien trete endlich wieder das blaue, rote, gelbe, grüne, schwarze, weiße Haus in ungebrochener, leuchtender Tönung. Natürlich ist die fortgesetzte Pflege der Farbe mit Neuanstrich und Ausbesserung die notwendige Folge, wie es noch heute in Holland und vielen anderen Gegenden Tradition ist und einmal überall war. H. Zehder.

Bisherige Unterschriften:

Architekten: Bruno Ahrends, Berlin. W. C. Behrendt, Herausgeber der „Volkswohnung", Berlin. Peter Behrens, Berlin. Elkart, Stadtbaurat in Spandau. August Endell, Direktor der Kunstakademie in Breslau. Paul Gösch, Schweiz. Jakobus Göttel, Köln/Rh. Wa. _ropius, Direktor des staatlichen Bauhauses Weimar. Erwin Gutkind, Referent im Reichsarbeitsministerium, Berlin. John Martens, Ortelsburg. Paul Mebes, Berlin. Bruno Möhring, Berlin. Bruno Paul, Direktor der Kunstgewerbeschule Berlin. Friedrich Paulsen, Schriftleiter der „Bauwelt", Berlin. Hans Poelzig, Stadtbaurat in Dresden. Scharoun, Insterburg. Paul Schmitthenner, Stuttgart. Fritz Schumacher, Baudirektor in Hamburg. Heinrich Strammer, Berlin. Bruno Taut, Berlin. Max Taut, Berlin. Martin Wagner, Stadtbaurat, Berlin-Schöneberg. Hugo Zehder, Herausgeber von „1919, Neue Blätter für Kunst und Dichtung", Dresden. Paul Zucker, Charlottenburg.
Ausschuß für Kunst, Volksbildung und Wissenschaften, Oberbürgermeister Rosencrans, Insterburg. Dr. Adolf Behne, Charlottenburg. Bernhard Kampffmeyer, Vorsitzender der deutschen Gartenstadt-Gesellschaft, Berg.-Gladbach. Dr. Hans Kampffmeyer, Landeswohnungsinspektor, Karlsruhe/B. Prof. Dr. Hermann Mehner, Physikochemiker, Berlin. Dr. Karl Ernst Osthaus, Hagen/Westf. Adolf Otto, Generalsekretär der deutschen Gartenstadt-Gesellschaft, Grünau-Berlin. Prof. Dr. Strzygowski, Universität in Wien. Erich Worbs, Chemiker, Berlin.

Paul Scheerbart summed up this mood of cultural despair with frightening concision:

"Bump the Europeans off!
Bump 'em, bump 'em,
bump 'em off!"

Colorful Magdeburg and Bruno Taut

In March 1921 Bruno Taut, supported by the parties on the Left, won a close race for membership on the Magdeburg Board of Works. When he took office in May, he announced the main thrust of his building policy: *to transform Magdeburg into a colorful city.* The following month, in an article in the local press, he declared war on drab streets. Unbroken color was what the city needed, and Magdeburg's main business thoroughfare, *Breiter Weg,* was earmarked for the first experiments. (10)

"I want to say in public forum, that in my short time in office I have had to look on with horror at how the most diverse buildings, whether large or small, whether they have strongly articulated facades or flat ones—in short, that every one of these freshly painted buildings, regardless of type, has been sopped in the same greasy off-color gravy, in one of an infinite number of hues on the miniscule scale which runs from skim-milk to pea soup. I should like to see these buildings given back their character with true color."

Taut tried to gain the proprietors' trust, saying that any time they planned to paint their buildings they should come to him, so that *...in an atmosphere of friendly cooperation and without compulsion we can bring color back to our city's streets.*

The reaction on the part of the House Owners Association was, however, indignant—they would have no part of this *socialization of their streets* and stood fast on the right of self-determination. *Though it is true that the buildings are private property,* Taut replied, *the appearance of our city is a public concern.* (11)

Magdeburg's centrally located City Hall was among the first buildings to receive the new treatment. On May 14, 1922 the *General Anzeiger* announced that the painters had finished. (12) The color scheme, submitted by Karl Völker of Halle, was bordeaux red with white joints for the rough-hewn masonry of the ground floor and the applied orders above, and white for the rendering of the upper storeys. The allegorical, free-standing figures along the cornice and the putti over the entrance had been given a coat of striking yellow-ochre, and the arched domes of the open entry halls gleamed in alternating red and blue.

One of the first private buildings to go chromatic was the Barasch department store. Shorn of its late 19th-Century wedding-cake mouldings it was given a new, expressionist face by Oskar Fischer, a member of the *Novembergruppe* of artists. His geometric shapes, in colors ranging from sea-green to light brown and contoured in black, were distributed across the building's facade without regard for door and window openings. (13) Similar suggestions to do away with the old stuccowork and replace it with polychrome decoration had already been prominent in the Labour Council for Art's 1919 survey. (Municipal practice following World War Two was the same, if only in the negative sense—buildings were relentlessly stripped of their damaged stucco, but the textured rendering that replaced it was invariably a non-color: dirty urban grey.)

There was no stopping the chromatic architects now. To give the movement even more impetus, on June 22, 1922 Taut invited entries to a competition for facade and outdoor advertising design. (14) For the jury he was able to enlist such men as César Klein and Walter Gropius, both of Berlin. The activities were directed towards the Central-German exhibition in Magdeburg (MIAMA) planned for July to October 1922, and the artists of Magdeburg, tired of hearing their city called a suburb of Berlin, answered the call. Little doubt was left that the polychrome treatment of the city had a definite promotional function: at the opening of MIAMA the city distributed a *Guide to Painted Buildings in the City of Magdeburg* that reported on projects and listed every object which had received a new coat of paint, from public buildings to kiosks and soft-drink stands, from roof gables to trolleycars and fences with painted ads. By the end of 1922 over 100 buildings had gone polychrome.

And by March of the next year complaints had begun pouring in about their sad condition. The new plaster was already fading and peeling. *Deutsche Bauhütte,* a building journal, punned on Taut's name and the verb meaning *"to melt": In Magdeburg hat es schon lange "getaut": all the pretty colors are succumbing fast to rain and frost.* (15) On January 16, 1924 Bruno Taut submitted his resignation from the Board of Works.

Though Taut's example and energy had brought the Chro-

matic Movement almost to the point of victory, his setback in Magdeburg was just what his critics had been waiting for. The articles in *Deutsche Bauhütte* set the tone of the attacks:

"Then the herd of Tautologists arrived and made sure that the Germans overstuffed themselves on color-sense. Cafés and lounges reveled in orgies of color, walls and lighting fixtures outshouted each other, and anybody who braved them could be sure that St. Vitus' Dance and seasickness would be the more harmless maladies they caught there. And the facades screamed in blue, red, green, orange, ochre, chocolate, violet and pink, not to mention grey and even black..." (16)

The dailies, of course, picked up *orgies of color* very thankfully and made it into a catchword with which to scourge —and sometimes even to praise—their originator. What everyone had to agree, however, was that Taut had brought the question of color in architecture out into the open by discussing his policy in public forum. And the group of artists that published *Frühlicht* backed up their fellow-member's conviction that architects, since the nature of their work was intrinsically public, had no business riding their private artistic hobby-horses but ought to concentrate on setting those social forces free that existed as potentials wherever human beings lived and worked together. (17)

One of the movement's less strident critics, however, Albert Sigrist, who wrote on architecture during the Twenties from a Marxist point of view, thought that this kind of optimism about color was misplaced. We have to agree with him when he says that a colorful urban scene, by itself, cannot be expected to give city dwellers new meaning or joy in life.

Color in Public Housing
Large-Scale Projects of the Twenties
Bruno Taut Returns

When foreign capital began coming into inflation-racked Germany as a result of the Dawes Plan, the country's industry, and with it the building trades, began to breathe freer. In 1924 the public housing board GEHAG was founded in Berlin and Bruno Taut was named artistic director of its planning division. Basing his work on the plans of Martin Wagner and Hermann Jansen, who envisaged areas and belts of green

Das farbige Magdeburg

In einer ganzen Reihe deutscher Städte bestrebt man sich, der Baukunst die Farbe zurückzugewinnen, aber nirgends mit dem Eifer wie in Magdeburg, seitdem Bruno Taut das Bauamt der Stadt leitet und Kraßl zur Mitarbeit herangezogen hat. Natürlich hat Tauts Arbeit auch heftigen Widerspruch gefunden. Wegen Verunstaltung der Stadt ist es bis zur Drohung mit Handgranaten gekommen. Solche Schroffheit der Stellungnahme läßt auf eine bemerkenswerte Neuerung schließen.

Wie sah Magdeburg vor Tauts Einwirkung auf das Städtebild aus?

Magdeburg wurde als Sitz eines Erzbischofs in den wendischen Landen an der Elbe gegründet. In mehrhundertjähriger Arbeit gelang es, die dazwischen Stämme mit den westwärts und nördlich sitzenden germanischen, besonders den sächsischen, zu verschmelzen und aus der Verschmelzung Deutsche zu machen. Um 1300 war diese Entwicklung im wesentlichen vollendet. Magdeburg blühte nun mehrere Jahrhunderte als eine der ersten Städte, bis die Blüte 1631 in der Verwüstung durch den barbarischen tschechischen General Tilly zugrunde ging. Aus dieser Zeit vor 1631 sind in Magdeburg nur einige Kirchen und unerhebliche Reste von Wohnhäusern erhalten. Künstlerisch maßgebend sind die Bauten aus der zweiten Hälfte des 17. Jahrhunderts. Dazu kommen etliche Biedermeierbauten und viel Neueres, das ganz gewiß nicht besser ist, als was man in allen deutschen Städten findet.

Der durchgängig verwendete Baustoff ist Putz, dazu kommen seit etwa 1850 Ziegelrohbauten. Die Farbe ist bei gemäß durchweg grau, sog. „Steinfarbe".

Tauts und Kraßls Bemühungen haben nun bewirkt, daß eine schon recht ansehnliche Reihe von Häusern in reinen und kräftigen Farben gestrichen wurden. Der Preis lichtechter Farben ist nun vielfach so hoch, daß nur eine ziemlich kurze Reihe ungemischter Farben zur Verfügung steht: ein schönes Eisenoxydrot, Ultramarinblau, Chromgelb, Malachitgrün, schwarz und weiß. Kobaltblau ist leider zu teuer, es wäre vielfach wohl schöner als Ultramarin. Zu diesen Farben kommen Schwarz und Weiß und die durch Mischen herzustellenden Farben, besonders etliche braune Töne.

Die ungewohnten reinen Farben haben Widerspruch erweckt, noch mehr wohl Aufteilungen wie die des Hauses Barasch (Bauwelt, Heft 44, 1921). Hier ist die sonst ebene Fläche zwischen den Fenstern durch gerade Linien und Kreisbogen aufgeteilt. Die Felder sind dann in verschiedenen, ziemlich blassen Farben getönt. Auf die Fensterlöcher, Balkenlagen usw. wird keinerlei Rücksicht genommen. Eigentlich farbig kann man dies Haus nicht nennen. Es wird auch kaum viel Nachfolger finden und jedenfalls keinen wesentlichen Teil in dem Bilde des farbigen Magdeburg. Einige andere Häuser sind noch da, die ganz ohne Rücksicht auf die in der Tat sehr üble architektonische Gestaltung bemalt worden sind, bei denen rücksichtslos Linien und Flächen über den „Schmuck" laufen. Ein dreistöckiges Haus ist blau gestrichen und hat ein Gewirr von handbreiten Linien, vorzugsweise

in chromgelb. Da in dieser Straße auch alle anderen Häuser farbig behandelt sind, d. h. keinen einzigen steingrauen Fleck zeigen, wirkt dies Haus (vom Volk als Blauhaus bezeichnet) wohl fremdartig und gewaltsam, aber nicht als Mißklang.

Fast alle übrigen Häuser sind in der Art farbig geworden, daß die glatten Flächen einen Ton erhielten. Die Fensterumrahmungen, etwaige Säulen, Pilaster, Verdachungen, Gesimse, bildhauerischen Schmuckstücke sind dann in abstechenden Farben gestrichen, etwa gelbe Säulen, blaue und weiße Gesimse, schwarze Fugen usw. Diese Häuser wirken fast sämtlich fröhlich, hoffnungsvoll. Gelegentlich sind die Quadern in wechselnden Farben gestrichen, mehrfach kommt braun für das Erdgeschoß vor. Beachtlich ist hier, wie die Formen, die ja durchweg irgendwie aus der griechischen Baukunst stammen, vielfach erst durch die Farbe zur Wirkung kommen, als ob sie sich nun erst auf ihre ursprüngliche Bestimmung besönnen. Waren doch die ältesten Vorbilder aller uns in der Renaissance wieder halblebendig gewordenen Formen einst farbig.

Um baukünstlerische Leistungen hat es sich bei den bisher behandelten Häusern nicht gehandelt. Sie konnten also auch künstlerisch nicht geschädigt werden.

Anders steht es mit zwei Bauten, an die Hand anzulegen sich mancher gescheut hätte: das Rathaus und das Gesellschaftshaus im Klosterbergegarten (Friedrich-Wilhelm-Garten). Das Rathaus ist ein etwas derber, nüchterner Barockbau, gegen 1700 errichtet. Er ist jetzt rot und weiß gestrichen. Das gequaderte Erdgeschoß ist ganz rot, nur mit schwarzen Fugen, das Obergeschoß hat rote Pilaster und Gesimse, die glatten Flächen sind weiß, Kapitäle, Figuren sind gelb (zum Teil grün abgetönt), der Fries ist schwarz. In den Gewölbekappen wechselt Blau mit Rot. Im Treppenhaus kommen auch helle Tönungen von Rosa, Grün, Grau vor. Der Gesamteindruck ist prächtig, wohl gelegentlich etwas handfest, wie aber der Ton in den Bauformen liegt.

Ein zarter Bau ist das Gesellschaftshaus im Klosterbergegarten. Dabei sprüht es von heiterer Anmut. Ein Schinkelscher Entwurf liegt zugrunde. Ueber einem Sockelgeschoß erheben sich zwei wenig vortretende Flügel und zwischen ihnen eine zweigeschossige Säulenhalle, unten leider durch Fenster geschlossen. Sämtliche Formen sind so zart, als wären sie für Marmor gezeichnet. Dieser Bau hat nun ein rotes Sockelgeschoß, rote Säulen, ultramarinblaue Wände mit malachitgrünen Pilastern und weiße, in den Zierraten gelbe Gesimse. Die Säulen der Straßenseite haben auch weiße Stege zwischen den Riesen. Der Gesamteindruck dieses Hauses ist von der heiteren Anmut, die es ausdrücken sollte. Es ist ein wahres Festhaus. Im Innern wechseln mehrfach im gleichen Raum die Farben der Wände, der Saal hat eine recht dunkle Decke erhalten, überhaupt bedarf es wohl einer längeren Einfühlung, um hier mit den Malern der Räume zu empfinden.

Eine noch kühnere Arbeit ist die angefangene Bemalung des Kaiser-Otto-Denkmals vor dem Rathause. Es handelt sich um ein Reiterbild mit zwei allegorischen Figuren. Diese

throughout the city, the color specialist from Magdeburg began to lay out the suburbs and housing developments around the periphery of Berlin. Experience having made him cautious, however, he toned down his public approach to a more pragmatic one—if the landlords could not be entrusted with paint, then the Town Planner would have to do the job himself, from start to finish.

Each of the GEHAG developments—the Hufeisensiedlung in Britz, the low-cost housing at Weissensee, the Prenzlauer Berg developments—received an individual color scheme. Houses or groups of houses rendered in an unbroken blue, red, green, yellow or white and heightened by bands of brick or clinkers as structuring or framing elements around doors and windows lent these developments visual interest. In 1926 GEHAG began what was to be one of its largest projects, in the private residential suburb of Zehlendorf. From the start this plan met with great resistance from people who saw it as a threat to their woods and meadows—the district mayor, who did not want ... *petty officials and members of the middle class moving in,* even called in the police to prevent groundbreaking. The project was not to be stopped, however, and by 1932 the last of the five construction stages had been completed and the Waldsiedlung (Onkel-Tom-Siedlung) in Zehlendorf, serviced by a new subway station, was a fact. Its two- and three-storey houses were some of the city's most interesting from the viewpoint of color.

For the last of the project's five sections, *Am Fischtal,* the municipal building authorities imposed the condition that a unified color scheme be submitted in advance. Taut and his assistant, Franz Hillinger complied, and came up with the plan illustrated here: The five parallel streets running north and south with their offset rows of two-storey dwellings were done in a basic red and greenish-blue, alternating left and right. This complementary scheme was reversed at the backs of the houses, so that those with a red street-side had a green yard-side and vice-versa. The facades were articulated with bands of glazed brick in the Mondrian manner. To set the projecting foundation bands off from the ground and first-floor rendering they were painted white on the red houses and yellow on the green ones. This served at once to strengthen the chromatic effect and reduce the buildings' height optically.

Taut took lighting conditions into full consideration when planning his color scheme. All the surfaces which receive cool morning light were painted dark greenish-blue and those facing west a deep Pompeii red to catch the warm afternoon and evening sun. Window frames in combinations of white-yellow-red on red stucco and yellow-red-white on green rounded off the composition. Some of the houses were placed at intervals closer to the street, and Taut emphasized their position further by rendering them all red or all green, which makes them appear almost to tower over their neighbors. Closing off either end of the parallel streets of the development, the staggered rows of dwellings to the north and the flush rows to the south were rendered yellow with white foundations on the street side, and black borders were used to set off doors and windows and articulate the facades. Except for the blue houses at either end, all of these had white back walls. In a letter to the local building authorities on April 14, 1930, Taut explained his scheme as follows:

"The main point of it, to our way of thinking, is that color should be used to underline the spatial character of the development. By means of variation in color intensity and brilliance we can expand the space between the houserows in certain directions and compress it in others. Thus one of the key principles behind the enclosed color scheme is an optical widening of both streets and yards by means of relatively dark colors. This also has the emotional advantage that on the garden-side of the houses, the glass-roofed verandas will appear lighter against the unbroken walls above them if these walls are rendered a darker hue... On the other hand, we plan to intensify the effect by choosing contrasting colors for the rows of dwellings on the cross-streets—colors that are quite intense and active and yet pleasing to the eye." (18)

Taut's color scheme has withstood the test of time better than it has the vagaries of the market. The houses are now in private hands. The long houserow fronting Argentinische Allee, known popularly as The Whiplash, was originally an intense, almost garish yellow interrupted rhythmically by pairs of narrow stripes in red, blue, green and white. During the Fifties and Sixties the GEHAG, for reasons of its own, began changing this conception with the result that today a modernistic harmony has superseded Taut's sensitive and original, if weathered scheme. Clear local regulations could still save it, however. The Keim Mineral Dyes that were used in the original rendering could be reproduced by taking stucco samples. It would truly be a public service to have these fine colors restored.

In his *Memoirs of a Developer* Taut quoted, with pride and

gratification, what Vandoyer said of his Waldsiedlung:

"The houses have a very simple modernity and above all are extremely cheerful. Behind its veil of pines each street has its own face, its own color. True, dwellings like these do not necessarily make for human happiness. But at least they invite you to be happy."

Mebes—Emmerich—Salvisberg

Of course Bruno Taut was not the only German architect of the Twenties to use color as an integral element of town planning. Two other names that should be mentioned in this context are Mebes and Emmerich, though these architects are perhaps better known for their use of polychrome materials than stucco—their Heidehof project in Zehlendorf is a case in point. Salvisberg, on the other hand, lived in a house with chromatic rendering himself, and built a row of dwellings near the Botanical Garden in Berlin which he gave a rhythmic scheme in white, yellow, orange and reddish-brown. (19) One also meets the name Salvisberg in a completely different context, that of the *White City*. Despite color's tremendous gains in popularity during the Twenties, several of Berlin's other key housing developments remained consciously and proudly white.

Freedom, Space and Function: White Joins the Fray

Ornament is a crime—if we review Adolf Loos's architecture to find out how he used color, we soon realize that his famous statement might just as well have read: *Color is a crime.* The White City on Berlin's northern periphery was built under the same banner, for it stood for a particularly purist and functionalist approach to architecture the best known examples of which are perhaps the Bauhaus buildings at Dessau (1925-26) and the experimental housing development Haselhorst at Spandau near Berlin, both designed by the leading advocate of the style, Walter Gropius. To functionalist architects white, clear and bright, meant no less than Freedom and Space—a door through which the Human Spirit could re-enter architecture.
The battle between the Whites and the Colors was described thus by a proponent of the latter forces, Mr. Meier-Obrist:

"Their emphasis on the function of architecture, their preference of the smoothest, simplest and most purely constructive forms, flat roofs and all this led them to think of color as a romantic relic. White was their battle-cry. White was colorlessness per se—or rather, all the colors of the spectrum in one. White was the dogmatic Funtionalist's talisman." (20)

Fernand Léger by contrast, who in 1925 could still speak of a *Révolution du mur blanc,* warned his hearers against that very thing in a lecture held on May 3, 1933:

"From an artistic standpoint a bare wall is perfect, but from a social one it fails. And to think, gentlemen of the architectural profession, that we might have come to some agreement about these walls. You didn't want to believe that colors are there to destroy lifeless surfaces, to make them habitable, to take away their absolute, architectonic status... While you were off running after the Absolute you should have looked back over your shoulder once—you're alone, you have no followers." (21)

Otto Haesler and Ernst May

Otto Haesler in Celle and Ernst May in Breslau and Frankfurt also played a part in the urban color controversy. Haesler, who established an office in Celle in 1906, was commissioned by the Volkshilfe Public Building Society (established 1923) to build two developments, the *Italienischer Garten* with 44 apartments in 10 buildings (22) and *Georgsgarten,* which was to have 180 flats and a number of facilities for common use. (23) In designing the color schemes for these projects Haesler had the aid of Karl Völker, an artist from *colorful Magdeburg.* One sketch for the east facade of Block I will serve as an illustration: The main body of the building is yellow, the projecting bays which run through the top storeys are rendered white in front with brownish-yellow sides. The metal frames of the lower windows are likewise yellow, while the bay windows have black centers and red casements. Haesler described his partisanship for chromatic architecture in these words:

"Advocating color in architecture involves much more than wishing to see buildings painted bright hues or wanting to improve people's taste in general. The task is a much larger one. It means taking the architectural value of each building

and of entire streets and squares and raising it to a new level, increasing the overall effect. This job requires a lot of responsibility, yet by the same token it is extremely important that it be done." (24)

Ernst May was justified in calling himself one of the pioneers of the chromatic city. Color, he asserted, was one of the cheapest and easiest ways to make standardized housing interesting and cheerful. We shall let him explain his approach in his own words. On the Bunzlau Siedlung, planned for Schlesische Heimstätte, May wrote:

"The main body of the houses was rendered blue and red such that two sides each were tinted in each of these colors. What we achieved by this color scheme was that, thanks to the overlapping of the houses, which were very simple in shape, new and exciting color combinations came about. The public outcry this caused was incredible—the poets even hymned it as a 'revolutionary act'. Yet red and blue is about the most elementary color combination imaginable, as one glance at early medieval religious pictures will show. Then too, as Mr. Dülberg has pointed out, the Hessian peasant women, who certainly cannot be suspected of revolutionary tendencies, wear holiday costumes in which red-blue is the dominant chord—and that in public." (25)

On his color scheme for the city of Neumarket, May wrote:

"We have done the main through street and the business district in very lively reds and yellows, while the cross-streets of the quiet residential areas flanking the center are dominated by blues and greens. Around the city periphery the buildings are a reserved, cheerful white to which the buildings that flank the main access roads provide a brilliant color contrast. It goes without saying that these color cues do not mean that one mile-long street should be a solid yellow-orange, the next one solid blue, etc. We have given them only as suggestions for the dominant hue in each case. Starting from an overall color scheme such as this one, each street can naturally be treated in a sensitive, artistic and individual way. Nor is our plan meant to be a recipe. It should be thought of as a first practical attempt to solve this exciting —and up to now so cavalierly treated—problem." (26)

From 1925 to 1933, in his position as Municipal Building Councillor in Frankfurt am Main, May was a prominent advo-

cate of new types of standard public housing. During these eight years a total of 15,000 flats were built to his specifications. In working out the color schemes of his developments May was aided by Hans Leistikow, a commercial artist.

Der Farbenbund and a New Controversy

With the proclamation of the first German Paint Day in 1925, a convention mainly for publicity purposes that was to be held annually thereafter, and with an exhibition of polychrome architecture held the same year, Hamburg became the unofficial capital of the movement. The next step was taken on January 1, 1926, with the founding of a Society for the Promotion of Color on the Urban Scene, or Farbenbund for short. Financed by the German paint and dye industry and by the housepainters' guild, this group saw its main tasks in cooperating with city administrations and various conservationist groups, and planned to open counselling centers to further its aims.

The Farbenbund took publicity very seriously. Its own organ, Die Farbige Stadt, appeared in 1926. Though financial difficulties forced the magazine to fuse with Fritz Gurlitt's Stadtbaukunst in 1929, it reappeared under its original title in 1932, stripped down to the essentials and without color plates.

Between 1925 and 1929 the Farbenbund organized over 100 exhibitions and popularized its efforts further by holding lecture series and maintaining its advisory services. In just five short years, the society announced with all the pride of authorship, over a million buildings in Germany had received a coat of chromatic paint or stucco.

The activities of the Farbenbund did not go uncriticized, however. Among its strongest opponents were Heinrich Tessenow, Max Läuger and Theodor Fischer (27), of whom the last in particular was a lifelong adherent of a rejuvenated Materialstil, or polychromy achieved by the use of building materials rather than paint. The Academy of Arts also raised its voice in opposition. (28) In a document submitted to the Mayor of Berlin, Dr. Böss, and signed by Max Liebermann as its president, the Academy registered its disapproval of the provocative coloration that schools, public baths and other prominent buildings had begun to display:

"The Academy of Arts has had a commission inspect some of the buildings that have of late received the chromatic treatment described above and has been regretfully forced

*to admit that the application of color to already existing struc-
tures has led to some very distressing lapses.''*

By 1928 the chromatic movement had begun to wane; the
Farbenbund took leave of its more progressive members
and sympathizers and devoted itself increasingly to devising
color schemes for the old sections of German towns with
their medieval, timber-framed houses. By 1932 the society
had changed its emphasis from *Farbigkeit* to *Farbe,* color to
paint, from aesthetics to economics: Paint, it now adver-
tised, preserved valuable architectural substance, was an
indicator of the technical quality of a finish, a way to attract
more tourists, a sign of a city's cleanliness and order. (29)
The following year the Farbenbund, like many other organi-
zations more or less forcefully brought under central control,
came out with strict guidelines to prevent the homeland from
defacement by colorless—or all too colorful—decoration. It
was 1933, and the pristine pan-German village had become
the new ideal.

Color in Architecture
A Provocation?

Color—architecture—cities—colorful cities—color on the
urban scene—how does it all fit together? Is a colorful urban
backdrop enough, will more color really change our living
and working environment? This is the most basic question of
all. To put it differently: Is it possible to raise a city's visual ac-
cessibility, the quality of experience and orientation, without
merely underlining its character as a huge, conglomerate
consumer object?
Let us go back a step first. Who decides where and how
much color is used in the urban environment? In Berlin of
the Classicistic Period it was the feudal aristocracy and the
architects who worked for them. In historicist Berlin of the
19th Century (The Greystone Period) it was entrepreneurs
who continued to build in the feudal tradition. Then, in the
first twenty years of the present century a discussion arose
about including those city dwellers in the process of
planning and design who up to that point had always been
planned and designed for (or around). In a few cases such as
the Garden Suburb of Falkenberg, planners even listened
when residents told them that they would like to live with
more and brighter colors. For the first time, the needs and
opinions of people who were to spend their lives in public

housing were seen not as incidental but as primary to plan-
ning policy.
In the center of the city of Berlin there was no physical room
for change—the landowners, communities and their archi-
tects had already filled every available space with the monu-
mental boxes of the Wilhelmine Era. With the advent of
republican democracy in the Twenties and the rise of the
garden suburbs, wider participation in the planning process
became one more facet of a growing political emancipation.
Though in Magdeburg, where advocates of chromaticism
overdid things, open conflict broke out between planning
from above and participation from below, the first step had
nevertheless been taken—the step towards helping people
actively appropriate and use the surroundings they lived and
worked in, the step towards socialization of town planning in
the widest sense.
If whatever is new, interesting, unusual has the power to
provoke us, then color can have that power too. Used in the
right way it can roughen up a perceptual field worn smooth,
can give us new eyes for our environment. The more provo-
cative a stimulus is to our perception, the more it can set
creative power free, excite the desire to take an active part in
shaping our surroundings. Once imagination is stimulated to
produce new and individual images, the chances are that
some of them will be images of freedom. (30)

Excerpted from: ''Farbe im Stadtbild'', Abakon Verlags-
gesellschaft mbH, Berlin 1976

(1) Cf. Lichtwark, Alfred. Palastfenster und Flügeltür, 1899, quoted in Meier-Oberist, Edmund: A. L. und die Farbe in der Baukunst, "Die farbige Stadt", Vol. 1, No. 2, 1927, p. 8.

(2) Cf. Avenarius, Ferdinand. Die Furcht vor der Farbe, "Der Kunstwart", Vol. 9, No. 21, 1896, p. 322.

(3) Cf. Schumacher, Fritz. Farbige Architektur, "Der Kunstwart", Vol. 14, No. 14/2, 1901, p. 299.

(4) Cf. Behne, Adolf. Die Bedeutung der Farbe in Falkenberg, "Die Gartenstadt", Vol. 7, Dec. 1913, p. 249.

(5) Behne, Adolf. Wiederkehr der Kunst, Berlin 1919.

(6) Cf. Taut, Bruno. Eindrücke aus Kowno, "Sozialistische Monatshefte", Vol. 24, No. 21/22, 1918, p. 899.

(7) Taut, Bruno. Beobachtungen über Farbenwirkungen aus meiner Praxis, "Die Bauwelt", No. 38, 1919, p. 13.

(8) Ja! Stimmen des Arbeitsrats für Kunst in Berlin, Berlin-Charlottenburg 1919.

(9) Cf. on the subject of color on the urban scene "Die Bauwelt", Vol. 10, Sept. 18, 1919. Contributions to the history of chromatic architecture in Germany and Switzerland in the first third of the 20th century are discussed in great detail by Mr. Hans-Jörg Rieger in his PhD dissertation, Zurich, 1974 (MS).

(10) "Magdeburger Zeitung", June 26, 1921, morning edition and "Volksstimme", June 26, 1921.

(11) "Magdeburger Zeitung", July 19, 1921, third edition.

(12) "General-Anzeiger", May 14, 1922.

(13) Article in the "Magdeburger Zeitung" of Oct. 14, 1921, headline Magdeburg Victim of Ultra-Expressionist's Rabid Experimentation. See also "Volksstimme", Oct. 25, 1921, where the painting of the department store was called a rape of the existing architectonic structure.

(14) "General-Anzeiger", June 25, 1922.

(15) "Deutsche Bauhütte", May 7, 1924.

(16) "Deutsche Bauhütte", April 8, 1922.

(17) "Frühlicht", Vol. 1, 1921. Reprint of 1963, p. 71.

(18) Letter from Gemeinnützige Heimstätten-Spar- und Bau-Aktiengesellschaft (GEHAG) to the Municipal Building Inspectors of the District Zehlendorf, dated April 14, 1930, initialled T/Be.

(19) Color plate in: "Die farbige Stadt", Vol. 2, No. 3, 1927, plate 1/2.

(20) "Die farbige Stadt", No. 6, 1931, p. 73.

(21) Cf. "Schweizerische Bauzeitung", June 24, 1933.

(22) Described in: "Bauwelt", Vol. 17, No. 45, 1926, p. 31; illustrated in: "Baugilde", Nov. 30, 1925.

(23) Cf. Pehnt, Wolfgang. Die expressionistische Architektur, Stuttgart, 1972, p. 195. He calls it the first German development executed in the new style of architecture. Color illustration in: Gut, Albert. Der Wohnungsbau in Deutschland nach dem Weltkriege, Munich, 1928, plate III. See also: "Bauwelt", Vol. 17, No. 45, 1926, p. 26 and "Form", Vol. 2, 1927, p. 193.

(24) "Schlesisches Heim", Vol. 12, 1924, p. 410.

(25) "Schlesisches Heim", No. 2, Feb. 1925, p. 60.

(26) Ibid.

(27) Cf. the article by Edmund Meier-Oberist, Gegner der Farbenbewegung, "Die farbige Stadt", Vol. 4, No. 12, 1930, p. 319 ff.

(28) Cf. the article Gegen die Verunstaltung Berlins. Auch die Akademie äussert sich, "Bauwelt", No. 8, 1926, p. 157 f.

(29) "Farbige Stadt", No. 11, 1932.

(30) "Die Mappe", Vol. 57, 1937-38, p. 32.

Color Sense
and Color Scene

Color effect -
The psychophysical motion set going in the human orga-
nism by color perception. Each color causes a certain effect
not all of which can be attributed to memory or associations
but is an inherent quality of that color. Thus color perception
does more than lead to knowledge about the things of the
external world; it is also deeply involved in the realm of per-
sonal experience and may influence the inner state, attitude
or even well-being of the viewer. Goethe expressed this
when he spoke of the "sensous and moral effect of color".
Orange and yellow appear warm, blue and violet usually
cold; between these extremes lie red and green which,
however, appear colder or warmer as they tend toward the
blue or yellow end of the spectrum (the words "cold" and
"warm" indicating the "temperature" of a color should be
taken metaphorically). The lightness or darkness of a color
—its value—also contributes to its effect. Further, colors
evince certain spatial values: all intense colors seem to ap-
proach the viewer, or appear close or limiting, whereas light,
broken or greyed, and particularly cold colors seem to re-
cede from the eye, suggesting distance. Finally, the various
colors possess emotional expressiveness, i. e. they may ap-
pear joyful and vivacious, exciting and activating (especially
red, yellow and orange), or on the other hand have a quieting
effect. Apparently emotional associations also play a role in
the effect colors have on us; blue, for instance, suggests the
color of the sky, red that of blood, etc. Substantial associa-
tions of this kind have over the centuries taken on symbolic
value.

from: "Lexikon der Kunst", Vol. 1,
VEB E. A. Seemann Verlag, Leipzig 1968, excerpted

Color Sense and Color Scene
by Martina Düttmann

"For looking does not teach us anything about the concepts of colors."

It is not colors but our notions about them Wittgenstein looks at in his ingenious *Remarks on Color,* and he does so from every possible angle. He asks: How does our conception of a color relate to that color itself? Do we know colors when we know their names? Is color perception something one can describe in words, color composition something one can learn by rule? Is there a bridge between the idea of white and the word *white?*

Goethe, it seems, had already given answers to these questions, in the shape of the rules and apercus of his *Farbenlehre.* Nowhere has the integral view of color been put with more elegance:

"Since neither from knowledge nor from reflection can a whole be assembled, as the one lacks the inward and the other the outward view, we shall have to conceive of science as art if we expect from it any sort of wholeness. And we shall have to seek this wholeness not in the general, nor in abundance; for, just as art is wholly embodied in each particular work, so ought science to be present completely in each separate object it treats.—However, if it is to fulfil a demand of this kind, scientific activity can afford to neglect none of the human powers. The depths of intuition, a solid grasp of the present, mathematical profundity and physical precision, the heights of reason and the penetration of understanding, the agility and yearning of imagination, a pleasure in the sensuous informed by love—none of these must be missing in that vital, fructifying grasp of the moment through which alone a work of art, whatever its content, can arise."

The two planes Goethe speaks of are there every time we experience colors, every time we get out the paintbox und put a stroke of blue next to a stroke of red—the plane of perception, of pleasure in the sensuous, of yearning imagination; and the plane of words, concepts, names. The points on these planes do not correspond one to one; if they were parallel we could expect to translate directly from image to word and back again. No, these two planes seem mysteriously to bend, merge and interlock, combining knowledge with experience, logic with emotion to shape one, comprehensive judgement.
This, at any rate, is the ideal.

This part of our book carries the title Color Sense and Color Scene. To argue our point we have chosen the plane of images rather than that of words; the texts that accompany the illustrations are meant only as aids to understanding. What we have tried to do here is to bring together examples from many parts of the world of the different moods architectural color can convey. Many of them will be familiar to you already.
Certain colors and the mood they create seem to belong to a certain spot, such as white to the Greek islands. It is a white that takes on color from the Mediterranean air, first warm then paling as the day goes on, a white broken by sharp shadows and tinted by the colors of its surroundings. Other colors fix a certain epoch for all time in a city; this has happened in Cracow, where the melancholy hues of art nouveau linger on like a perpetual twilight. In other places, atmospheric color derives from a dominant building material, such as the reds, browns and violets of Amsterdam's brick; or from the very diversity of the materials that have gone into a city's making, for example the natural stone, wrought iron, wood and colored glass that pick out lights in the grey 19th-Century facades of Berlin. The blue light that suffuses New York we recognized to originate in those glass expanses which reflect one another and the sky endlessly; the warm red that stays in the memory after leaving London, on the other hand, seems to adhere less to the obvious busses, shop windows and neon signs than to emanate from the life of the city itself. There are color moods that live from the changing seasons alone, and others that cannot come to life without material decay and renewal. It is tempting to attribute moods to chance; but what we call chance is usually determined by sympathy and tradition. Nor do color schemes, at least not many, follow hard and fast rules.

"Say what you see, and above all, what is much harder—see what you see," wrote Le Corbusier, and it is a statement worth thinking about. There is no School of Seeing. Though we often remember words, sentences, verses, fragments of prose, and use them in our speech every day, most people never use what they see; if they remember it at all, it is only unconsciously, and they certainly would be hard put to describe what they have seen. Even critics of architecture do a lot of judging and very little describing.

What we have attempted to do in this chapter is this: to show images for the eye to discover. We have ordered them into

what you might call a sensitive whole, and the long titles and short texts give a miniscule, hopefully helpful interpretation of them. What we have not wanted to do is put together a copybook of color schemes—copying these examples would be difficult anyway, since their effects depend too much on peculiar scene, history, mood and light. We have spread them out before the reader so that he may experience them vicariously, add them to his own experience, and perhaps, when faced with a decision about color in his own work, he will be able to fall back on this store of variations and suggestions, and find it a little easier to take *that vital and fructifying grasp of the moment*.

"White is highly sensitive to light..."

"All white bodies suggest to us the ideal of purity and simplicity."
Goethe, Farbenlehre, 7, 5

When it is used in architecture, white requires all three attributes—purity, simplicity and sensitivity to light. Purity means holding to a visually unambiguous architectonic conception, whether on a large scale or small; simplicity the use of clearly defined masses and edges; and sensitivity to light means conceiving the masses of a building plastically to take the play of shadows and colored reflections into account.

Photos: Johannes Uhl

How White Changes Color in Changing Light: Mykonos

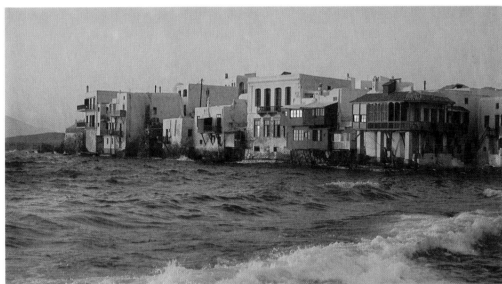

Trees as Architecture, Architecture as Nature: Granada and Barcelona

Green symbolizes nature and growth. Architecture, a human art, is the opposite of these—made-up, artificial. The greens of nature are the basis, the backdrop and sometimes even the opponent of architecture, in which, incidentally, the color green is rarely used. Yet there have been times when artificiality has not stopped with built walls; men have trimmed nature to their needs, creating corridors, rooms, arcades and labyrinths out of living plants. Nature in turn fights back in the only way it knows how, by growing —engulfing walls, obliterating windows, blocking entrances. Entire conceptions of architecture have been based on this vital opposition. In Granada one finds columns placed to resemble a tree-lined avenue; and Gaudi, in Barcelona, built artificial trees.

Photos: Werner Düttmann, Johannes Uhl

Graphic Ornament on Pavement and Walls: Seville

"A piece of music might be called a painting in sound, just as a painting is a composition in color. In both cases dissonances arise when the tones are jarring or unrelated, and harmony when the combination of tonal or chromatic nuances gives pleasure."
Johannes Blockwitz, Farbenspiele, 1880

Combining colors is easier when a building has clear boundaries, geometric or ornamental, which serve to separate colors and order them, and which as formal patterns are just as effective as the colors themselves. Often enough, when a building in Spain catches the eye it will be Moorish rather than European; this style, whether linear or plant-derived, is still very prevalent in Spanish cities, and not only as architectural decor but as patterns on sidewalks and squares, park and garden borders, fountain walls, grillework and trellises.

Photos: Johannes Uhl

Traditional Contrasts: Burano

That the color schemes of Burano's houses are very old can be seen by the layers and layers of paint they carry. Each building is a different color. While the window openings are almost always framed in white and the shutters are green, the facade may be any color of the rainbow. Foundation and walls often contrast and each storey may even be done in a different shade. When renovation time comes around their owners usually choose a shade of blue or red very similar to the existing one, or at most more intense, thus insuring a certain formal continuity... The city board has recommended that entire blocks not be repainted all at once, but that each building be renovated when the need arises. This is why the workings of time are particularly evident here—a certain organic contrast is preserved which lends individuality to the houses as it does to the boats in the harbor.
Suse Schmuck, 1970

Photos: Sikkens Archive

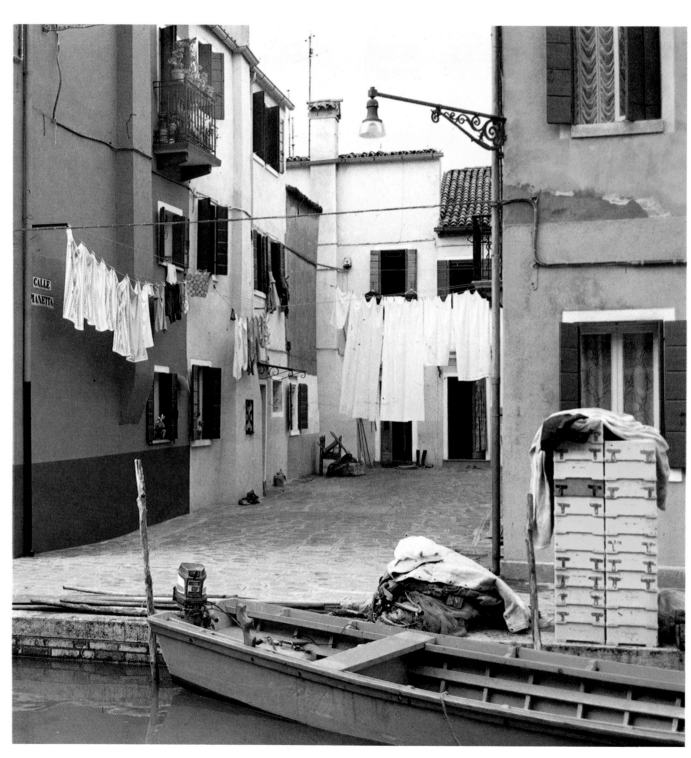

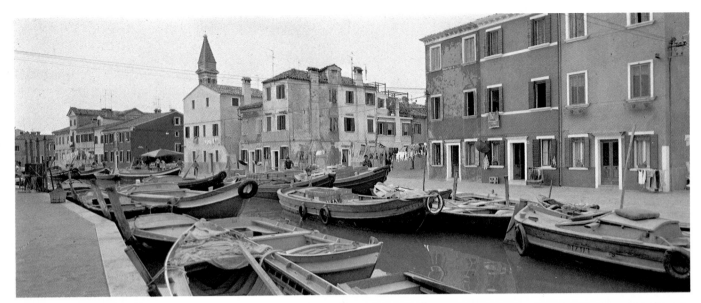

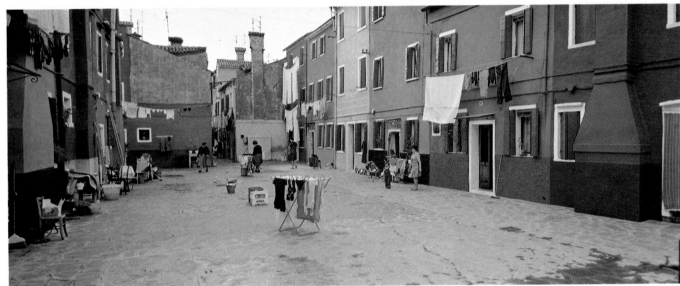

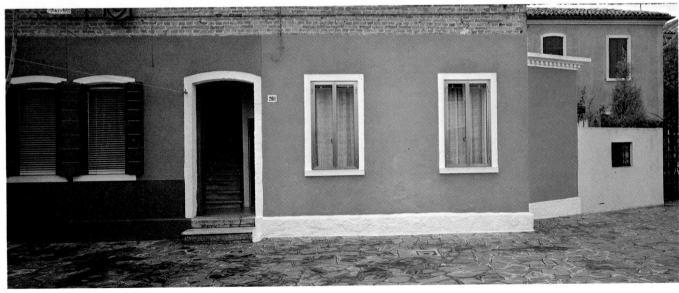

Where Reflections Are Blue: New York

"Blue makes on the eye a strange and almost indescribable impression. It is, as color, a force, though it stands on the negative pole and is, at its highest purity, what one might term a stimulating void. There is something in its appearance of conflict between activity and inertness."
Goethe, Farbenlehre, 778-9

"Under the influence of blue one underestimates time and judges weights as being lighter than they actually are."
Faber Birren, 1950

Reflections falsify; they alter the proportions of a place and turn directions end for end. Glass walls metamorphose through three stages: opaque and solid from a distance, they begin to mirror what is opposite them as we move closer until finally, when we are standing directly before them, they grow transparent and reveal what is behind them.

Photos: Johannes Uhl

Brick and sandstone are building materials that in the highly artificial context of modern cities stand for the natural, the organic—particularly in domestic architecture. Their hues run the gamut from yellow and red to brown and violet, in all nuances, and if we find them somehow natural it is because of three characteristics: stone colors are earth colors; their hues are intrinsic not applied; and stones or bricks are still set by hand—there is always a certain irregularity to the joints and to the finished wall that bespeaks the artisan.

Photos:
Eigen Haard, Amsterdam;
GA Houses 3, 1977;
Hans Düttmann, Berlin

Color Through Building Materials: The Brick Houses of Amsterdam

We tend to associate a certain idea or feeling with every city we know. Paris, for instance, may appear to the mind's eye as a network of silvery boulevards; Berlin as clothed in the heavy stuccowork of late-19th Century facades. Tokyo is an apparition—one huge neon skysign—and Cracow floats as though in the light of dusk, shimmering in green and mauve. London —the very word evokes life, and everything harsh, architectonic and cold flees before the memory of its streets bursting with human activity. London is a city dominated by red.

The busses fill the streets with it, the countless billboards and advertising signs add their touches of it, and the buildings, with their red windows, doors and even walls complete the picture. Even in London's pubs everything from chairs to carpets to walls to window-panes seems to have been dipped in red.

Perhaps there is no more of this color in the streets of London than in those of any other city you might name, however; perhaps it is merely the openness and warmth with which this city greets every stranger that seem to make this warmest of hues outshine all the others there.

Photos: H. Plarre, Berlin

The Color of Construction: Paris Scaffolds

"There is a great difference in appearance between dyed silk and wool. Method of manufacture and weave themselves bring divergencies among fabrics. Roughness, smoothness, gloss are cases in point."
Goethe, Farbenlehre, 874.

Rough, smooth and glossy surfaces contribute to the effect of color in architecture too, and in turn to the changing atmosphere we experience as we pass through a city. Even construction sites have their own unique spectrum —next to the colors of scaffolding and sheds, weathered stucco and old wood, reinforcing irons, wire and screen we find the colors of use, the peeling paint and cracked masonry, the dulled, roughened textures that time creates. And all of these yield gradually to the colors of renewal, the optimistic swaths of paint and factory-fresh materials, the glass and bright plaster until finally greys, browns and soft violets are only a memory.

Photos: Johannes Uhl

Black Grilles and Fire Escapes:
Chicago and Los Angeles

"Black cannot be derived as can white. We perceive it as a solid, non-transparent body."
Goethe, Farbenlehre, 9

The activity of building transforms opaque, solid bodies into complexes of walls and rooms, windows and door openings, light and shade. Painting a wall black would be to deny the essence of architecture —which is why black is used almost always for elements one can see through: grilles, window frames, fire escapes, iron tracery or ornament, or in screens that stand outside the loadbearing walls.

Photos: Werner Düttmann, Johannes Uhl

Details in Wood, Wrought Iron and Stained Glass:
Fin de Siècle Apartment Buildings in Berlin

The colors of an old building's details very often have something personal about them. The tenants may have put up new awnings over their balconies, painted doors and window frames, or rediscovered the stained glass windows in the stairwells that so fascinated them as children. What makes colored detailing of this kind stand out is the quality of materials and surfaces—the deep shimmer of enamel on wood, the subdued and delicate tones of stained glass; or the warm tints of sandstone used in casements and frames, or the hard, metallic colors of wrought-iron grilles or aluminum trim. Color can be applied to architectural detailing on the spur of the moment, too. It's almost like painting between the lines, for whenever two materials meet there is an edge to hold to. Anybody can give a door or a window a new coat of paint or install new handles or trim. This must be why modern buildings, shorn of all decorative detail, are so resistant to the personal touch—what is there to paint?

Photos: Uwe Rau, Berlin, from the multivision "Berlin"

Architecture as Canvas: Morellet in Paris

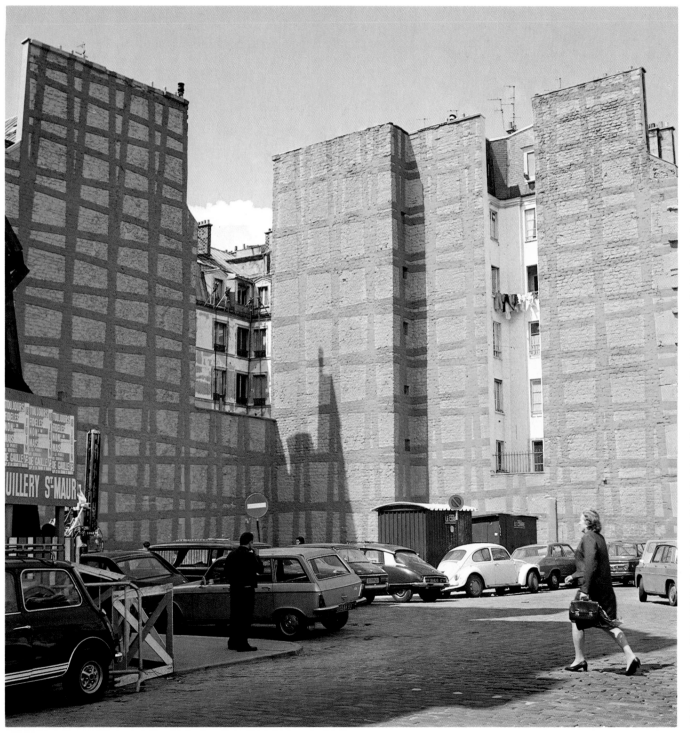

Wall-paintings, murals, Big Art—many names for one thing, the art of bringing color to the urban scene in the shape of monumental paintings that completely disregard the detail and utility of the buildings they cover. These oversized canvases hanging in the living-room of the city lay claim to every imaginable art-style. Still-lifes with fruit, landscapes with trees, realistic-looking crowds projected on the wall, their faces smiling and satisfied or just the opposite; some even hark back to the illusionistic architectural vistas so popular during Baroque times, by putting windows and doors where they are most unexpected and least needed. Then there is Minimal Art in two dimensions.

These images are transitory, however, for like any other rendering they cannot escape the effects of weather, and still less the protests of people who have grown tired of them. Suddenly smooth plaster, a purist mural, occupies the space where glaring color had been. The wall-painting by Morellet in Paris is no more.

Photos: F. Schmuck, Wolfhard Schulz, Dinslaken

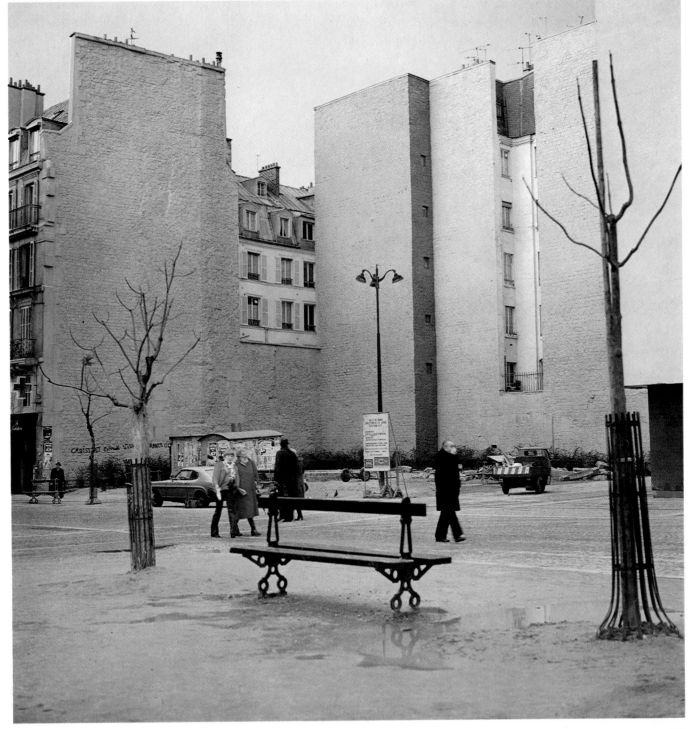

Color Correspondence Between Painting and Architecture: Mondrian and Rietveld

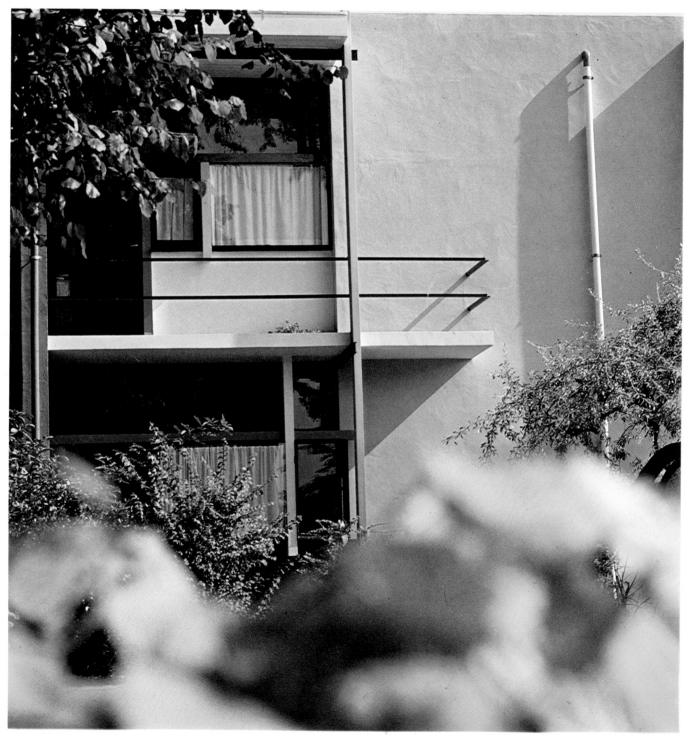

"An equal correspondence among all plastic means is necessary. Even if they differ in terms of dimension or color they should nevertheless be equal in value. In general, equilibrium requires large areas of non-color and comparatively smaller ones of color or mass."
Piet Mondrian,
Plastic Means, 2, 1927

This conscious equation of architecture with painting, with the former as a kind of utilitarian frame for the latter to fill, was one of the central precepts of the De Stijl movement of the Twenties. Seen in this way color relates to the essence of architecture and becomes an integral part of it—the essence of architecture being, in the definition of this group, construction in lines and planes, in the qualities of lightness and heaviness, with the aim of achieving a balance between limiting planes and masses, between light and the absence of light.

Photos: Sikkens Archive and Piet Mondrian: Composition, 1932 from: Mondrian und De Stijl, Exhibition catalogue galerie gmurzynska, Cologne 1979

Color Systems
by Friedrich Schmuck

Color quality -
The specific character of a color that arises from the attributes of hue, degree of lightness (or value), purity (or saturation), intensity and emotional effect. Hue is that attribute of a color by which it can be distinguished from another of the same lightness and purity. Often, based on the arrangement of the colors on a wheel and in analogy to the compass, a color's hue is termed its 'direction'. Lightness refers to the degree of difference of a color from black, as the darkest, and white, as the lightest color. Color purity (or saturation) is that attribute which determines the degree of difference between a certain tone and neutral grey. Color intensity is the strength or 'power' of a color; the saturated colors of the color wheel are perceived as most intense. Both intensity and saturation are diminished by the addition to a color of white, black or grey. This means that each color reaches its highest point of intensity and saturation at a different degree of lightness, e. g. yellow at a higher degree of lightness than blue. Nor do all saturated colors affect the eye with equal strength; no saturated green, for example, can approach the intensity of a saturated red. The emotional value of a color arises from the psychophysical effect it has on us, which is partly at least the result of a certain inherent expressiveness unique to each color.

from: "Lexikon der Kunst", Vol. 1,
VEB E. A. Seemann Verlag, Leipzig 1968, excerpted

Classification of Colors: Attributes and Definitions

1 Color wheel
Chevreul, 1861

If architects are to devote as much care and foresight to color schemes as they do to the dimensions, proportioning and masses of their buildings, they cannot get along without some kind of color classification or other. A color system with a selection of samples is the best way, not only to find out what paints are available on the market, but to gain an idea of what colors exist and how they relate to each other. Without a system or classification of this kind, it is very difficult to plan in terms of color, or even to match existing architectural colors with any precision at all.

Classifications that have been devised with great care to include as many shades and variations of color as possible are called color systems. If a system also has samples or chips to illustrate its colors, we call it officially a color catalogue. These samples are designated according to the principle on which the system is based. There are several different principles for color systems, and we will discuss them below in detail. One general rule for color samples is that the gradations in tint from one sample to the next be so fine that one can imagine what color lies between them.

Color names

In order to be able to talk about colors we have to name them, or, if the color in question has no particular name, we should be able to identify it clearly by some combination of numbers or letters. Roughly, of course, we speak of reds and yellows, greens and blues, browns, greys, and black and white. Combinations of these terms such as yellow-green and blue-green serve to identify mixtures; still other colors are named after certain characteristic objects, like orange, turquoise and violet. Beyond this, however, lie countless color gradations, and these pose difficulties because there are no commonly accepted names for them. Here we have to make do with codes of numbers and letters. Even if these designations are very abstract, they are a much greater help in describing colors than such names as Arctic and Sahara, which, though they may be beautiful, call forth a slightly different picture in every person's mind.

Color hue

Hue is the attribute by which we distinguish colors by kind, the property that makes blue different from red. Black, white and grey have no hue. The elementary hues that our eye dis-

cerns are red, yellow, green and blue; the finer differences in hue are indicated on the scale: red, orange, yellow, yellow-green, green, blue-green, blue, violet, purple. This sequence, of course, is that of the rainbow, which is the spectrum of sunlight. The only color that is missing in a rainbow is purple, which is derived by mixing violet and red. Purple thus forms the link between the two ends of the spectrum, making it continuous—which is why it is often represented on a color wheel (Fig. 1).

White, grey and black are distinguished by the fact that we perceive them as colorless, as being neither reddish, yellowish, greenish nor bluish. Since they have no color (or 'chroma'), white, grey and black are called achromatic colors.

All gradations between, for example, a brilliant, intense red at one end of the scale and white, grey and black at the other, are of the same hue (Fig. 4). This hue may be designated by the wavelength of the spectral color from which the red has been derived. In the same way, all further hues can be identified by their wavelength. A sequence of colors spaced at equal intervals by wavelength, however, will not appear to the eye to be equally spaced (Fig. 2). This is why, in color systems organized by hue, the intervals are determined not by wavelength but by visual impression.

Saturation

After kind, or hue, of color, its degree, or saturation, is the second attribute by which we distinguish colors. Saturation is a word taken from chemistry, where it is used to describe the strength of a solution. By analogy to color, the more pigment is carried in a medium, the stronger, darker, more saturated that color becomes. The saturation of a given red, for instance, is determined by noting whether it is brilliant or subdued, or whether it is more or less closely related to the achromatic colors white, grey and black.

Lightness

To complete the description of a particular color, we require in addition to its hue and saturation the third attribute of lightness. The lightness of a pigment is a measure of how much light is reflected from its surface by comparison to the amount of light reflected from an optimal white surface. To designate a color's lightness a reference value of A is used,

which will lie somewhere between A = 100 for perfect white and A = 0 for absolute black.

Since, like hue intervals determined by wavelength, intervals of relative lightness do not appear equal to the human eye, lightness values are determined by visual impression in all color systems which are organized on the basis of this attribute (Fig. 3).

Color content

In some systems colors are described and designated by their color content rather than by their saturation or lightness. The term color content refers to the proportion of white, black or full color that is contained in a particular tone. A full color is one which is highly saturated and at the same time as light as possible. Red, yellow, green and blue, as full colors, have each a very characteristic lightness: red and green lie in the medium range of lightness between yellow at the light end and blue at the dark.

Some color systems, particularly those which are organized by color content, place the primary or pure colors on which the classification is based, regardless of their natural lightness, on a level with a medium grey (Fig. 4 and 5). Thus in systems of this type lightness cannot be used as a reference.

Basic colors

Basic colors, also known as primary or principal colors, are determined in various ways. One is to assume that any color which cannot be obtained by mixing others is a basic color. This is true of the pigments red, yellow, blue, black and white.

Another method of determining basic colors is purely perceptual, i.e. all those colors are called basic which have no trace of any other color in them. According to this view, the basic chromatic colors are those which are neither whitish nor greyish, and the principal achromatic tones those which are devoid of chroma, i.e. have neither a reddish, yellowish, greenish nor bluish cast.

The basic chromatic colors are defined in detail as follows: that yellow is considered basic or primary which is neither reddish nor greenish, that red which is neither bluish nor yellowish, that blue which has no trace of green or red, and that green which shows no yellowish or bluish tinge (Fig. 6).

2 Color circuit, according to DIN 6164 norm, showing the difference between equal hue intervals as determined by eye and by instrument. The circuit is spaced equally by visual impression; dots indicate steps of about 20 wavelengths each.

3 Lightness scale, according to Munsell, showing the difference between equal lightness intervals as determined by eye and by instrument. The sequence is spaced equally by visual impression; dots indicate equal steps in relative lightness value.

4/5 Two hue families, red
and yellow, from the
SIS Color Atlas.
In pure form red and
yellow have different
characteristic lightness;
here they are placed,
with all the other
pure colors, on a level with
a grey of medium lightness.

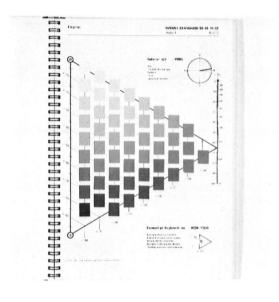

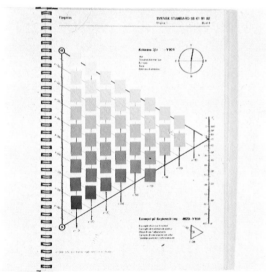

(Although we know that green paint can be mixed from yellow and blue, green is generally conceived, for systematic purposes, to be an independent color.)

Development of color systems

Even a designer or architect who has had a great deal of experience with color would find it difficult and time-consuming to mix, say, two different hues of exactly the same lightness. If he had some pattern to work by, though, his job would be much easier—he could try out different color compositions with the samples at hand, and soon would probably find his practical knowledge of colors and their countless possibilities had increased. Nor would his creativity necessarily suffer in the process.

Color systems are fine aids to composition, since they bring order into the beautiful confusion of the color range. They give us sequences of colors neatly listed by hue, saturation, lightness and interval. Some systems even go one step further. That published by Schuitema, for example, provides a number of suggested color combinations that make the designer's decision that much easier.

History
of Color Classifications

Though color systems may differ in detail, the colors they treat are eternal. Let us look now at some of the criteria on which these various systems are based.

Criterion One: Basic colors

All of the various attempts through history to classify colors have aimed at deriving all possible hues from the primary colors and mixtures of them. A good practical example of this process is three-color printing by the Hickethier method, in which it is possible, by carefully choosing the shades of only three basic colors, yellow, magenta and blue, to reproduce a very large area of the visible color field.
Some contemporary color systems, however, do without the determination of basic colors altogether. They rank all hues equally. An important characteristic of every color system, whether it designates primary colors as such or not, is the manner in which they are placed relative to one another. In some systems, basic colors are given positions of prominence at the corners of a triangle, a square or a pentagon. On the color wheel, basic colors figure by placement alone.

Criterion Two: Achromatic colors

Historically, one of the central questions in color classification has been the relation between achromatic and chromatic colors. One of the earliest schemes, that of Aguilonius, puts the chromatic colors yellow, red and blue, in order of natural lightness, between white and black (Fig. 9). Not until Newton (Fig. 10), who set the example for most systems to follow, were the achromatic colors separated from the chromatic and arranged in the center of the color circuit.

Criterion Three: Lightness

This arrangement paved the way for the transition from two-dimensional systems like Newton's to three-dimensional systems. The first of these, Lambert's color pyramid (which, by the way, was also the first system to include a complete range of samples) places black in the middle of a plane defined by yellow, red and blue, the basic plane of the figure (Fig. 11). Colors of very different lightness share this plane, from a very light yellow to black, the darkest dark.
In the color sphere that Runge devised shortly after Lambert's pyramid (Fig. 12), as in Ostwald's double cone of

6 Basic chromatic colors. The four basic chromatic colors are arranged differently from system to system. On the diagrams below of the more recent classifications (color circuits), their approximate position is indicated by dots.

7/8 If we transfer color sequences from the UCS grid to a circuit, we find that the grid classification does not conform exactly to the color intervals on a wheel.

a hundred years later (Fig. 25), medium grey is taken to be the center of the basic-color plane. This arrangement brings the colors of this plane closer together in terms of lightness than was the case in Lambert's scheme. Though yellow is still the lightest color here, the darkest is not black but blue. In the Munsell system, finally (Fig. 19), which was developed about the time of Ostwald's double cone, the chromatic hues are placed on a level with achromatic colors of equal lightness. Munsell was the first to define the color space exactly in terms of hue, saturation and lightness.

Criterion Four: Color interval

Even the very early systems of Lambert and Runge took the interval between colors to be an organizing factor. Lambert reduced the number of colors in his hue sequences as they approached white, in order to make the intervals large enough that color differences could still be detected (Fig. 11). Runge placed those colors which do not contain contrary elements such as black and white on the surface of his sphere, equidistant from the grey at its center (Fig. 12).

All recent systems developed since Munsell have attempted to order colors such that the intervals between them appear equal to the eye. However, writing on visual impression as a criterion for color spacing, Richter (Lit. 10) maintains that it is actually impossible to devise a system in which every color is perceived as equidistant from its neighbor. Uniform spacing, he says, can only be achieved specifically, i.e. with relation to one of the three referents of hue, saturation and lightness. Nickerson, by contrast, says about the Uniform Color Scales (UCS; Fig. 30, 31) that all twelve samples on the three-dimensional grid are equidistant from the thirteenth in its center, and that each of the twelve may itself form the center of a similar grid. The UCS system, however, does not include the color sequences by hue and saturation that Richter considers the organizing criteria of a color system (Fig. 7,8).

Limits of the color space

The colors that mark the outer boundaries of color systems have been chosen in various ways. In many systems, such as that of three-color printing, all colors are given as samples, and the outer limits of the system are marked by se-

lected basic colors and mixtures of these. Other classifications take what are termed optimal colors as their limits. Optimal colors are especially pure, bright colors which are obtained from the light spectrum—they are quite beyond the range of pigments.

Using color systems

How useful a color system will prove in practice depends of the range of samples it offers, and even more on the exactness with which these samples conform to the principles on which the system is based. No set of color chips, of course, can hope to be any more than an approximation to actual, let alone hypothetical, color variations.

Only those systems that have been developed since about 1910 will satisfy stringent requirements as regards precision of samples. There are certain basic requirements that samples must fulfil if they are to be of use to the designer. Obviously, they should be separate to allow comparison and experiments in color composition. All of the modern systems described here offer loose samples of this kind, with the exception of the Schuitema system. Large samples are particularly important when it comes to choosing colors for architectural applications. Without samples of sufficient surface area it is very difficult to judge how colors will look on a full-scale building. The Sikkens Color System (ACC), the DIN 6164 system, and the SIS (NCS) classification offer large samples of this kind.

It is also a great advantage for practical work to have a system which gives the colors used most often, e.g. in architectural design, in a larger number of variations than other, less commonly used shades. Selections which are particularly useful for architectural applications are provided by the ACC (Sikkens) System, and to a certain extent by the DIN 6164 norm, which concentrates on highly saturated and glossy colors.

The historical development of color systems shows how the definition of the main criteria—hue, saturation, lightness, interval—has become more and more precise with time, allowing classification of color in ever greater detail. It is also obvious that certain elements that were central to earlier systems, e.g. primary colors, have lost their significance in the course of change and innovation.

We have selected a number of examples to illustrate the history of color classification; they are presented below in chronological order. By describing each of these experiments and models in some detail, we hope to enable the reader to follow up the main ideas that have led, step by step, to the color systems of our own day.

1 Billmeyer, Fred W. and Saltzmann, Max. Principles of a Color Technology. New York, 1966

2 Bouma, Pieter Johannes. Physical Aspects of Color. Second edition. London, 1971

3 Gericke, Lothar and Schöne, Klaus. Das Phänomen der Farbe. Zur Geschichte und Theorie ihrer Anwendung. Berlin, 1970

4 Gerritsen, Franz. Farbe. Optische Erscheinung, physikalisches Phänomen und künstlerisches Ausdrucksmittel. Ravensburg, 1975

5 Goethe, Johann Wolfgang von. Materialien zur Geschichte der Farbenlehre, Erster Teil; Materialien zur Geschichte der Farbenlehre, Zweiter Teil; Schriften zur Farbenlehre. Vol. 41/42, dtv Complete works. Munich, 1963

6 Heimendahl, Eckart. Licht und Farbe. Ordnung und Funktion der Farbenwelt. Berlin, 1961

7 Hickethier, Alfred. Ein-Mal-Eins der Farbe. Zur Farbenordnung Hickethier. Fourth edition. Ravensburg, 1975

8 Matthaei, Rupprecht (Ed.). Goethes Farbenlehre. Ausgewählt und erläutert von Rupprecht Matthaei. Ravensburg, 1971

9 Müller, Aemilius. Die moderne Farbenharmonielehre. Winterthur-Zürich, 1948

10 Richter, Manfred. Einführung in die Farbmetrik. Berlin, 1976

11 Schöne, Wolfgang. Über das Licht in der Malerei. Fourth edition. Berlin, 1977

12 Seitz, Fritz. "Sind Farbordnungen für Entwerfer brauchbar?" In: Systematische Farbgestaltung. Conference report, ed. by Kurt Görsdorf. Stuttgart, 1969

13 Wyszecki, Günter. Farbsysteme. Göttingen, 1960
14 Wyszecki, Günter. "Farbsysteme." In: Systematische Farbgestaltung. Conference report, ed. by Kurt Görsdorf. Stuttgart, 1969

1613
The Color Diagram of Franciscus Aguilonius (Francois d'Aguilon)

1704
Isaac Newtown's Color Wheel

9 Color diagram,
Franciscus Aguilonius

10 Right: Isaac Newton's
color wheel

The basic colors white, yellow, red, blue and black are arranged in a row in this system, by order of lightness: yellow follows white and blue precedes black. The arcs give all the possible mixtures of any two basic colors. Mixtures of three are not given, nor have colors been divided into achromatic (white-black) and chromatic (yellow-red-blue), as they are as a matter of course today.

Nevertheless, Aguilon has differentiated between mixtures of achromatic with chromatic colors (the upper arcs) and chromatic with chromatic colors (the lower arcs). On the upper arcs—with the exception of the white-to-black one—the type of hue or chroma remains the same, i.e. on the yellow arc the hues run from white to yellow, whereas degree of saturation changes, i.e. it increases from white to yellow. The colors on the lower arcs, by contrast, change in terms of chroma, e.g. from yellow to orange to red.

Using a prism Newton found that white light contained all the colors of the spectrum. The bands of color he differentiated were red, orange, yellow, green, blue, indigo and violet; with purple, which did not appear either in the light spectrum or in the color wheel Newton derived from it, these colors give a continuous series.

In the center of the color wheel formed by bringing the red and violet ends of the spectrum together, Newton assumed white to be, and he placed progressive mixtures of white with all the spectral hues between center and periphery. The sectors of the wheel differed in size according to the observed width of the bands of the light spectrum.

1745
Johann Tobias Mayer's Color Scheme

1772
Johann Heinrich Lambert's Color Pyramid

Mayer's first attempt at classifying pigment colors was published in 1745. The scheme of his pigment mixtures was the same as that used by Aguilon in his color diagram. Like Aguilon, Mayer chose his basic colors and designated them as follows: A for white, E for yellow, I for red, O for blue, and U for black. The combinations formed a triangle:

AE EI IO OU
AI EO IU
AO EU
AU

Mayer's scheme did not include further mixtures of these combined colors.

In 1758 Mayer described in a lecture (which was not published until 1775) how he had expanded his color classification. In this later scheme he took as basic colors only three —red, yellow and blue—and set them at the corners of a triangle. Along the sides of the triangle, between each pair of basic colors, he envisioned eleven hues that would arise by mixing them systematically. Within the triangle he planned to arrange 55 shades mixed from the primary colors. At the exact center he placed grey, which, he said, would be produced by mixing equal parts of red, yellow and blue.

Toward the end of his talk Mayer suggested how his color system might be expanded by lightening all of the colors to white and darkening them to black, through twelve stages in each case. He thought, however, that the number of colors lightened or darkened should be reduced from triangle to triangle in order to insure that the difference between the hues would remain large enough to allow them to be clearly distinguished from one another. Thus Mayer's scheme, which comprised a total of 819 colors, can be envisaged as two pyramids placed base to base.
Black and white are ranked as basic colors even though, in contrast to his 1745 scheme, Mayer does not call them such; rather, he refers to them as representing the states of darkness and lightness.
Though Mayer, with this scheme, took the step toward a truly three-dimensional color classification in theory, it was not until 14 years later that it took visual shape—with the color pyramid that Johann Heinrich Lambert devised on the basis of Mayer's idea.

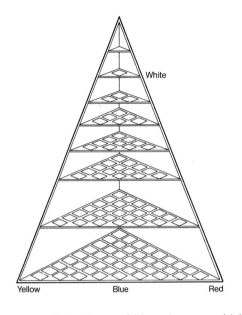

At the corners of the base of his color pyramid Lambert placed the three primary colors blue, yellow and red, and along each of its sides seven mixed hues. The area of the base contained 21 colors mixed systematically from the three primary colors; at its center was black which, in Lambert's view, would arise if equal parts of red, yellow and blue were combined.

The sides of the pyramid have similar divisions, and contain the colors one gets with progressive addition of white. Since it is difficult to distinguish tones of extreme lightness Lambert reduced their number towards the points of the pyramid, until the sixth triangle counting upward contained only the three primary colors with large proportions of white and the seventh white itself which, as Lambert noted, "represents whiteness or light and thus reflects all colored rays at once."

The 108 hues of Lambert's pyramid are designated by the proportions of each of the colors they contain. White is classed as the fourth basic color; black as a composite color.

11 Color pyramid,
Johann Heinrich Lambert

Literature 16:
Lambert, Johann Heinrich.
Beschreibung einer mit dem Calauschen Wachse ausgemalten Farbenpyramide... Berlin, 1772.
Reprinted in: Ostwald, Wilhelm (Ed.).
Die Farbe. Sammelschrift für alle Zweige der Farbkunde, Nos. 28,29 (1922) and No. 34 (1923)

1810
Philipp Otto Runge's Color Sphere

12 Color sphere,
Philipp Otto Runge

Literature 17:
Matile, Heinz. Die Farben-
lehre Philipp Otto Runges.
Second edition. München-
Mittenwald, 1979.
Literature 18:
Runge, Philipp Otto.
Farben-Kugel oder
Construction des Verhält-
nisses aller Mischungen
der Farben zueinander...
Hamburg, 1810. Facsimile:
Mittenwald, 1977.

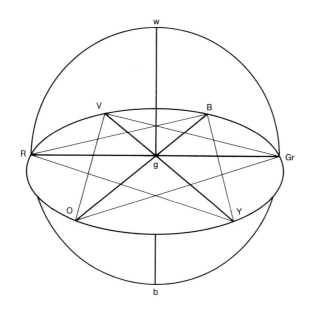

The five basic elements of Runge's color system are white, black, blue, yellow and red. He divides white and black from the remaining three, "which are the only ones we call colors". These three primary colors are to have hues such that the blue is neither yellowish nor reddish, the yellow neither bluish nor reddish, and the red neither yellowish nor bluish. Since each of these colors is unique with respect to the others, Runge has placed them at equal intervals from one another, at the points of an equilateral triangle.

Midway between two primary colors lie what Runge terms pure-color mixtures—green, orange and violet. By superimposing the mixture-triangle on that of the primary colors, Runge obtains an equilateral hexagon the points of which are equidistant to white and black, which occupy the endpoints of a line perpendicular to the plane of the hexagon. Grey lies halfway between white and black, and thus at the center of a circle described by the points of the color-hexagon. This grey is obtained by mixing equal parts of either white and black or of the three primary colors.

Since both mixtures of the pure colors and of the the pure-color mixtures are free of grey, Runge has arranged them according to hue at a distance from grey equal to that of white, black, the primary colors, and the pure-color mixtures. He thus obtains arcs that describe a sphere around the grey centerpoint.

Runge sums up the discussion of his color sphere in the following words: "Now one will as little be able to conceive of a nuance which, mixed of the five elements, does not touch or is not contained in this scheme, as to imagine another correct and complete figure for the scheme itself. And since every nuance is placed in correct relation to all pure elements and to all mixed colors, this sphere may be considered a general table in which someone who has previously had to consult divers tables for his business, will now find all colors within one context. And, as the attentive reader will have recognized, no plane figure can be found to represent a complete table of all mixed colors; their interrelation may be demonstrated only cubically."

1868
William Benson's
Color Cube

Benson's color cube is determined by eight principal colors: red, green, blue, yellow, sea-green, pink, and black and white. The primary colors in Benson's scheme are red, green and blue as they appear in the spectrum of sunlight. Among the principal colors are three hues that arise from additive mixing of the two primary colors, and which are complementary to the third. These are a yellow, mixed of red and green and complementary to blue; a sea-green mixed of green and blue and complementary to red; and a pink, mixed of blue and red and complementary to green.
The remaining principal colors in this scheme are black and white. White is given by additive mixture of the three primary colors; black represents the absence of light. Further mixed hues are placed in the intervals between the principal colors. Benson's cube is tipped up on one corner, so that the black-white axis is vertical. The three primary colors occupy the endpoints of the three edges of this cube which terminate in black; the three mixed colors the endpoints of the three edges which terminate in white.

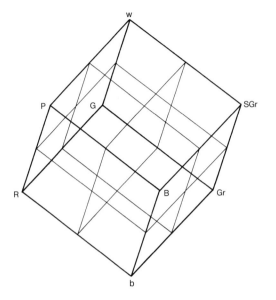

13 Color cube,
William Benson

Benson's is the first known classification in cubic shape, and one of the first to give samples. William Benson was an architect; he wrote a comprehensive study on color theories and experiments both of his own day and from the past.

14 Basic colors and mixed colors of the Benson color cube. This classification is rather hard to follow, being based on the laws of additive light mixing; the resulting colors are not so easy to imagine as paint or pigment mixtures.

Literature 19:
Benson, William. Principles of the Science of Color. London, 1886.

Contemporary Color Systems

Munsell Book of Color

Publisher: Munsell Color Company,
Baltimore, Maryland

Year of publication: 1929 and later editions

In the following overview we have divided color systems into two groups according to the main factors on which they are based. Two further systems are discussed which have unique factors and are not so easily classified. The first main group comprises systems that are based on the attributes of hue, saturation and lightness. These are the Munsell, Hesselgren and ACC systems.

In the second group we have placed systems in which colors are classified by hue, white content and black content—the Ostwald and SIS (NCS) systems. Somewhere between the two groups falls the DIN 6164 classification, which, since it does not give colors by lightness as evaluated by visual impression, as do the systems in Group One, we discuss together with Group Two. The UCS system is treated separately. This system is characterized, in addition to the criterion of color lightness, by that of equal spacing of colors by visual impression. Finally, the Schuitema color composition system is discussed as a case in its own right.

All of the color systems described here have been chosen for their applicability to architecture, and because, being widely distributed, they are easily available to architects. If the RAL color register is not listed here it is owing to the fact that it is not a color system as such, but a collection of about 150 commercial paint tones which is supplemented, for example, whenever new colors are prescribed for traffic signs. RAL colors are no longer included in the more recent German DIN norms, e.g. those covering marking colors. Instead, reference is made to these norms in the DIN color chart No. 6164.

Type of system

Colors are identified in terms of three attributes: hue, value (lightness) and chroma (saturation).

The colors of each hue family are not constant in terms of compensatory wavelength; Munsell corrected the hue definition in common use at the time in order to ensure that all the colors of a particular family would be perceived visually as approximately equal.

The degree of lightness of the colors in the Munsell system is derived by direct comparison to base values (A = Y), with the result that two colors of equal lightness but highly differing saturation may appear unequally light.

The color circuit in the Munsell system is based on the five principal hues of red, yellow, green, blue and purple, which have been chosen such that they appear visually equally spaced. Similarly, the 40 intermediate hues are spaced equally to perception. Colors that lie directly opposite one another are complementary (or compensatory), i.e. when mixed they produce grey—a fact that in some color systems is taken to indicate that these colors are harmonious in combination.

Samples

Over 1000 colors of 40 hues and a grey scale, as chips, either matt or glossy, in different sizes.

Prices

40 cards with samples 1.5 x 2.2 cm about DM 840.00

Basic diagrams for the analysis and comparison of contemporary color systems.
15 Arrangement of hues on circuit.
16 Graph of saturation/lightness (or color content) for each system.
17 Graph to compare saturation and lightness notations of each system in terms of reference values.

Sources for contemporary color systems

1 German norms (DIN): Beuth Verlag GmbH, Burggrafenstrasse 4, 1000 Berlin 30, Germany
2 Norms of other countries: Deutsches Institut für Normung e.V., Burggrafenstrasse 4, 1000 Berlin 30, Germany
3 Sikkens Color Collection 2021: Sikkens GmbH, Postfach 1126, 3008 Garbsen 1-Hannover, Germany; and Sikkens, Sassenheim, Netherlands
The remaining color systems are available through special bookstores. All systems and norms are on loan through the Deutsches Institut für Normung, Berlin.

Remarks

No chips are provided for light, low chroma colors of V/ >9 and /C <1 or for dark colors of V/ <2.5.

A new system has since been devised on the basis of the Munsell Book of Color, and the hues renamed by "Munsell renotations".

Notations

H = Hue. Notation of the five principal colors and five intermediate colors is by hue initials and their combinations, i.e. R, YR, Y, GY, G, BG, B, PB, P, RP. Consecutive numbers are given for the finer divisions of the scale, beginning at R = 5 and moving through YR = 15, Y = 25, etc. Combined notation with the hue initials and repeating decimals is also given, i.e. red = 5 R, 7.5 R, 10 R, 2.5 YR, 5 YR, 7.5 YR, 10 YR ... 10 RP, 2.5 R, 5 R. Neutral (achromatic) colors are denoted N.

V = Value. Lightness values given from 0/ for ideal black to 10/ for ideal white.

C = Chroma (saturation). Chroma notation is given from /0 for neutral (achromatic) colors to /12, /14, /16 and higher, depending on hue.

Notation for chromatic colors: H V/C
Notation for achromatic colors: N V/ or N V/0
Colors of extremely weak chromaticity (C = /0.1/0.2) are given as N V/(H,C).

18 Hue family of blue in the Munsell system

19 Schematic diagram of Munsell Book of Color. Top left: Color circuit with designation of sectors (see text). Basic colors are indicated by dots. Top right: Graph of saturation and lightness levels. Bottom left: Figure of the Munsell system. Bottom right: Comparison of color positions. Solid dots indicate comparative positions of two colors of equal Munsell saturation (chroma); open dots the position of two colors of equal Munsell lightness (value).

HESSELGREN's Color Atlas

Publisher: Color Center AB, Stockholm
(formerly T. Palmer AB, till 1963)

Year of publication: 1953, and later editions

20 Two sheets
from the HESSELGREN
Color Atlas:
Color circuit and color
family

The Atlas shows clearly that
color series of equal
saturation end in black, and
hence that the steps
between dark colors are
smaller than those between
light ones.

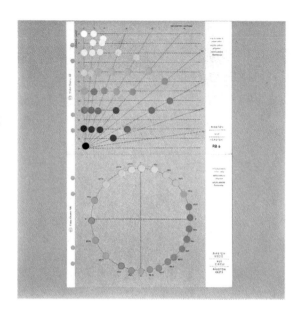

21 Schematic diagram
of HESSELGREN color
system.
Top left: Color circuit with
designation of sectors
(see text).
Position of basic colors
indicated by dots.
Top right: Diagram of
saturation and lightness
intervals.
Bottom left: Figure of
HESSELGREN system.
Bottom right: Comparison
of color positions.
Solid dots show position of
two colors of approximately
equal HESSELGREN
saturation; open dots that of
two colors of equal
HESSELGREN lightness.

Type of system
Colors are classified in terms of three attributes: hue, lightness and saturation.

The color circuit is divided into quadrants with the four major colors of yellow, red, blue and green, determined visually. Between yellow and red there are five intermediate colors, there are seven between red and blue, and three (later four) each between blue and green and between green and yellow. Thus the circuit has a total of 24 hues. The intervals between the major colors vary in an attempt to make the steps appear as visually equal as possible.

Samples
Approximately 600 (originally 500) colors of 24 hues and a grey scale, round chips (0.9 cm in diameter), mounted on 25 cards according to system classification (one including color wheel) or as loose samples, matt or glossy, 5.0 x 10.0 cm, arranged in a four-part box.

HESSELGREN's Color Atlas is out of print.

Notations
H = Hue. The hues of the four major colors are given by their initials (Y, R, B, G); those of the intermediate colors in the yellow-to-red quadrant by Y, YR4, YR8 ... YR20, R; those of the following quadrant by R, RB3, RB6, ... RB21, B; and those from blue to yellow by B, BG3, BG6, BG12 ... GY12, GY18, GY21, Y.
White, greys and black are given only by degree of lightness.

L = Lightness, given in values of 0 for white to 24 for black and accordingly for chromatic colors.

S = Saturation, which is given in values of 24, 28 and higher, depending on the hue.

S' = Color strength (intensity)

C = Cleanness (purity)

Notation for chromatic colors: H-L-S
Notation for white, greys and black: L

Acoat Color Codification (ACC) System

as applied in the Sikkens Color Collection 2021

Publisher: Akzo Coatings, Amstelveen, Holland
Year of publication: 1978, and later editions

Type of system
Colors are classified according to three attributes: hue, saturation and lightness. The color circuit of the Sikkens Color Collection 2021 is divided into four along the red-green und yellow-blue axes, then into 12 equally spaced sections und finally into 36 unequally spaced sections—to meet the practical demands made on the manufacturer's paints in architectural applications.

Samples
Two versions, 635 (655) colors in 36 hues plus an achromatic scale, matt-surfaced chips (15 (35) hues available in gloss). Samples measure 2.8 x 3.5 cm (2.8 x 7.0 cm) and are printed five each on 127 (131) strips measuring 3.5 x 20.5 cm (7.0 x 20.5 cm). Also available as loose chips measuring 7.0 x 13.5 cm on four color cards in a folder, or as loose leaf sheets, 21.0 x 28.0 cm, with case.

Prices (protective fee)
Collection of 635 printed strips about DM 12.00
Four color fans in folder about DM 35.00
Loose leaf sheets in case about DM 175.00

Notes
Colors can be produced in all common types of building paint and enamel by all Sikkens outlets and can be ordered in all package sizes by almost every paint shop in Western Europe.

Notations
H = Hue, and HC = Hue codification, which is done by means of 24 letters plus numbers from 0 to 9.
The colors of the 12-segment circle are denoted A0, C0, E0 ... W0, Y0, A0; those of the 36-segment circle A0, A6, B2, B6, C0, C4, ... Y0, Z0, A0.
The symbol for achromatic colors is 0N; that for colors of low chromaticity AN in the hue range of A0 to A9, and for the other hues BN, CN ... YN, ZN, AN.
S = Saturation
SC = Saturation code, which is given by consecutive numerals from 00 for achromatic to 99 for highly saturated colors.
L = Lightness
LC = Lightness code, which is given in consecutive numerals from 00 for ideal black to 95 for ideal white; the numbers 96 and above are reserved for fluorescent colors.
Notation of chromatic colors: HC. SC. LC; of colors of low chromaticity: SC = 01, 02 HN. SC. LC
Notation of achromatic colors: 0N. 00. LC

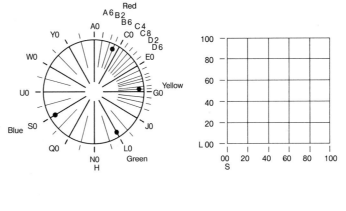

22 Two color families of the ACC system (Sikkens Color Collection 2021)

Reading across: Colors of equal lightness.
Reading down: Colors of equal saturation.
Note that the steps on the yellow scale are smaller than on the blue, yellow being used more frequently in architecture.

23 Schematic diagram of ACC color system.
Top left: Color circuit with designation of sectors (see text). Position of basic colors indicated by dots.
Top right: Diagram of saturation and lightness scales.
Bottom left: Figure of ACC system.
Bottom right: Comparison of color positions.
Solid dots indicate approximate position of two colors of about the same ACC saturation; open dots the position of two colors of same ACC lightness.

Farbnormenatlas
(Color Norm Atlas)
by Wilhelm Ostwald

Publisher: UNESMA, Grossbothen, Leipzig
Year of publication: 1920, and later editions

24 General table of the
Color Norm Atlas by
Wilhelm Ostwald

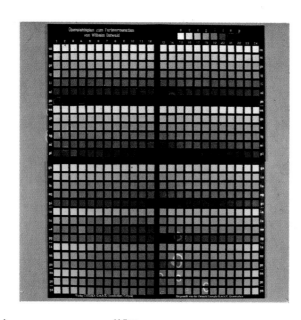

Type of system
Colors are identified in terms of three attributes: hue, white
content and black content. "Color contents" are understood
as results of additive mixture, as one obtains, for example,
by using a color disc. Full colors are defined as those which
have the highest possible saturation and at the same time
the greatest possible lightness.
The Ostwald color circuit is divided into 24 sections. The col-
ors of the "cold" half of the circuit from yellow through green
to blue have been selected such that they are complementa-
ry (or compensatory) to those of the "warm" half, from blue
through red to yellow, i. e. in additive mixture they give grey.

Samples
Approximately 650 colors of 24 hues and a grey scale, as
matt-surfaced chips measuring 1.0 x 1.0 cm and mounted
on four plates to represent the general scheme, or as loose
cards measuring 4.0 x 5.5 cm and packed in four boxes.

The Farbnormenatlas is out of print.

Notes
The Ostwald color system has found application in other col-
or charts such as that of the Color Harmony Manual, first
published in 1942. Here the number of hues was increased
to 30 and other material added to give a total of over 900
color samples (hexagonal chips measuring about 2.2 cm on
a side). This manual is also out of print.

Notation
N = Hue number
Yellow = 1, 2, 3 ... 24, 1. Achromatic colors are denoted by
letters from "a" for white to "p" for black (in the Farb-
normenatlas only).
w = white content, from "a" (maximum) to "p" (minimum).
s = black (schwarz) content, from "a" (minimum) to "p"
(maximum).
v = full color content, determined by the equation:
$v + w + s = 100$.
Chromatic colors are denoted: N w s
Achromatic colors are denoted: w

25 Schematic diagrams of
Ostwald color system.
Top left: Color circuit with
designation of sectors
(see text). Dots indicate
position of basic colors.
Top right: Diagram showing
steps of white content and
black content (see text).
Bottom left: Figure of
Ostwald system.
Bottom right: Comparison
of color positions.
Solid dots show position of
two colors of equal Ostwald
full-color content.

Literature 20:
Ostwald, Wilhelm. Einfüh-
rung in die Farbenlehre.
Leipzig, 1919.
Literature 21:
Ostwald, Wilhelm. Physika-
lische Farbenlehre. Der
Farbenlehre zweites Buch.
Second edition. Leipzig,
1923.

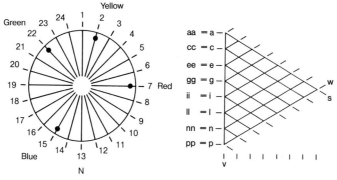

SIS Color Atlas

Based on the Natural Color System (NCS),
Swedish Norm SS 01 91 02

Publisher: SIS-Standardiseringskommissionen i Sverige,
Stockholm, Sweden
Year of publication: 1979

Type of system
Attributes by which colors are classified in this system are
hue, black content and full color content. The full color con-
tent may consist of proportions of either one or two pure,
chromatic basic colors, i.e. of yellow, red, blue or green con-
tent, or of yellow-red, red-blue, blue-green or green-yellow
content. The designations of content should be considered
as indicating perceptual values rather than exact mixing pro-
portions.
The chromatic wheel is divided into the four basic quadrants
of yellow, red, blue and green, again colors as determined
by perception. Between each two basic colors nine interme-
diate tones are given.
Samples
Approx. 1,300 colors in 40 hues and five grey scales (achro-
matic, yellowish, reddish, bluish and greenish greys). Chips,
matt surfaced, about 1.2 x 1.5 cm, mounted in a book on 42
plates. Price about DM 580.00
Remarks
Other editions of this color system are available from Skan-
dinaviska Färginstitutet, Stockholm. Color samples available
up to DIN A2 (42.0 x 59.4 cm) size. A selection comprising
about 470 colors in 20 chromatic hues and the grey scales,
with chips measuring about 2.4 x 6.7 cm printed on sixty-
four 6.7 x 32.5 cm strips are offered by NORDSJÖ AB, Mal-
mö, Sweden, price: about DM 9.50.

Notation
s = black (schwarz) content; c = full color content
Both types of content are given by two two-digit numbers
beginning with 00 for no full color content (achromatic
colors), and with 01 for low black content; both scales end at
99. To designate full colors with s = 00 and c = 100, the
four-digit number is replaced by a capital C. White content is
derived from the equation w + s + c = 100.
Ⓒ = chromatic color
Basic colors are denoted by their initials (Y, R, B, G). The 36
chromatic hues that lie between each two basic colors are
characterized by their initials plus numbers from 10 to 90 as
follows: Y, Y10R, Y20R ... Y90R, R, R10B, ... R90B, B, B10G
... B90G, G, G10Y ... G90Y, Y.
Achromatic colors are designated by S for black and C = 00
for full color content; the achromatic basic colors white and
black by W and S.
Designation for chromatic colors: SC–Ⓒ
Designation for achromatic colors: SC

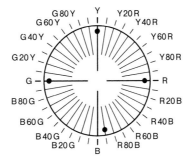

26 Hue sequence of
NCS color system with
schematic color circuit in
center (cf. Figs. 4 and 5,
which show two hue
families from the SIS color
atlas). Since the four
quadrants are divided
regularly, the hues do not
appear to be equally spaced
(cf. HESSELGREN). The
intervals between red and
blue appear too large, and
those between blue and
green and between green
and yellow too small. Of the
forty hue families every
second one, where
feasible, has color chips to
represent the entire range;
the remaining twenty have
chips covering half the
range.
Among the incomplete
families are those of
the basic colors.

27 Schematic diagrams of
the NCS color system.
Top left: Color circuit with
designation of sectors
(see text).
Top right: Diagram showing
steps of black content and
full-color content.
Bottom left: Figure of
NCS system.
Bottom right: Comparison
of color positions.
Solid dots indicate
comparative position of two
colors of about equal
NCS full-color content.

DIN Color Chart

28 Hue family from
DIN color chart

From top to bottom
increasing darkness; from
left to right increasing
saturation. Colors of equal
'darkness level' do not
appear to be equally light.

Publisher: DIN Deutsches Institut für Normung e.V., Berlin
(prior to 1975: Deutscher Normenausschuss, DNA)

German Industrial Norm Sheet DIN 6164, Parts 1 and 2
(formerly Sheets 1 and 2). With supplements 1-25 (matt-
surfaced chips) and 101-125 (glossy chips).

Year of publication
Color system: 1955, 1962 (pre-norm), 1980 (norm)
Supplements 1-25: 1960-62
Supplements 101-125: 1978 on

Type of system
Colors are classified according to the attributes of hue, sa-
turation and what is termed ''relative lightness''. This last
concept is defined as the relation between the lightness of a
color as perceived by a viewer and its greatest possible
(theoretical) lightness at the same saturation and hue. All
colors of equal DIN hue have the same hue-related or com-
plementary wavelength, which means that they are not
always visually perceived as being equal.
Since in the DIN system colors are arranged by relative light-
ness, when we compare two directly adjacent chips of the
same degree of lightness but highly differing saturation, the
more highly saturated color will appear darker (see Fig. 28).
The DIN color circuit is divided into 24 sections. Divisions
between the hues are perceived as being approximately
equal at a given level of saturation and lightness.

Samples
Approximately 600 colors (cards 1-25) or approx. 900 colors
(cards 101-125) in 24 hues and an achromatic scale, avail-
able either as 2.1 x 2.7 cm chips inserted in 25 cards, or as
chips of about half filing-card size mounted on cards (not all
colors given in cards 101-125)

Prices

Supplements 1-25 about DM 60.00 each,
about DM 1,100.00 the set
Supplements 101-125 about DM 90.00 each
Color chips of about half filing-card size about DM 6.00 each

Notes

No samples available for low-chroma, very light colors of S<1, D<1; very dark, "deep" colors to be included in future supplements of the 101-125 series. Renotation, fluorescent colors are given a negative darkness value to indicate that their fluorescence lends them a particularly high brightness. Technical color sciences work more and more with DIN Color Chart DIN 6164

Notations

T = Hue (Buntton) number (changed from the "Farbton" number of the pre-norm sheet). Achromatic colors are denoted by N (by a dash in the pre-norm sheet and Supplement 25).

S = Saturation level, counted from achromatic at S = 0 to S = 7 and higher, depending on the hue.

D = Darkness level, counted from ideal white (or from optimal color) at D = 0 to ideal black at D = 10.

A = Y = Brightness

Notation of chromatic colors: T : S : D.
Notation of achromatic colors: N : 0 : D
(in pre-norm and Supplement 25 : – : 0 : D).

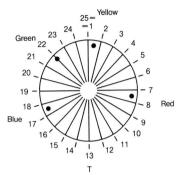

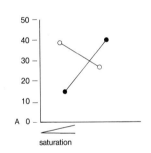

29 Schematic diagrams of DIN color system.
Top left: Color circuit with designation of sectors (see text). Position of basic colors indicated by dots.
Top right: Diagram of saturation and darkness intervals.
Bottom left: Figure of DIN system.
Bottom right: Comparison of color positions.
Solid dots indicate position of two colors of equal DIN saturation level; open dots position of two colors of equal DIN darkness level.

OSA Uniform Color Scales

30 Colors of one lightness level in the UCS system

Here we see that the fightness values in this classification do not correspond to visual impression—the saturated colors towards the outside, though they are of equal UCS lightness, appear darker than the others.

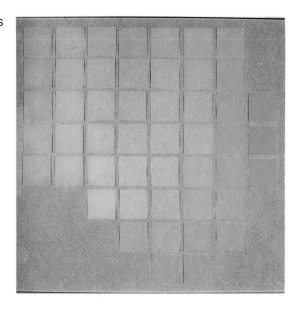

31 Schematic representations of UCS color system.
Top left: Hue classification (see text). Position of basic colors indicated by dots.
Top right: Diagram of lightness steps and color content.
Bottom left: Grid element of UCS system.
Bottom right: Comparison of color positions.
Open dots show comparative position of two colors of equal UCS lightness.

Literature 22:
Nickerson, Dorothy.
"Gleichabständige OSA-Farbreihen. Ein einzigartiges Farbmustersortiment."
In: Farbe + Design, No. 12 (1979), pp. 16-24.

Publisher: OSA (Optical Society of America)

Year of publication : 1977

Type of system
Classification of colors in the OSA system is based largely on the principle of equal color spacing as set forth in the UCS system. The basic colors are arranged on a regular spatial grid made up of cubo-octahedral elements. Each of these elements is bordered by eight equilateral triangles and six squares; the twelve corners are equidistant from the center, by the length of one side.

Twelve colors, placed as in the UCS system at the corners of a cubo-octahedron, have to their neighbors as well as to a thirteenth color in its center a distance which the eye perceives as equal. Furthermore, each of these twelve colors may itself form the center of a cubo-octahedron.

All points on the grid are designated by symbols indicating their position in a three-dimensional coordinate system which is constructed along the three axes of achromatic colors, the colors from yellow to blue, and those from green to red.

Lightness values are given in the UCS system such that they conform as nearly as possible to lightness as perceived visually. This means that when we compare two adjacent colors of equal lightness but greatly differing saturation, we in many cases perceive the more highly saturated of the two as being darker than the other.
Samples
Approx. 500 colors on glossy chips, measuring about 5.0 x 5.0 cm, inserted in 30 cards.
Price about DM 700.00
Remarks
Light colors of $L > 4$ are not available as chips.
The notations in this system give hue and saturation only indirectly.

Notation
L = Lightness, which is given in values from -7 for dark colors to +5 for light colors.
+j stands for yellow (jaune) and -j for blue.
+g stands for green and -g for red.
Here, the higher the value, the greater is the color saturation.
Achromatic colors are designated j = 0, g = 0.
Designation for chromatic colors: L j g
Designation for achromatic colors: L 0 0

SYST-O-COLOR
VIER-KLEURENSYSTEEM
by Paul Schuitema

Publisher: Mouton & Co., Den Haag, Holland

Year of publication: 1965

Type of system
The system consists of various combinations of two, three and four colors, printed by the autotype process. Basic colors in the order of printing are blue, yellow, magenta and black. Each of these colors is used at ten different screen densities—printed with a No. 0 screen, the surface takes on no color; with a No. 9 screen, the color is solid (Fig. 32).

SYST-O-COLOR comprises 288 compositions in rectangles with ten colors on a side, giving one hundred equally sized fields. The color of each field is built up of from one to four colors in as many printing runs, with the colors screened more or less strongly according to one of the three basic schemes below.

In the first scheme, the entire 10 x 10 area is first printed evenly at a single screen number, giving all 100 fields a constant color element. In the second, the ten rows are printed in progressively darker screens, running either horizontally or vertically. The third pattern, finally, gives one of four basic compositions, with screen numbers set for each of the 100 fields (Fig. 32).

Concerning notation, the colors in this system are designated by screen number of each of the four basic colors as follows:

Pure solid blue:	9000
Solid green:	9900
Pure solid yellow:	0900
Solid orange:	0990
Pure solid red:	0090
Pure black:	0009
Solid black:	9999

Notation
Compositions are designated according to scheme.
Scheme 1: screen number from 0 to 9;
Scheme 2: arrows pointing across or down in direction of screen density from 0 to 9;
Scheme 3: letters A, B, C and D that stand for compositions so designated.

32 Basic schemes
of Paul Schuitema
color composition system

Top: The four basic colors
screened horizontally
and vertically.
Bottom: The four basic
compositions, given here in
black.

33 Schuitema color
composition system in
practice.
Two basic compositions, A
and D, in black on far left;
three variations on each by
addition of new colors,
different screen densities
and other basic
compositions.

A Color System for Architectural and Interior Design

34 Color circuit. Basic colors red, yellow, green, blue and their intermediate tones distributed on a wheel. The Sikkens Color Collection 2021 circuit shows varied spacing of hue sectors. The yellow field, which is commonly used in architecture, is much denser than the blue-violet sector. In this diagram the colors are arranged such that those of equal saturation and lightness lie at the same distance from the center.

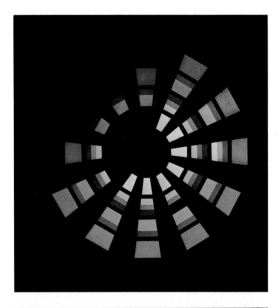

35 The sheer variety of color can be confusing, unless colors are classified by hue. Other classification criteria are saturation (degree of color content) and lightness (amount of light reflected by a color).

The ACC system with its classification of colors by hue (designated by letters from A to Z), by saturation (numbers from 00 to 99) and by lightness (00 to 99), covers the entire range of colors. Theoretically over a million shades can be determined and designated in terms of these three criteria. This almost unlimited choice, however, is not much help in practice. Designing with colors is not like solving an abstract mathematical formula; it involves experimenting with actual color samples.

There are two ways to make a selection of samples from the broad range of a color classification. The simpler is to pick an equal number of representative chips from each hue range and work from there. Or, one's choice of color can be oriented to the design task at hand. This, naturally, involves making a decision, and there are color systems which have been devised to help. One of these is Collection 2021, which has been designed with architects' needs in mind. Its color circuit is more closely spaced than usual in the warm range, giving very fine nuances of red, orange, ochre, brown and yellow, and fewer shades in the blue and violet range. This is very much in keeping with architectural applications, since such colors as green, blue and violet are much more rarely used in wall paints than tones which are related to the natural colors of building materials such as brick and field-stone.

Collection 2021 offers a total of 635 shades. They are available in paints and other finishing materials for buildings old and new, for example Sikkens Color facade paints, textured and smooth rendering, silicate paints. The series also includes primers, glossy and matt enamels, and acrylic-based paints for construction details, as well as coverings for interior use such as wall paint and latex.

All the colors of this collection are defined according to the three criteria of the ACC system. Using these criteria, any shade which is not in the selection but which an architect might find indispensable for his composition, can be determined and mixed to order. No matter what country setting or existing urban space he is designing for, an architect can create new and original compositions from the Collection 2021 range. One example is illustrated here, a selection of shades in the colors of natural stone. Any number of combinations are possible, whether you wish to find colors to harmonize with wood or concrete, create a white-in-white com-

position, or run the gamut from rose-pink to grey. One such composition that has been inspired by a country setting and the houses there is presented in Part Six of this book, with the work of Philippe Lenclos.

In Part Three, which is entitled Color Typology, we look at architecture in terms of color patterns, and ask, for example, how and when a facade should be articulated with color, whether ornament should appear light before a darker background or vice versa, whether windows gain by being outlined in a contrasting color, whether a new building on a dull grey block should be painted to match or the grey taken up, combined with other colors, and used to set an interesting accent that changes the street's aspect completely.

After deciding what it is that needs painting, the next thing an architect has to do is find a color scheme. One of the most useful tools for this is a color fan. If you have decided on a scheme that is related to that of the neighboring building, say, then you just open the fan at the place where that color is to be found together with all its variants in saturation and lightness. A slight variation on the theme can be found by opening the fan at a related hue; a stronger difference by looking for less closely related colors; and a true contrast to the existing scheme, finally, can be found at the opposite side of the color wheel.

After this preliminary decision has been made, the selected shades are combined in various ways until a satisfying composition results. This process is greatly aided by having large samples—Collection 2021 offers them in typing-paper size, in all 635 colors—which enable you to determine about how the colors will look on the full-sized building. (It should be remembered, however, that colors will always tend to appear darker on full-scale surfaces, which are rougher in texture than the samples and moreover are subjected to the play of light and shadow.)

When a composition has been chosen, the next step is to try it out on elevation drawings made to about 1:100 scale. An even better check, though it does cost a lot of time and effort, is to use plaster models of the type described in Part Three of this book. In our experience, 1:50 scale models are the ideal link between color samples and a satisfying final result, and, in terms of a responsible color decision, are well worth the work involved.

36 Selection of natural stone colors from the Sikkens Color Collection 2021

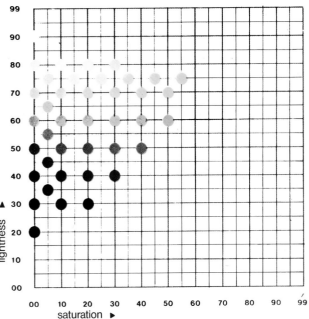

37 One hue family from the ACC system: Family F2

Hue families are designated in this system by a combination of letters and numbers; saturation (horizontal axis) and lightness (vertical axis) by numbers from 00 to 99. The vertical axis at a saturation of 00 represents achromatic colors.

38 Color fan

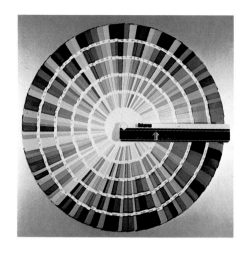

39 Hue in hue. Colors
differ only in terms of
lightness and saturation.

G0.55.80

G0.10.80

G0.10.30

40 Hue variation. Adjacent
colors from the yellow
sector of the circuit, of
slightly different saturation
but same lightness.

F2.35.80

G0.30.80

G8.20.80

82

D6.50.60

G0.55.80

J0.20.30

A0.20.30

G0.20.60

N0.10.40

G0.60.75

U0.05.75

41 Hue difference.
Adjacent hues with slight
variation in saturation and
lightness.

42 Hue contrast. Widely
spaced hues with slight
variation in lightness and
saturation.

43 Maximum
hue contrast.
Colors that lie on opposite
sides of the color circuit.

Color Typology
by Johannes Uhl

Color composition
The combined effect of two or more colors to produce a "chord" that rests on the principles of color relation and is experienced to visual perception as a unified whole. The word "chord" has been borrowed from music; similarly, we may speak by analogy of a color "melody" if the individual colors of a composition produce a pleasing and harmonious effect. Every good color composition is carried by a single color chord or a limited range of chords, the character of which will be determined by the qualities of the colors used and their proportionate visual weight. If a composition lacks a chromatic unity, i. e. if its colors jar or appear unrelated, we speak of a color dissonance and call such combinations without inner cohesion gaudy or garish.

from: "Lexikon der Kunst", Vol. 1,
VEB E. A. Seemann Verlag, Leipzig 1968, excerpted

Color Typology 1: London Houses
Photographs by Hansrudolf Plarre und Peter Sohn

A walk through London, chance observations that result in a pile of slides, which we look through, sort and describe —and already we have a whole catalogue of typological possibilities. Every description of a photograph amounts to a case-study of the use and effect of color on the urban scene. Many of the color schemes we have come across may be more accidental than planned; yet we know that much can be learned from describing and analyzing them.

The relation of color to architecture, however, is not an incidental one by any means. Buildings are volumes divided into parts, and color tends to follow these divisions. A building may be said, roughly speaking, to consist of three sections: a foundation or base that connects it to earth and pavement; a middle zone with its rows of windows; and a roof-zone, which terminates the building and sets off its silhouette against the sky.

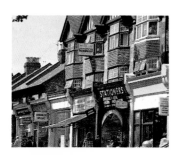

Architectonically diverse block.
Buildings of varying height and roof-pitch, yet with continuous base-zone, same storefronts and relief. Color schemes vary, however.

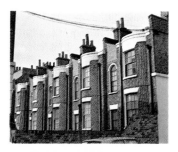

Color through material. Brick walls, all relief elements—stairs, bays, entries, corners, projecting cornice—white.

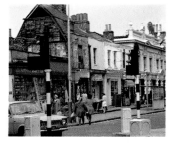

Street in different construction stages.
1st building: Condemned. Somber color.
2nd building: Partially torn down, ornament removed, painted over with enamel.
3rd building: Restored.

Color through material. Brick walls, all relief elements—stairs, bays, entries, corners, projecting roof—white.

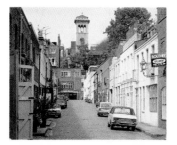

Color vis-à-vis.
Color scheme changes from building to building. Painted rendering, painted or natural brick. Window and door frames in contrasting colors to walls.

Color through material. Walls brick-color, base and window frames white, doors a contrasting color, railings black, sashes white.

Color vis-à-vis.
Color scheme changes from building to building, within limits—rendering white or light-grey, stone brownish-purple. All windows white. Gardens enliven base-zone.

The finer articulation of a building consists in its relief— elements such as cornices, window frames, niches, projecting bays and balconies, recessed or external stairwells, corner mouldings and overhanging roofs, entryways and storefronts. Since this relief layer lies before the actual wall or facade, we shall term the color of the wall "background color" and that of relief elements "foreground color".

The next level of color is that of a building's details—window sashes, doors, railings, awnings, ornaments, signs, stained glass, house numbers and names. Here the natural colors of materials such as wood, iron, bronze and baked enamel play a part, unless they too have been painted over. It is usually only on second glance that we notice detail coloring, after we have taken in the foreground and background colors of a building.

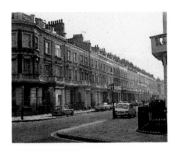

Neo-classical street. Uniform facade articulation and ornament, colors vary within a limited scale— white, grey, brown, blue. Corner building a darker accent.

Neo-classical street. Uniform articulation and ornament, uniform color scheme, except that the white is tinted in various shades of light ochre to light blue. Window gratings black throughout.

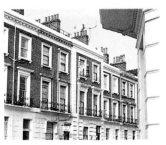

Neo-classical street. Uniform style, uniform relief; color scheme alternates from building to building such that background color of one is foreground color of the next.

Mixed street. Various building styles and heights, with different ornament, yet white paint-scheme pulls them together into a block.

Neo-classical street. Uniform style and relief, uniform color scheme: bases white throughout with black railings, brick upper walls, white window ornament and cornice.

New building among old. White as relief-color of the old buildings and wall-color of the new, giving the block unity.

Suburban street. Uniform building style, no relief. Colors change from house to house, in variation on the neo-classic scale of white, brick red, grey, blue.

Houserow with planters. Changing tints of white as foreground and background color. Ornamental color provided by plants and shadows.
All photographs:
Hansrudolf Plarre

The three zones of a building, its relief elements and its details make up an intricate pattern of planes and projections. Color may be used to emphasize this pattern or to blur it; it can pull a building's zones into one surface or split them into countless fragments by overemphasizing relief. Color is capable of uniting a row of diverse facades; yet it can also resolve an architectonically unified street into its component parts. Sometimes an individual building's base is painted a color that contrasts with its surroundings; what we more often see in practice, however, is that the bases of an entire row of buildings have been painted the same color, making a long, continuous band, only above which each building reveals its individual personality.

Houserow with stucco rendering, yard side. Wall-color white, divisions and windows black, downspout black, giving ornamental effect.

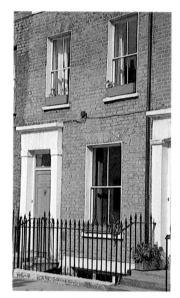

Detail color. Yellow brick, white trim, green doors and flower boxes.

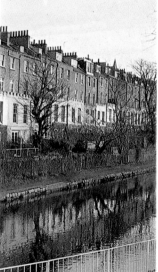

Houserow, yellow brick, yard side. Two-storey bases cut the houses in half; each has a different colored base.

Detail color. Yellow brick, white band, various colored shopfronts below.

Reversing foreground and background color can change the effect of a building completely. Traditionally, projections such as window and door frames, which receive the most light, are painted white or some lighter color to make them stand out even more from the dark rendering or brick. The opposite tack was first tried on industrial buildings—window frames painted a dark color that receded into the facade and gave the impression of an unbroken brick wall. Many architects of the International Style took their cue from this scheme for residential buildings, setting narrow, dark-colored window frames in walls of smooth masonry.

Color through materials. Industrial building in yellow brick, with dark window frames and metal-colored cranes.

Color through materials. Red clinkers, white stucco trim, black metal railings. Red and white are of equal weight here.

Color through materials. Industrial building in yellow brick, with dark windows, white stone trim, dark metal stairs and railings, cast-iron columns painted white.

Color through materials. Red clinkers, white on window frames and underside of ornament only. Black metal railings. Here, red dominates.

All photographs: Hansrudolf Plarre

Color, then, can either blur or focus architectonic contrast. A good example of this is the silent dialogue between old buildings and new. The expanses of white paint, roughcast concrete and glass used in modern architecture provide a perfect foil against which the brighter colors of older buildings—especially red and yellow brick—appear to decorative advantage. Then, too, since modern buildings are usually much higher than their venerable neighbors, from a pedestrian's eye view they actually do form a backdrop for them —a canvas on which peaked roofs and projecting bays look almost as if they had been painted. Ornament is another subject that is handled very differently in old buildings and new. If modern architects show a predilection for the horizontal format in windows and banding, their predecessors obviously had a taste for the vertical.

Dialogue between old and new on a town-planning scale. High-rise buildings in non-colors as a backdrop for red brick houses.

Dialogue between old and new: Lillington Street. Contrast: Red brick of new buildings to greyish white rendering of old.

Photographs (3): Hansrudolf Plarre

Dialogue between old and new on a town-planning scale. High-rise building in non-colors as a backdrop to houserow in shades of brown.

Lillington Street. Adaptation: Red brick in both new buildings and old.

And the way glass is used in modern architecture often seems like a conscious homage to the past—great expanses of glass, being intrinsically non-ornamental, function like mirrors in which old buildings live again in reflection. Then there is the question of silhouette. Old buildings, constructed layer by layer of stone or brick, fitted with windows and doors and perhaps applied orders, stop abruptly at a cornice. Their walls are perpendicular and their roof-line usually strictly horizontal. Now, one thing reinforced concrete und huge prefabricated elements have done for modern architecture is to emancipate it from the flat wall. Almost every city nowadays is enlivened by terraced buildings that put unexpected diagonals into the picture and create irregular frames through which older buildings appear in a fresh light.

Dialogue between old and new: Truman Brewery.

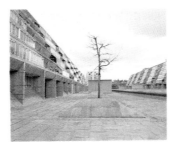

Dialogue between old and new: Brunswick Centre. Colorful condemned building, grey new one.

Truman Brewery.
New glass construction provides backdrop for old tract.

Brunswick Centre.
Terracing of new construction puts a diagonal accent into a picture of verticals; its non-colors of concrete and glass stand out from existing dark red.

Truman Brewery.
Color dialogue—blue glass, yellow brick.

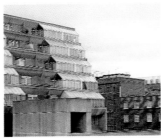

Brunswick Centre.
Funnel-shaped grey courtyard functions as frame, emphasizing dark roof-silhouettes of existing buildings.

Truman Brewery.
Reflections carry on the dialogue.

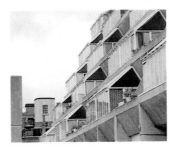

Brunswick Centre.
Detail of new construction: Grey concrete and glazing, black and white accents.

Photographs (9):
Peter Sohn

91

What is normal in typography—black on white—is an extreme case in architecture, where this ultimate contrast between two non-colors is very rare. There is no shortage of all-white buildings, of course, yet black occurs chiefly on railings, window-gratings, ornamental ironwork. Half-timber construction is another and special instance of black and white in architecture. The buildings of that type in High Holborn, London have vertical beams placed at such narrow intervals that support and fill are of equal breadth, a fact that gives their facades a striped look that is not only wonderfully effective, but fulfils that rare case of black and white given equal weight in architecture. Though the dark rectangles of the windows interrupt this perfect pattern, they are important for reasons beyond the merely practical: they transform what otherwise might too much resemble stage-flats back into substantial walls.

Black and white in architecture.
Detail coloring: White wall, black window frame, black sashes, dark glass, black railings.

Black and white in architecture.
Detail coloring: White wall, white window frames, white sashes, dark windows, black railings.

Black and white in architecture: Stable Inn, High Holborn.
Roof-zone dark, wall vertically striped with black beams and white fill.

Stable Inn, High Holborn.
Detail: Black and white stripes of equal width. Dark windows.

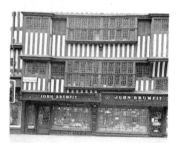

Stable Inn, High Holborn.
Base with shops, coloring dark.

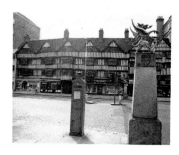

Stable Inn, High Holborn.
Overall view. Vertical striping dominates.

Color on the urban scene—that includes much more than architecture, of course. There are the people for whom buildings are made, who live and work in them; there are traffic lights, display windows, advertising signs, pavements, trees, the scaffolding and construction mats that obscure facades temporarily, and there are umbrellas and reflections in puddles on wet days. And there is that tendency much in evidence lately to collect the tremors and vibrations of color in the urban air and concentrate them into murals or wall-paintings. Huge firewalls, invitingly abandoned-looking, are filled with outsized evidence of what artists see as happening—or should be happening—in the city: Crowds jostle in two-dimensional hurry, painted trees appear where real ones will not grow, light streams through windows that are not really there.

Non-architectural color on the urban scene.

Colorful banners on high-rise building.

Doors—red and blue.

Wall-painting on a gable.

Displays—red and blue.

Billboards on base.

Bus—red.

Lettering on a fence.

Political poster—red.

All photographs:
Peter Sohn

93

Color Typologie 2:
Types of Urban Space and Color Schemes
by Johannes Uhl

There are four different scales on which color can be seen: (1) on the scale of an entire city or of one neighborhood; (2) on the scale of the street, where color can create various moods depending on how it is used on buildings on opposite sides of a street or adjacent to one another; (3) on the scale of individual buildings, where different color patterns are created by the use of foreground and background color; and finally (4) on the scale of details—windows, shutters, orna-ment. In addition, there are four points of view from which color can be taken in: walking down a street we see color surfaces from the side, from the front, from below or from above, depending on how fast we walk and what attracts our interest. Someone coming to visit will notice different things than a complete stranger to the city; an architect will have a different eye than a shopowner or resident.

Different scales on which we see color:

Scale of the neighborhood

Color planes as seen from different points of view:

From the front

Scale of the street

From the side

Scale of a single building

From below

Scale of a building's details

From above

Urban space is made up of various situations which, if we have lived in a city for a long time, our eye takes in as a whole. These situations should ideally have a certain architectonic unity, and also a unifying color scheme. The two most common urban spaces are street and square; a simple intersection might be called the opposite pole to a square, and a courtyard behind buildings the opposite of a street. These four types of urban space are illustrated here as being the most important, though of course there are any number of variations on them. A square, for instance, may have an open space in its center, or a church, or a park; a street may be wide with a line or two of trees running down its center, or it may be a broad avenue that cuts a swathe through the city, with a canal, a river, or a railway line dividing ingoing and outgoing lanes.

Types of urban space
can be defined und unified
with color.

Plan view, perspective, and
elevation

Street

Intersection

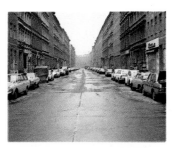

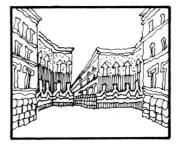
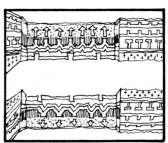

Square

Courtyards—outside
versus inside

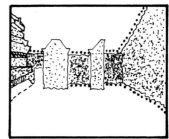

With these four types of urban space in mind, we can begin to go into detail. How should a street be conceived in terms of color? Assuming a certain unity is our aim, should we emphasize the planarity of the facades by painting them a uniform, light tone on both sides of the street, or would a homogeneous dark scheme be better, which, with the dark asphalt, would compose the street in spatial terms? Should the foreground color of the facade relief be the same throughout, with changing colors of rendering, or vice versa? Or could one conceivably apply horizontal stripes of color, thus lengthening the street's perspective?

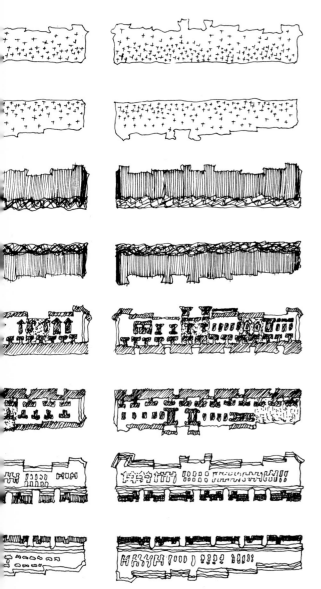

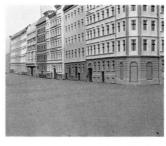

Variations in color pattern in one type of urban space: The street

Light buildings against dark pavement. All buildings uniform

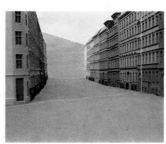

Dark buildings against dark pavement. All buildings uniform, creating channel effect

Facade foreground (base, mouldings, frames) dark, facade background light. Varying foreground hue

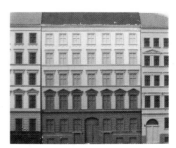

Facade divided horizontally into foundation, base, window-zone, roof-zone

All of these color ideas can be reversed or varied in any number of other ways. For instance, foreground and background color could alternate from building to building, breaking the street space up and rendering it ambiguous and finite; or a unifying scheme could be used on one side of the street, and on the other, color contrasts from building to building, interrupting the perspective again and again. The reverse of horizontal banding that leads the eye quickly to the vanishing point, would be to emphasize the corners with color —strongly accented corner buildings act as boundaries, framing and unifying a row of buildings of various styles and colors.

Vice versa—foreground light, background dark

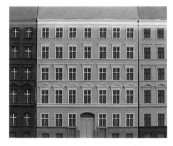

Changing foreground and background from building to building

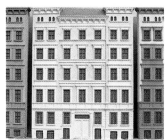

Stripes on one side of the street, accents on the other

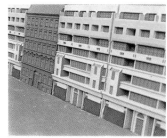 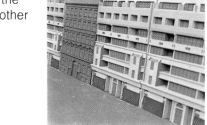

Corners frame the street. Internal color variation with uniform end-buildings

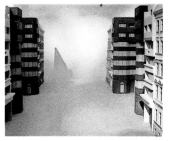 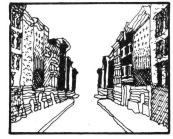

All drawings and photos: Johannes Uhl

Another condition on which the effect of color strongly depends is light. Even intense colors will lose their brilliance in subdued light, which is perhaps why, in northern Europe, light and broken hues are so common in architecture—off-whites, light yellow, ochre, brown, pink, even light blue and purple. The orientation of a building is another important condition of color effect. Elevations that face east receive the morning sunlight and reflect it onto the facades opposite, and those that face west receive the more subdued evening light. North elevations receive the least light of all, and are therefore most effective when painted a light color; south elevations, by contrast, can take strong and brilliant colors best of all.

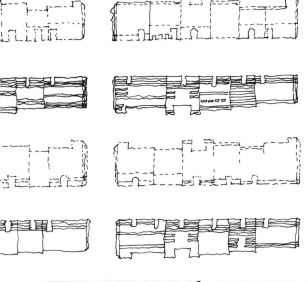

Color schemes depend on orientation. Streets running east and west, and north and south:

On the north-south street, the west side is light and the east side dark

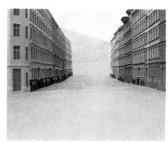

On the east-west street, the north side (the side facing south) takes and reflects light onto the dark south side, lightening its color

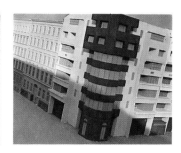

Corner building like a hinge separates light and dark colors

When old buildings share a street with new, the dialogue between them can be raised to the level of a debate with contrasting color, or subdued to a whisper by means of a homogeneous scheme. A new building can be integrated into its surroundings by simply painting it into them, or made to stand out, despite austerity of form, by accenting it with color. Or the other way round—a single old building on a new block can look like a precious painting in a simple modern frame. If its color scheme is not particularly exciting, on the other hand, the old building can be integrated into the picture by painting it to match the new, whether their color scheme be simple or based on stark contrast.

Color schemes for the dialogue between old and new:

A new building on an old block, but this time with its uniqueness emphasized with color

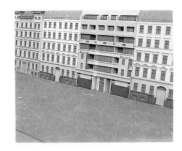

A new building integrated into an old block by giving it the existing color scheme

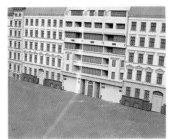 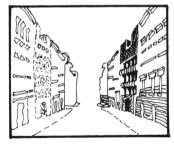

A block of new buildings with their own color scheme frames an old building left in its original state

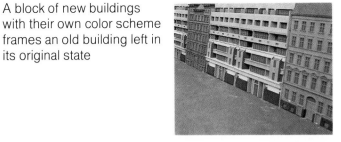 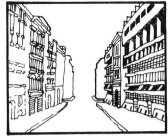

A block of new buildings with an old one integrated into it by uniform scheme (either existing or new)

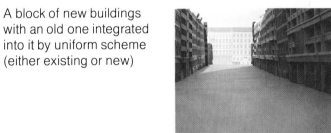

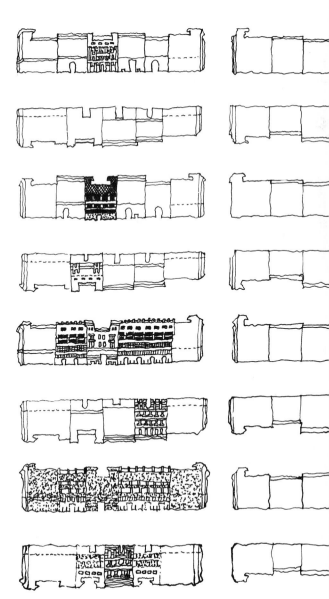

Color Typology 3:
Case-Study for a Street in Berlin-Kreuzberg
by Johannes Uhl

Step 1: Atmosphere

The buildings of Kreuzberg, an old quarter on the eastern fringe of West Berlin, are dingy and weather-beaten; the predominant color of their facades is a nondescript brown that cools gradually to violet in the distance. The only spots of brighter color are the Turkish shops painted in every combination of turquoise, pink, prussian blue and dark glossy green. We recorded aspects of this scene on color film, abstracted the results later by making black-and-white enlargements from which in turn photocopies will be made. On these we plan to sketch in our proposed color schemes.

Step 2: Systematic photography to scale

We took photographs of each building on both sides of Adalbert Strasse, a block 800 meters in length. We set up our camera in a first-floor window directly opposite each facade, choosing a wide-angle lens to avoid distortion problems.

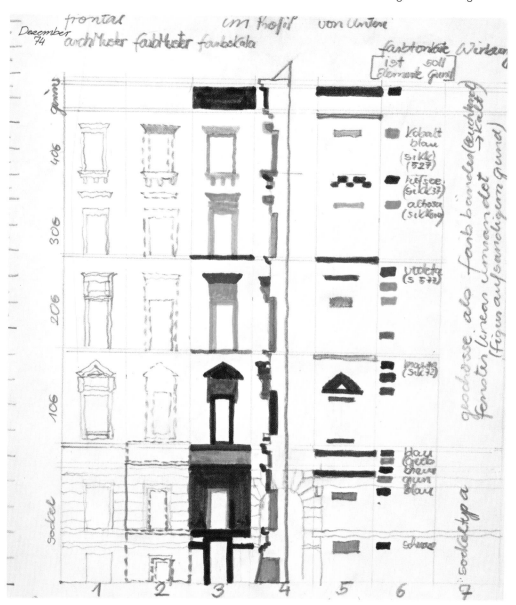

Page from a color sketchbook

Each frame included sections of the buildings on either side, the sidewalk and a section of street; the facade itself was in the distortion-free part of the negative, though its cornice was slightly distorted. From these negatives we then made prints to a scale of 1:100 (having included a measuring stick in the picture to enable us to work to scale). Each facade was cut out, cropped at the foundation and pasted to its neighbor to form a strip that corresponded to the block, from the center line of one crossing to the center line of the other.

Step 3: Making transparencies and photocopies
The block-long strips with all the facades to a scale of 1:100 were reproduced and transparencies made in line and half-tone to scales of 1:1000, 1:500, 1:200, and 1:100. As it turned out, we finally worked only on in the three larger scales.

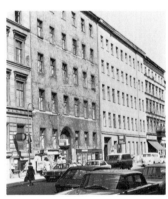

Black-and-white enlargements

Film-strips of Adalbertstrasse, 800 meters to scale

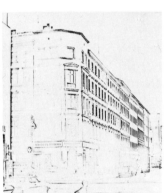

Photocopies

Strips cut into separate facades

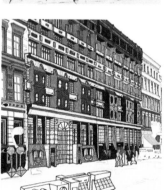

Photocopies with colors added

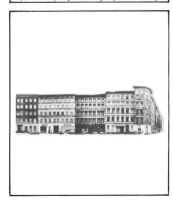

Facades pasted together to form the block.

1:1000
1:500
1:200
1:100
1:50

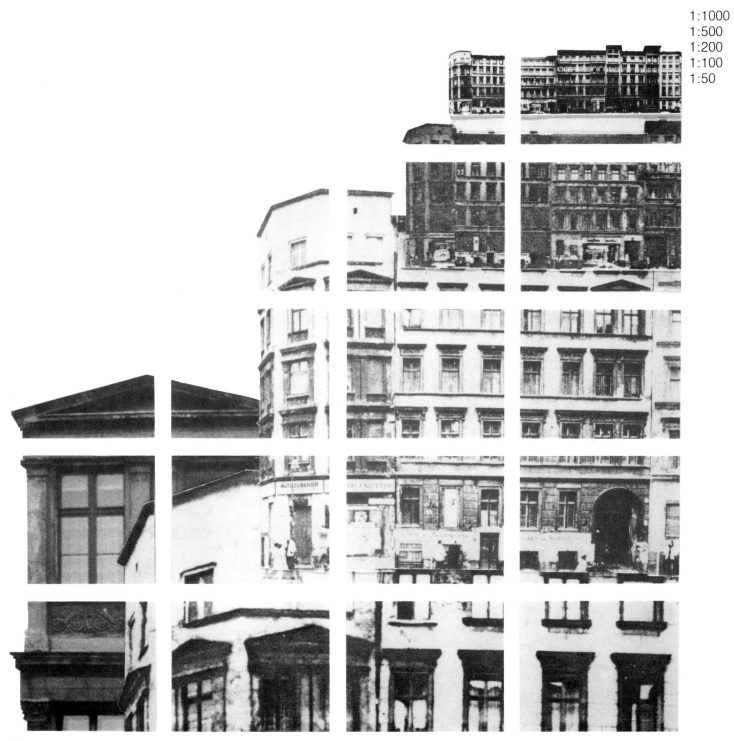

Step 4: Model building
The photographs of the individual facades were enlarged to 1:50 scale, working to the buildings' floor plans. We then started to build models of eleven different basic types of building, again to 1:50 scale.
A. We began by building wooden models according to the photographs. Mouldings were cut to shape to approximate each building's ornament, making sure they were tapered to allow easy removal of the silicon mould later. Types of wood were selected that would take the mould lubricant evenly.
B. A silicon mask was prepared on the models and reinforced with a layer of plaster.
C. Then plaster models were made using these silicon moulds. We decided not to reinforce the plaster models to allow for easier repair in case of breakage. We set them aside when they were finished to dry for about three weeks.

Model-building credits:
Photography: Frank Busch
Wood models: Siggi Johne
Silicon moulds and plaster models: Max Schmidt

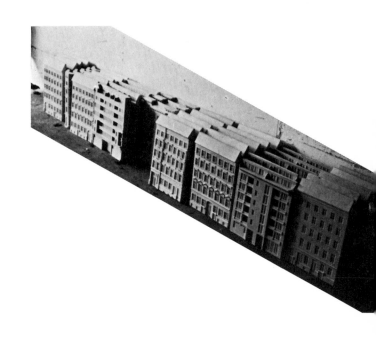
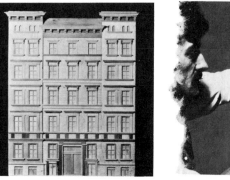

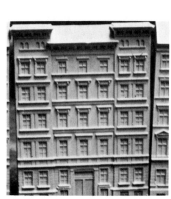

The entire procedure up to this point had taken about six months.

Step 5: Painting the scale facades

The materials used were chalk, felt pens, pencils and poster paints. During this phase most of the architects working on the project consulted artists and color specialists. We found that various difficulties were involved in working with the different scale facades.

The 1:500 scale gave us a general idea about how various color combinations would look with respect to the entire block, but the colors themselves appeared much too bright. The 1:200 scale came a little closer to allowing us to judge an overall scheme. Yet even at this scale the effects were illusory and the colors were still too loud. The 1:100 scale allowed us to test paint samples, vary details on individual facades and experiment with various tone values and intensi-

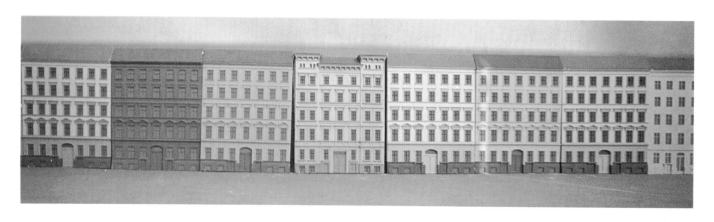

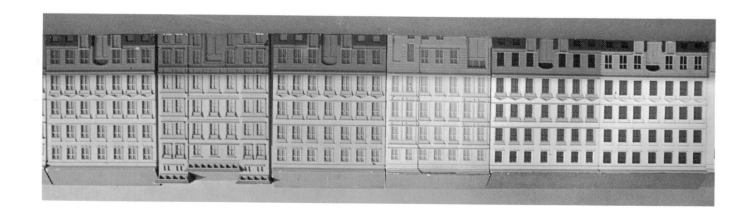

ties, always in the hope that the results would be applicable to the full-scale buildings.

Step 6: The plaster models (1:50 scale) were painted using poster paints or spray cans and fitted together into a block. With the aid of these models, we found, the color scheme and effect of each individual building could be judged with a certain accuracy. They came closer than the drawings to simulating how the colors would appear in the actual setting.

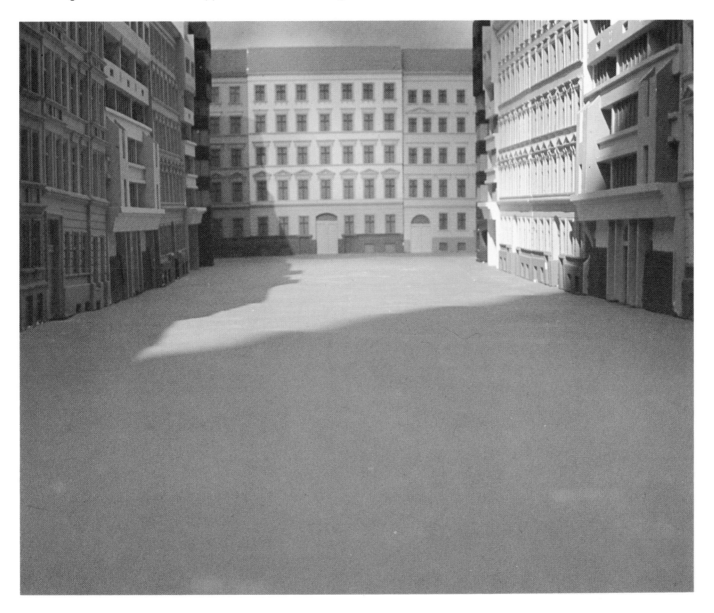

We developed our color ideas in three steps:
1. The various situations of the old and new buildings in the neighborhood were noted. We decided among the various possibilities of integrating them, emphasizing them, etc.
2. Appropriate color patterns were chosen for the different situations (foreground and background color, base, lower foundation, color gradations, stripes, etc.)
3. Colors were chosen to harmonize with existing ones.

1 North-south street:
Old buildings.
Foreground (projections and detailing) dark, a greyish-purple tone.
Background (wall color) light. Variations in hue and brilliancy of background.

5 Buildings on a square.
On a large square, we see facades from a greater distance than on a street, so their individuality can be emphasized with color, patterning.

2 Corner building on north-south street.
Stripped of ornament, leaving only background to work with. We paint base background color as well, only lower foundation darker.

6 East-west street, facades facing south, mostly new.
Plenty of sun, we can use bright yellow-ochre.

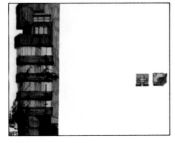

3 New corner building on north-south street.
Hinge-like building seems separate from block. We emphasize this with various dark blues.

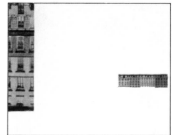

7 East-west street, facades facing north, mostly old.
Northern light allows dark hues, greys with additions of color. South side reflects light onto them.

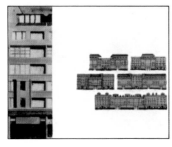

4 New building on north-south street.
Foundation similar hue to pavement, roof-zone like existing buildings, mid-zone concrete color.

8 Special type of scheme for small square or short street. Horizontal striping throughout, for instance.

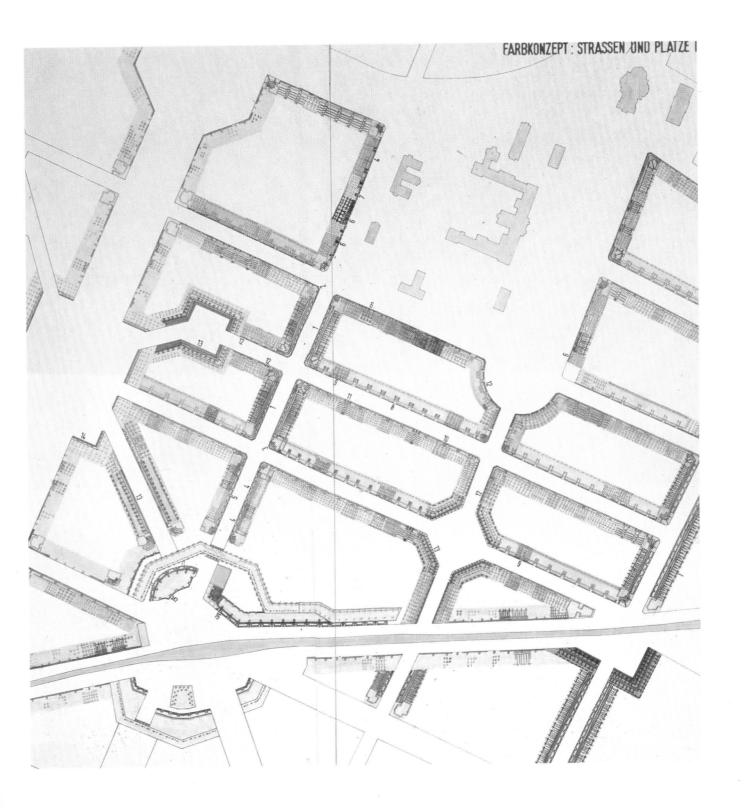

City Portraits in Color
Cracow Paris New York Berlin

Vavel Hill with the Vistula in the foreground. The oldest, and for centuries
the most important center of Cracow.

Cracow: Hues of Melancholy
by Tadeusz Chrzanowski

Building styles are the product of environment and history. With any human settlement, the natural conditions obtaining will determine what materials are available for building, and historical developments will determine how they are used; we know also that times of particular political intensity put a strong stamp on a city's face. Of course there are many other factors that come into play in the effect a city has on our senses, one of the main of which is climate, since it influences the reflection and refraction of the sun's rays, which bring color into being; beyond that, we leave the realm of physical fact and are thrown back on conjecture and intuition. Is the blue, translucent mist of Paris, for example, merely a physical phenomenon caused by humidity and pollution or is it more of a mood, a collective experience and passion, the scintillating impressionist air that has always hovered, like a live thing, over the Seine?

Cracow also has its river, the Vistula, and it lies in a basin surrounded by high hills. Like most cities in this situation Cracow is plagued by accumulations of warm, humid and often enough polluted air which are cleared away periodically by winds and storms from the mountains. If its climate is harsh, its tone is one of subtlety—imagine a city painted in pastel and faded hues filled with hidden promise, that twilight mood that vacillates always between uneasy expectation of change and love of the past. The late Gothic period and the fin de siècle were indeed the two ages that brought the finest harvests to the art and architecture of Cracow, and they have left an indelible impression on the sensibilities of its inhabitants. One might even say that building materials and climate, those determining physical facts, have not gone as far towards bringing the colors of Cracow into being as this acceptance, bordering on love, of melancholy.

This is perhaps the appropriate place to insist on the ineffable, on that which lies outside the realm of quantification and definition. Though I shall not be able to get around the duty to list hard facts, I wish to preface them with the warning: they by no means say all.

Nature has not been prodigal of resources for building the city of Cracow; for long periods of its history wood predominated, even at the city core. As present-day archaeologists are finding, wood was not only the primary material of the earliest settlement but also, reinforced with clay and soil, the backbone of the massive fortifications that protected the Old

St. Andreas Church, a romanesque structure built in the 13th and 14th centuries; next to it the baroque convent of the Klaryski nuns.

Kanonicza Street, perspective view. Vavel Castle is visible in the background, and in the foreground a parsonage with sgraffito ornament. Built in the latter part of the 16th century.

Florjańska Street with
Florjańska Gate, erected
1307-1489.

Town Wall, built in the
late 13th and early 14th
centuries and heightened
in the 15th.

Town. By the Early Middle Ages, however, a second source
of building material that promised to be just as rich as the
forests had been discovered, in the sandstone ranges not
far from town. Quarrying commenced on a large scale and
soon the warm, yellow hues of this durable stone had be-
come the dominant accent in Cracow's color scheme. Other
varieties of stone also passed through the town gates: the
Jurassic limestone typical of the mountains around Cracow
and Vielun, a cool, soft, greyish-white material which does
not lend itself to precise working and very little of which is
still in evidence in the buildings of this and later periods; and
marble, not discovered in Poland until the Renaissance,
which was, however, sometimes imported during the Middle
Ages from as far away as Hungary or Salzburg for royal
tombs and official buildings.

Modern Cracow is a conglomerate of a number of organic
centers, villages and new suburbs. Its original pattern of
settlement was mosaic-like, with habitations rising around
the countless tributaries, arms, canals and ponds into which
the Vistula branched across the valley. Some of the old
names of streets and squares, like Na groblach (On the
Dam) and Na stawach (On the Pond) still witness to the exis-
tence of these waterways. Settlement of the Vistula Valley
began at a very early date. The first and for a long time the
most important center was Vavel Hill, a rock formation that
rises high above the rivercourse, chosen for the protection it
gave against the frequent floods. Habitation spread up the
sides of this hill until finally its heights had been claimed by
the symbols of sacred and profane authority, cathedral and
castle; then the city began to spread ever further north-
wards. During the Middle Ages other, separate centers were
established: Kazimierz, later to become the site of the
Jewish Quarter, and Kleparz, also known with civic pride as
Florence. Finally, in the 18th Century, the opposite bank of
the river was settled and the town of Podgórze came into
being. The integration of all these various centers has long
become a fact, even in the literal, topographical sense, for
tributaries, canals and ponds were filled in to construct the
city's streets and squares. Perhaps the clearest idea of
Cracow's configuration was given by a Polish writer of the
Renaissance, who compared it to a lute, the neck of which
was formed by Vavel Hill. This is truly an apt and beautiful
metaphor, since it not only describes the city's physical
shape but touches on something more difficult to put into
words, something I can only call the musical quality of the
colors and composition of Cracow.

Draper's Hall, Suciennice. An early-14th century building that was restored for the first time in the early 16th century, and for the second time between 1875 and 1879. The focus of life on Market Square.

Collegium Maius, the oldest building of the university. Built in the 14th century, it was connected to the living quarters in 1492-97 to form a courtyard.

Collegium Maius, courtyard. Late-Gothic colonnade.

Some time in the late 10th Century the first two buildings in masonry were erected on Vavel Hill, one circular in plan and the other roughly square, and both faced with stone. (Judging by its remains, the latter may well have been a Palatine residence.) The first large cathedral followed in the Romanesque period, and soon, at the foot of the hill, more and more churches and chapels began to go up, all of masonry and stone construction. Domestic architecture, however, continued to rely largely on wood, and, if one were to call up a visual image of Cracow at the time, it is probably not too far from the truth to think of it as being dominated by the amber of timbers against a background of warm yellow and grey stone.

In 1241 the Mongol hordes razed Romanesque Cracow to the ground. This date marks the end of an era, for reconstruction, which began only a short time later, was already in the Gothic mode. The damage to the city had been so great that only the course of King's Way, the former main trading route, still witnessed to its original plan; the new layout divided the city into a system of regular grids, with identical lots or curia. At its exact center a marketplace, one of the largest in this part of Europe, was laid out in a space corresponding to four curia and their dividing lanes. This, the spot at which commerce and administration were concentrated, was to become the heart of Cracow—and it still is to this day. And, as if to emphasize the city's position at the crossroads of the east-west and north-south trade routes, Draper's Hall was erected here, an impressive masonry structure that dominated the Marketplace. Not only had masonry entered domestic architecture by the close of the 13th Century, but a new, man-made material had put in its appearance—brick. The style that ensued, known as Brick Gothic, differed in one key way from that prevalent in other parts of Nothern Europe —the architects of Cracow never completely omitted natural stone from their designs. Stone was used not only for sculptures and decorative detailing but also for such structural elements as window casings, house corners and arches, as well as for ornamental facings and those typically Gothic pointed niches, mullions and tracery.

The heyday of this period fell in the reign of Casimir the Great (1333 to 1370), popularly known as the king who "came to a Poland of wood and left behind one of stone". Additions were made to Vavel Castle and the cathedral was completed, and with these structures, their stonework con-

trasted by surfaces of hard-fired brick, that color scheme which was to become so characteristic of Cracow—rich reds set off by warm yellowish-greys—was given the royal seal.

The town's great basilicas were also erected under Casimir, the last of the House of Piast, and under his successor; from 1392 to 1397 Cracow's central church, St. Mary's, received the two-towered facade that it is famous for today. During the same period a number of imposing municipal structures were erected also, including the city hall tower, which was completed in 1383, and the mighty town fortifications with their countless towers and bastions.

The late Gothic style, however, cannot be said to have flourished in our city, though it did leave behind one quite unusual architectural monument, the Collegium Maius, which was the first building of Cracow University. In terms of style this structure marks the watershed between Gothic and Renaissance in Cracow, uniting as it does features typical of each style. Its residential buildings, dating from the 14th Century, were connected in the early 15th Century to form a closed court, to which arcades were added from 1492 to 1497. These arcades are still very Gothic in their restlessness; their columns, which carry prismatic ornament in grey stone, lead the eye to vaulting which continues this crystalline, concentric rhythm. Above them, the walls glow in the deep red of a dying era, heightened by gilded portals and grillwork and alcoves shimmering in silver. Under the projecting roof, which is still very mediaeval in form, the Renaissance puts in its first appearance: coffering decorated with painted rosettes.

It is very difficult to say much about the domestic architecture of this period because none of it has survived in its original state. However, investigations are now underway and they have already turned up some interesting clues about how the first burghers of Cracow must have lived. For example, large windows have been found in a number of houses, which had been partially filled in by succeeding generations, probably for reasons of economy. Their stone casings are wonderfully crafted in patterns of spirals, shells, prisms and lozenges. In the interior of many of these houses richly carved columns or portals with elaborate friezes have been unearthed under centuries' accumulation of plaster, and coffered oaken ceilings with fine paintings have also come to light.

Cathedral on Vavel Hill, a fascinating mixture of styles and forms from the 11th to the 20th centuries.

Cathedral on Vavel Hill. On the left, the domes of Wasa Chapel (1605-1676), on the right, the domes of Sigismund Chapel (1517-1533). Architect: Bartholomeo Berrecci

Convent of the
Pauline Order, built
during the second quarter
of the 18th century.

Pauline Convent. Detail
showing coat-of-arms.

This patrician reserve in ornament and sobriety in color (aside from the rare bit of gilding) avoids every extreme; almost it seems as though the people who commissioned this work wanted a conscious contrast to the boisterous life outside, in the near marketplace, at the town's heart. Here, where the great Draper's Hall towered over tiny bustling shops, the glory of the East mixed with the austerity of the West; the first minglings of these opposites came with the Renaissance: not without reason has Sarmatian culture been called the Polish interpretation of Renaissance, Mannerism and Baroque.

The Renaissance took Vavel Hill by storm in the opening decades of the 16th Century. To refurbish the Castle and build the Memorial Chapel (later to be renamed after the great Sigismund) various Italian artists and artisans were called in, most of them from the towns of Tuscany. Soon the forms of Greece and Rome, reborn in the Florence and Ravenna of the late Quattrocento, had begun to soften and enrich the Gothic face of Cracow. Yet they were not accepted without resistance, for by about the middle of the 17th Century Poland's first architectural historian (who has remained anonymous to this day) had begun demanding that these foreign ideas be adapted to what he termed Polish customs and mores. Aside from this theoretician's pressure, the practice of collaboration with excellent local architects such as Master Benedykt assured that the new was skilfully combined with the old, and Gothic forms, which tend to dry abstraction, gained in vitality by their marriage with antique motifs.

Unlike the refined, court-patronized architecture of the 16th Century, that of the new urban middle class retained strong ties to tradition. Nevertheless, even in domestic building two changes came about that altered the face of the city to such an extent that one is justified in calling them revolutionary. The first of these changes affected architectural structure, and the second the treatment of the surfaces; both had an immediate effect on Cracow's color scheme.

The structural change that came about during the Renaissance involved a break with the Gothic tradition of carefully laid, decorative brick walls, which were replaced by rough masonry work finished either with costly varieties of stone, or in riffled stucco, or—if the builder could afford it—stucco applied to resemble roughhewn granite. Frescoes also

came into style, but the extremes of the northern climate made this experiment a short-lived one. Much more durable and popular were ornaments in sgraffito or stucco relief, which now began to replace sculpted stone. For almost three hundred years the characteristic dark brick red disappeared from the city's composition behind a pristine veil of plaster, except for the scattered grace notes of church towers and cathedrals.

The second great change affected administration buildings and those devoted in one way or another to trade (all activity in the field of church architecture having been brought to a temporary standstill in any case, thanks to the Reformation). In the mid-16th Century, Draper's Hall had burned to the ground, and when reconstruction was commenced, it was decided to erect a modern superstructure on its circular Gothic foundations: the two short sides of the building were topped by galleries and loggias and the facade crowned along its entire length by a pediment, which concealed the roof. Since pediments of this kind were thought to prevent fire from spreading across the roofs, they had the full approval of the city fathers; and soon another typical feature of Cracow, pointed, zig-zagged gables and steep roofs covered in tiles, shingles or leading, began to disappear from the scene, to be replaced for the next three centuries by long vistas of facades cut off at the top as with a huge Classicistic trowel.

Color followed suit; the streets and squares became rather cooler places with the spread of chalky whites enlivened by an occasional grey or blue; yet these new tones did not succeed entirely in overriding Cracow's traditional sunny yellows and soft pinks and the golden glow of sandstone. With the advent of Mannerism even more warmth began to enter the spectrum, for at the turn of the 16th to the 17th Century a reddish-brown marble was found at Checiny, and a little further on, near Lvov, rich seams of alabaster were unearthed—a material that from then on was known as "Russian marble". New materials offered new possibilities, and architects had soon begun to exploit them to create chromatic effects as well, rather than relying only on tinted rendering.

Another discovery, during the reign of the first monarch of the Vasa Dynasty, can be said to have marked the beginning of a new architectural era. In the Cracow suburb of Czerna

View of Florjańska Street, showing a building in the style of the French Empire known as "At the Sign of the Moor". First half of the 19th century.

Pijarska Street with neo-Gothic gallery of the Czartoryski Museum spanning the street. The gallery, designed by Maurice Ouradou, was built from 1879 to 1884.

At the Sign of the Spider, a house built in 1898 by Teodor Talewski on Karmelicka Street, where the architect lived.

At the Sign of the Spider, detail. Rough stones protrude from the smooth brick wall.

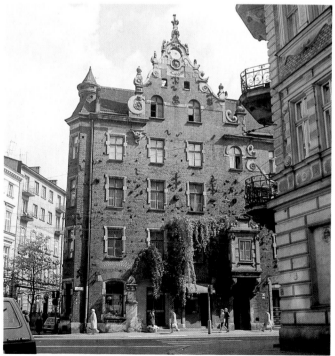

the Carmelite Order, which had come here from Spain, was granted a tract of land on which to build a hermitage; this tract included the quarries at Debnik. Now, opinions differ as to whether the stone won there was indeed ''black marble'', as tradition has it, or merely some similar dense, fine-grained variety of stone. This issue is less important than the fact that this material, which polished to a glossy black, faintly veined surface, was exactly what the fashion (and the ideology) of the time desired. The Polish Court had adopted Spanish modes of dress—severe black heightened by ruffles—and Black Marble was its perfect architectural complement. The result was an Early Baroque style both majestic and austere, in which asceticism was continually at odds with a very worldly pride.

The sable gloss of the *petite architecture* that was built with this material looked extremely effective against white walls, and was heightened still further by alabaster sculptures and discreet gilded accents which, very much in the Spanish style, were the more splendid for their ascetic setting. This glory, however, was limited to the interiors of the new chapels and palaces almost exclusively. And it was fleeting, as time was to show—the surfaces oxidized, lost their gloss and depth, and finally turned a steely grey.

That era was destined to be the last of any splendor that Cracow experienced for a very long time. Towards the end of the 16th Century Warsaw, closer to the country's center, superseded Cracow as the capital of Poland, and in 1655 ''The Deluge''—the Swedish invasion, which no one had expected—wreaked terrible destruction on the city. And, though the late Baroque, Rococo and Neoclassical periods left many fine landmarks behind, none could compare in rank and beauty to those of previous times. The colors of the city changed but little after the 17th Century; warm tones continued to predominate in combinations of yellow, buff, ivory and more rarely green. Stone yielded more and more to the cheaper stucco, which lent itself well to certain types of color effect (as witnessed by the bright coats of arms that came to adorn many townhouses).

The 19th Century did not change this picture much, but the changes it did make were severe—many invaluable architectural monuments were torn down, including the City Hall and large sections of the old Town Wall. Then too, the Austrian government forced the city into a new fortified girdle,

one of the side-effects of which was to hinder its growth; with the result that urban expansion in the modern sense did not begin in Cracow until about 1900. This stagnation had its good as well as bad sides, of course. In too many cities technical progress and new prosperity swept aside the past in the name of some euphoric vision of the future. Take Paris —while Baron Haussmann was erecting pompous monuments to the Deuxième Regime on the city's mediaeval and Renaissance ruins, in Cracow old, side-whiskered gentlemen in pince nez were stoutly defending every even faintly historical object that they saw threatened by the housebreaker's ball.

Yet in another sense Cracow was no exception to the European rule, searching throughout the 19th Century for some historical style or combination of styles that suited it. In Cracow's case, most of the architectural ideas came from Munich and Vienna. It was not until towards the end of this eclectic period that an architect of true originality, not to say eccentricity, made his debut. His name was Teodor Talewski (1879 to 1910) and with him the Seccession flowered in Poland. Talewski was the first to make truly creative use of the bricks and tiles and mosaics that had then come into fashion, a mediaeval touch particularly evident in the buildings he designed for Retoryk Street and in his own house on Karmelika Street, "The Spider", where a huge iron spider actually spans its web across the gable. Talewski is perhaps best known for the wonderful variations in texture and color he brought to exterior walls, often working rough-hewn, projecting stones into smooth brick surfaces. Also, like his contemporary Antonio Gaudi, he placed great importance on integrating architecture with its organic surroundings, even providing his walls with channels expressly for climbing plants.

The Seccession movement in Cracow was a borrowing from Vienna and, like its counterpart, it first manifested itself in an exhibition pavilion—the Palace of Art, built in 1901 to the plans of Francizek Maczyński. His was a good generation of architects: men like Stryjeński, Ekielski, Wojtyczka and many others enlivened the urban scene with buildings of the most fascinating shapes and colors, with flowing linear ornament, reliefs of obsessive force, wrought-iron grillwork in the shape of intertwining vines, stained-glass windows and mosaics—in short, every note in the last chord of the European fin de siècle.

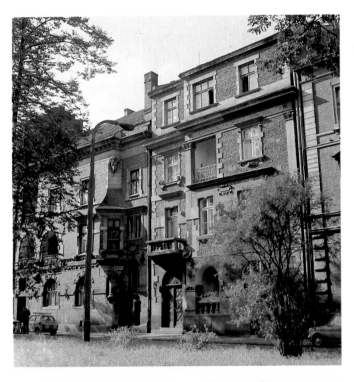

House on Retoryk Street, built in 1891. Architect: Teodor Talewski

House on Retoryk Street, detail. Revival of the brick Gothic style characteristic for Cracow.

House in Eclectic style
on St. John Street
mid-19th century.

Renaissance houses on
Sławkowska Street.
Neo-classical facades
added in the early
19th century.

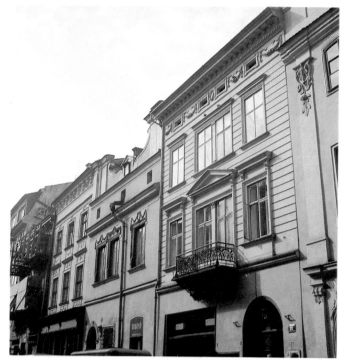

Against this background one man stood out in relief, an unusual and positive thinker by the name of Stanislaw Wyspiański. Genius was the word applied to him at the time, and I believe it still applies. He was a painter and a dramatist who united in his works a strange poetry and a very personal vision of Poland's destiny. Some of his finest designs, for the stained-glass windows of the Gothic Franciscan Church, may still been seen there today.

If art nouveau brought only a few exotic accents into the intimate, subdued spectrum of Cracow, it did mark the end of a historic cycle, and its mood of pervading melancholy may well come to be seen as the most fitting expression of the town's unique and irretrievable atmosphere. The 20th Century, of course, brought new technologies, new forms and valuable architectural innovations; perhaps we lack enough historical perspective on this period to say, but most of the modern buildings in Cracow seem derivative, more or less successful versions of things going on, perhaps with more conviction, elsewhere on the international scene. Whatever the case, there is only one area of the city—the preserve which contains park, Vavel Hill, the borough of Kazimierz, with its narrow lanes and courtyards shadowed by ancient churches—where that strange effluence still fills the air tangibly, the warm and gentle color of Cracow.

The great historical role once accorded this city grew out of its site, on a key ford of the Vistula. This same site has now become its misfortune. Clouds and fogs collect in the basin, the humidity is as high as breezes are rare. And these natural drawbacks have been made even worse by human activity: the industrial plants and particularly the refineries that encircle the city emit tons of dust and harmful chemical compounds every year. Public health suffers, and architectural substance suffers, too. The old buildings are rapidly losing their patina, their stones are flaking, decomposing. The air here is acrid enough to corrode metals, let alone fine rendering and stuccowork. Even the trees in the park are perpetually shrouded in fine grey dust.

A few years back so many voices were raised in alarm at what was happening to the city that the Polish government announced a plan to save it. Preservation and reconstruction became the order of the day. Since then there is hardly a corner of Cracow that has not been scaffolded and fenced around and minutely restored. However, though these pro-

jects and the conscientious research that paved the way for them have brought gratifying results, they have also given rise to extremely complex problems.

The first of these concerns color. Whenever a facade is renovated, the conservators have to decide how to finish it, and their choice is not an easy one—every historical building in Cracow is an anthology of styles, with every layer testifying to some chapter of the city's history. Though I have already attempted to give some idea of this variety, it is difficult to imagine, without having seen it, how the centuries have encrusted these ancient walls. Not that we subscribe to a purist doctrine or wish to return these buildings to some mythical "original state"; the architects and conservators have an almost equal respect for every layer their work reveals, and they are doing their best to conserve what can be conserved of each historical style. Churches in particular (and this is not only true for Cracow, of course) are wonderful compilations of mediaeval architecture and Mannerist, Baroque, Neoclassical and Secession decoration; and many an early townhouse combines Renaissance stonework with Gothic ceilings and wall-paintings in the style of the French Empire.

In writing these words I of course am conscious of the danger of going too far in one's respect for tradition, if the result is a building that is simply a collage of heterogeneous elements. Nor should historical structures be seen in isolation, as objects having a life of their own. Each belongs in a certain context which affects its appearance as much as the building itself reflects on its surroundings. And another point: Cracow is alive. Market Square is a noisy, bustling place even without the droves of tourists that come to see it every year. I have seen towns of extraordinary beauty—Sighisoara in Rumania, Telć in Czechoslovakia, Carcassone in France —which have petrified in their beauty, stiffened, so to speak, in the hands of overeager restorers. This is a fate that Cracow has no need to fear. It may be a city of museums, but it has too much life in its veins ever to become an open-air museum itself.

Thoughts like these have informed the restoration of Cracow from the beginning, and there is no doubt that they have changed its aspect. Only superficially is it the same city, submerged in its age-old dream. To give an example: the townhouses on Kanonicza and Mikolayska Streets, after centuries spent under plaster, now stand as they must have

No. 5 Kanonicza Street, a 15th-century house with masonry base and applied classic orders, ca. 1810.

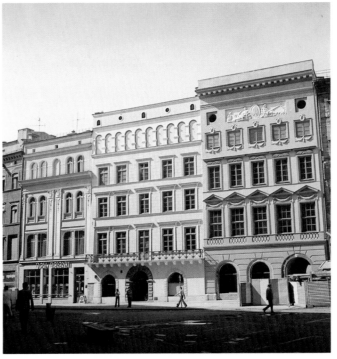

Market Square.
These three buildings are of various epochs; careful selection of color has lent their facades unity.

No. 5 Kanonicza Street.
Facade drawing,
1:200 scale. Record of the
building's state prior to
restoration.

looked in the Middle Ages, with their fine brickwork revealed. In other cases ornamentation of a more recent date has come to light, intricate stonework, say, and if enough of it has survived it is restored and the missing sections added by craftsmen. Most of the old buildings, however, are left in their present state, freshened up a little and, if necessary, structurally reinforced at crucial points. And when it comes to painting and rendering, color schemes are usually worked out for entire blocks at a time rather than for individual facades. Sometimes, when fine ornament is uncovered or the original color tone of a building is brought to light, it is taken as a pattern and applied to neighboring buildings. And with that sureness of taste that seems to thrive here a color scale is chosen, in warm tones or cooler pastels, blended to give that unique polyphonic harmony of stone and brick, rendering and ornament so characteristic of Cracow.

Other cities—Prague and Salzburg, to name only two—possess, thanks to their location and history, a panorama of roofs and gables that is inimitable as a poem. Since the advent of the flat cornice this poetry has been denied to Cracow. Yet there is an idiosyncracy of our skyline that perhaps makes up for that lack—I mean that greenish patina, clear and yet never harsh or cold, that shimmers on the peaked roofs and cupolas of Cracow's towers. This green contributes its own delicate note to the composition of architecture, parks, sky and river, another facet in the lucky star which, despite the countless storms that have ravaged my country, has always shone on this city, ancient Cracow, perpetually young.

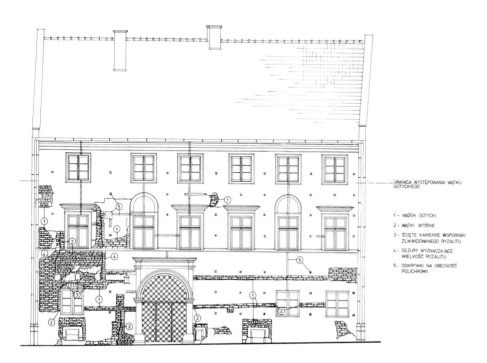

No. 5 Kanonicza Street.
Facade drawing,
1:200 scale.
Traces of various stylistic
epochs uncovered during
restoration work.
1 Gothic masonry
2 Traces of renovation
work, not datable
3 Remains of a double
arch
4 Paint traces from
different epochs

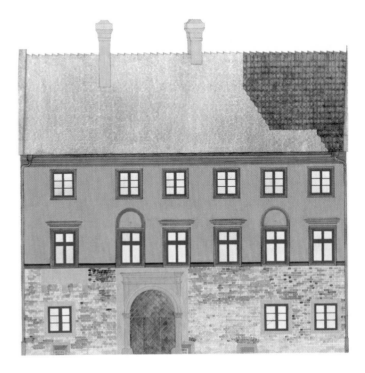

No. 5 Kanonicza Street.
Facade drawing,
1:200 scale.
Color scheme for
restoration:
1 Brick basement with
windows as in original state
2 Hard-fired brick walls on
ground floor stripped of
later ornament
3 Reconstruction of
double arch
4 Renewal of
neo-Classical stucco-work
on the upper storeys
5 Reconstruction of
Gothic tile roof

Paris, the Grey-White City
Photographs by Jan Rave and Johannes Uhl

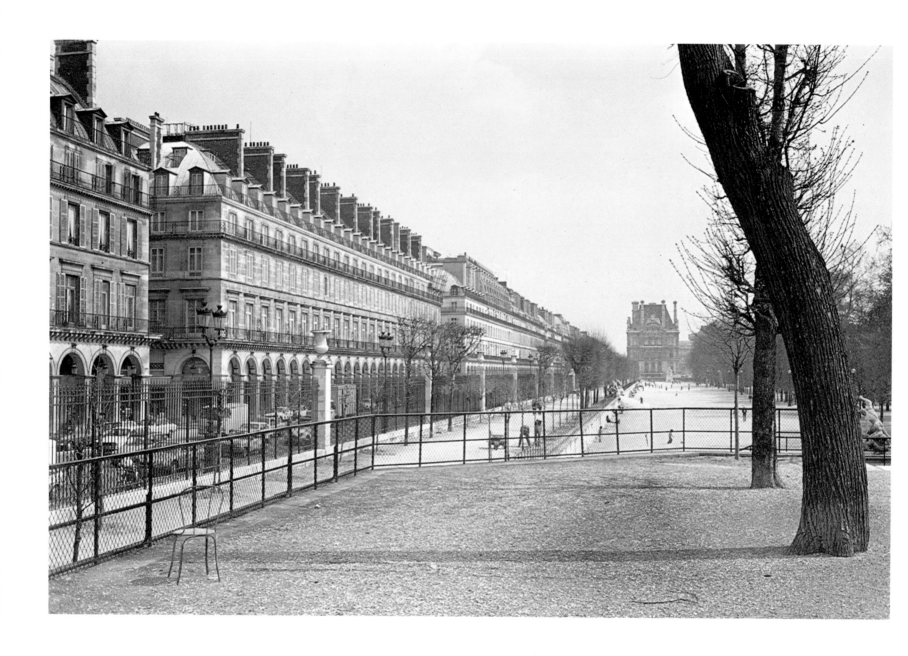

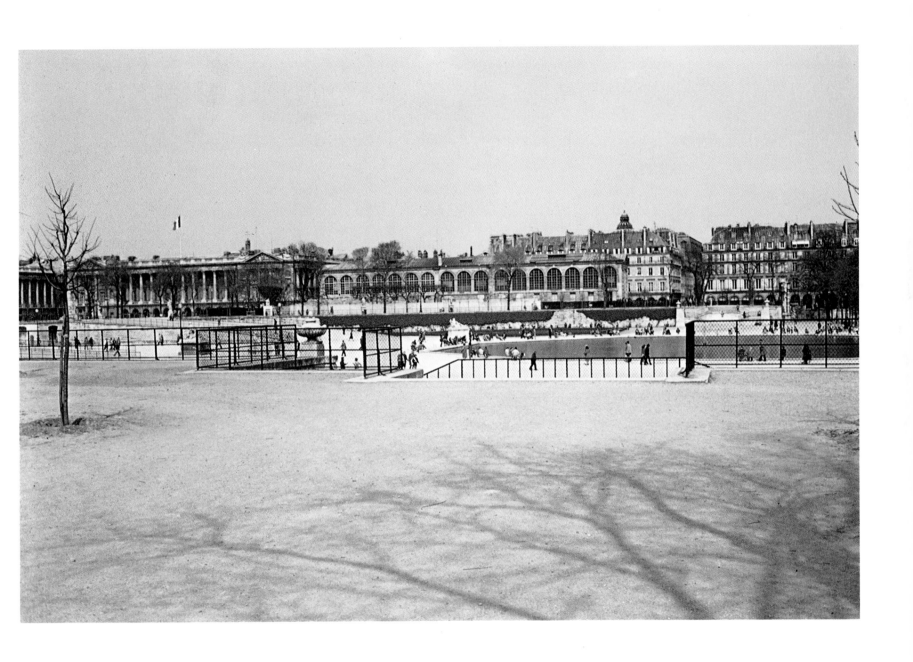

Paris
by Wilhelm Hausenstein

... And now it begins to take shape in my mind, something decisive; the detail becomes the whole: Paris is one single huge grisaille, a painting of infinite extent, grey in grey.

How many shades can grey take on? Impossible to tell. Yet Paris must certainly contain a little of every gradation, down to the slightest, there is—from the white-gone-grey of those mundane, petit bourgeois quarters to the dusty, soot-veiled greyish-yellow of that official sandstone which is always so cleanly cut and joined; from the leaden grey of slate and zinc roofs to the iron-grey of balcony railings and the smooth metallic blue-grey of the asphalt avenues—a poor list, granted. What this list signifies, however, is nothing less than a discovery—well, a small discovery, but one that is comforting just the same because in a word it says all: Paris is The Grey City. Ville lumière—what nonsense. What really counts is that Paris goes grey in grey. And it isn't in the least sad or stuffy, this dress, it is exhiliarating, it is noble, it is richness reflected a thousand times over—for in these greys shimmer all the potentialities and realities of an ideal palette. Here a delicate yellow flutters toward grey, a tea-rose, a sulfur-grey; there a pink appears, as though wafted over from the evening meadows along the Marne; now an almost-violet, a secretive lilac glows by a sudden sea-green. The colors hover in and out of grey like ghosts. Here and there a gold shines, now almost garish, now dull, on those agitated statues that flutter in the wind like bushes or flags at the ends of bridges. The Latin capitals of shop signs take it up; a tailor, a perfumer set their names in gold before edifice-grey, and by framing gold in grey they announce prosperity without indecorousness. I would not want to miss this grey: it belongs to Paris: yet it belongs to Paris only because Paris, through and through, is grey.

The image, I am beginning to see, will not be resisted. French taste has risen out of all this grey like Venus Anadyomene from the foam of the grey sea. Paris has never been a place that sees the colors of the palette, as they are, material and crass; she has had gradually to discover them through the medium of grey. Artists, of course, know that if you mix all the primary colors grey is the result. The city of Paris has done just the opposite: from the neutrality of grey she has extracted all the painter's colors, and not only the primary ones. Ah, what an eye one would have if one were to practise it by coaxing these colors out of grey! What arts of differentiation one would master! Yet how necessarily everything finally comes back to rest in this one mysterious common denominator called grey.

We in Germany do not realize what barbarisms we commit when, on the bad advice of zealous art historians, we begin painting our buildings red and yellow and green and blue and violet. This vulgarity sweeps the land unopposed, swamping every delicacy of gradation. Expressionist crudity has passed on its curse to poison the taste even of house-painters.

From its countless greys the modistes of Paris have distilled their taste; in them the city itself has practised the magic of nuance, and this throughout centuries that have repeated and resembled one another always. Nor does a schooling like this affect only taste in color, it affects taste in general; it brings with it every manner of refinement, even in form, in ephemeral gesture; yes, it sharpens the eye, but along with the eye it sharpens all the senses—the subtleties of Parisian cuisine would probably not exist were it not for the magic of the city's grey veil. Not to mention the differentiation of the painterly sense that we must attribute to skill in using grey, from Chardin to Picasso and Diaz, Braque and Derain; or French diplomacy, for that matter, which of course is pure grisaille.

Even the sky seems to be there solely to heighten our receptiveness to grey. Its blue has a silvery cast; and what is its grey if not the grey of the pearls set out in the incomparable jewelry shops along the Rue de la Paix? The very air is silver-grey.

The grey of dark and cloudy, even rainy days does not subtract at all from the effect. On the other side of the Rhine it sometimes drives us to desperation; not here. The Paris sky grows overcast; it begins gently to rain; the rain spins, the rain weaves. As another veil of grey settles over its aspect the impossible happens: Paris becomes even more beautiful, more intimate. Now the touches of gold are brushed more wonderfully matt than usual, and when they shimmer in the wetness, their luster is delicately subdued. The grey of the buildings retires behind a screen of grey air and waits for us to come and coax it out again. The green of the foliage, the green of the Tuileries only now springs into the full, tangible relief of existence; and the purplish red of rain-wet geraniums is lovelier than the feverish sharp red of geraniums under the sun.

How lividly white Notre Dame stands in the rain, an apparition wrapped in a soft grey web!

Where is a second city that rain magically transforms into ever more beautiful shapes instead of robbing it of youth and life, wiping it out altogether?

Gradually one approaches the whole. Now the high, narrow windows that seem to stretch down from ceiling to floor come into view; now the white shutters, those jalousies that fold up like an accordion. Details? Perhaps, but a city is composed of seemingly insignificant details. One could go on listing them for hours. The human mind, however, is gratefully capable of taking a part for the whole, and recognizing unity in detail.

from: Wilhelm Hausenstein, ''Europäische Hauptstädte'', Eugen Rentsch Verlag, Erlenbach, Zürich and Leipzig 1932

Quiet Days in Clichy
by Henry Miller

As I write, night is falling and people are going to dinner. It's been a grey day, such as one often sees in Paris. Walking around the block to air my thoughts, I couldn't help but think of the tremendous contrast between the two cities (New York and Paris). It is the same hour, the same sort of day, and yet even the word grey, which brought about the association, has little in common with that gris which, to the ears of a Frenchman, is capable of evoking a world of thought and feeling. Long ago, walking the streets of Paris, studying the watercolors on exhibit in the shop windows, I was aware of the singular absence of what is known as Payne's grey. I mention it because Paris, as everyone knows, is pre-eminently a grey city. I mention it because, in the realm of water-color, American painters use this made-to-order grey excessively and obsessively. In France the range of greys is seemingly infinite; here the very effect of grey is lost.

I was thinking of this immense world of grey which I knew in Paris because at this hour, when ordinarily I would be strolling towards the boulevards, I find myself eager to return home and write: a complete reversal of my normal habits. There my day would be over, and I would instinctively set out to mingle with the crowd. Here the crowd, empty of all color, all nuance, all distinction, drives me in on myself, drives me back to my room, to seek in my imagination those elements of a now missing life which, when blended and assimilated, may again produce the soft natural greys so necessary to the creation of a sustained, harmonious existence. Looking towards the Sacré Coeur from any point along the Rue Lafitte on a day like this, an hour like this, would be sufficient to put me in ecstasy. It has had that effect upon me even when I was hungry and had no place to sleep. Here, even if I had a thousand dollars in my pocket, I know of no sight which could arouse in me the feeling of ecstasy.

from: Henry Miller, ''Quiet Days in Clichy'',
New English Library Limited, London 1975
Originally published by The Olympia Press, Paris 1956

What I Saw and Heard in New York

In memory of Ingeborg Bachmann
by Martina Düttmann

New York is a city whose size you can decide for yourself. It's a relief. Every other city loads obligations on you to see everything or at least a lot of things or at the very least the things everybody else has seen and has told you about; you're afraid of going back home without the answers to a thousand questions, and so you spend most of your time on the flight back thinking up answers to at least some of them. New York is too big for all questions and too big for every answer. The New York you see is your own New York, with paths you have chosen, familiar traces, and friends you meet again in the hotel lobby, unexpectedly.

Friends and meetings with friends are a personal pattern superimposed on the city's grid. The subject I have come here to write about is another such pattern, a line of signposts, imaginary at first, marking the path I might take through the labyrinth. Every discovery I make along the way will be personal, self-defensive, and should give me a little solid ground to stand on.

Walking in New York. My subject is color in the city. One color is there already, I knew it would be and I now see it: the blue haze that hangs suspended between these sheer buildings that never tire of reflecting each other and the sky in their countless windows. I saw it from the airplane, this blue haze, and every panoramic postcard of Manhattan shimmers blue and violet; now, forgetting the street and considering the skyscrapers with an architect's eye, as monstrous sculptures, steel grids and glass, I see it from below. This blue tint is still, noiseless; you can't hear the city from an airplane, and down on the ground, when you stop and look up, all the way up, noises fade and the city grows silent. Of course you know by association that this blue haze, which is the color of all great cities, means roaring traffic, vibrating, humming glass, the cacophony of urban civilization—the funny thing is, you don't really hear it.

What I do hear are voices, clear, individual voices speaking beside me, above me. Even though I understand the language, my understanding remains academic; for these voices are at home here and I am not, and that is more frightening than any skyscraper facade or the numbered, nameless streets or the long distances or crossing six lanes of traffic in the middle of the block. And wrapped in this confusion of strange, clear voices are the colors of the street, the bright dresses, the show windows, the faces, the colors of doors and flowers and taxis, the colors of the paintings on apartment walls.

When I visit a foreign city I feel grey. A shadow, a theater-

goer in the dark with the bright stage before him. Grey, I walk the New York streets, my subject their colors. Enter the obvious: those patterns of color on walls and gable-ends, murals that take the subject of color on the urban scene literally—they expand over the old gables, they say expansively We bring color to the city, and they have been quoted to this effect hundreds of times. So, a good reporter, I look them up one by one. Landscapes, facades, abstractions, art of all kinds, all painted on walls, and all strangely artificial. Each mural is a surprise—architecture as canvas, hanging there in the huge apartment of the city—but that is all. They evoke no atmosphere. Though they have no frame they are isolated from their surroundings, stiller than a still life over a dining room table. And they are cool, impersonal in all their expansiveness. They could be anywhere; one town is as good as another, they seem to say, and what is worse, the life going on below them is no concern of theirs—that must be why they pale before the streetsigns, Walk and Don't Walk, the noise and the lights.

The colors of New York have not grown out of the land, out of its minerals and woods, out of its history—except as the immigrants and their descendants have shaped this history. The apartment buildings of brick and stucco that look as though they might just as well stand in London have been painted as neighboring houses in London are still painted today: one white, one red, one blue, one white. The colors are not composed, no decorator has devised this scheme: chance, taste, the spirit of fun, neglect have. These are the colors of use, of being-at-home, of possession. Yet the impression they give is not one of competition or contrast; you don't notice individual buildings so much as the pattern of a block: the colors are not stronger than the architecture, the windows, doors, stoops and roofs. They have a temporary look as though they could change overnight, yet even if they blossomed into lush and delicate polychrome the block, you feel, would be substantially the same.

Maybe this tells us something—that a building is both too large and too small to be taken in at a glance. We see whole blocks foreshortened and the color of each building merges into the whole. Streets which have one color along their entire perspective may give the impression of clarity, architectonic stringency; but the more color a street has, the livelier it is. And lively comes from life.

If we don't see buildings we do see their details—colorful entryways, basements, storefronts. This detail is like a visual language where every line, every pattern, every nuance of

color holds its meaning. Here you can compare, enjoy, taste that certain combination of blue, red and purple, hear notes soft and loud—suddenly you find yourself paying attention, all senses keyed, and you realize that you've become appreciative and critical and are no longer a complete stranger. The doors in New York ask to be opened, they're out on show like souvenirs beneath the sheer, blue, cool screens of the skyscrapers, inviting souvenirs—and souvenirs are always pop and garish, more so here, one would have expected, than in any other city in the world. Expectations like this are part of every traveller's luggage, I suppose, and it's always nice when they're fulfilled...

So I open the door, walk in, buy something, walk back out, and take a deep breath. There—I've almost shed it, this grey feeling of strangeness, because the colors on the facades seem even less at home than me now, the buildings smile through them and I smile back. I'm still a foreigner, all right, but the ground beneath my feet has stopped shaking; I got out my first words in a new language and was understood; the roar of the street has disassociated into voices and cries, the swish of tires, understandable discrete sounds.

Now my eyes see more clearly. They no longer look for what is typical of New York but for what is particular in New York. They find that waterfall between two buildings that speaks Italian; they find that plant, incredibly green and covered with blossoms, completely filling a restaurant window on the street that leads back to my hotel. And then, finally, I find everything I already knew was there and didn't have to look for: the bright billboards and skysigns, the scaffolding and movie marquees, the yellow taxis and the green firetrucks blocking the street, Central Park with trees in bloom, the children, the itinerant players, the clown. Arrived, submerged in sounds and colors, there's no stopping or saying when, and I want to see everything and take everything back with me and describe it all and take pictures of everything and take it all back home with me. This is the end of the first day.

All photographs: Rob Krier, Stuttgart/Vienna

Color in Berlin: A Historical Overview
by Harald Machnow and Wolfgang Reuss

1 Color often puts in a spontaneous appearance on the urban scene, and it is something to be thankful for. Whether accident or signal, advertisement or personal record of a fleeting event, this chromatic improvisation has become an indispensable part of the modern city.

This selection of paintings, etchings and photographs is meant to illustrate how color has been used on the buildings of Berlin throughout the city's history. We have no point to make or argument to add to the present debate on the subject; our contribution should be taken merely as an aid to 'seeing what we look at', in Corbusier's words.

We should state at the beginning that our overview was not conceived as a scholarly exercise in art history. It is rather a brief review of architectural styles and the contemporary interpretations of them that have come down to us. Our choice of illustrations has been as subjective as our choice of approach—in paintings of the 18th and 19th centuries buildings and their color schemes are treated in a very personal manner, and we admit that we have been no less personal in our selection of buildings to photograph and details of them to illustrate.

We have tried to document as many different examples as we could find of chromatic architecture in Berlin. Though our presentation is chronological, the dates given should not be seen as hard and fast boundaries, simply because the way we experience the tonal effects of a city is not something we can easily classify or systematize; nor is color a criterion by which buildings can be pigeonholed in architectural history or even ascribed to a certain architect's or artist's hand. The buildings are illustrated as they look today, with all the effects of time and weather. This of course means that the plates do not always reproduce the original color schemes authentically, yet they do suggest what their authors' intentions must have been. We have resorted to historical documents only in those cases where we could find no actual examples of a certain era.

2 House design for
Friedrichstadt, dated 1772.
By an unknown artist

For the appearance of pre-1800 Berlin we are largely dependent on historical sources, such as the watercolors of Johann Stridbeck or the sketch illustrated, an anonymous architectural drawing made in 1722 for a building in Friedrichstadt. Only one actual structure has survived, the Consistorial palais by Philipp Gerlach, which has since been restored to house the Berlin Museum.

The color scheme which both drawing and Gerlach townhouse have in common—strict classical decor with contrasting rendering—has since become the model for reconstructions of buildings of whatever style or epoch in Berlin, and as such almost a visual habit.

3 Consistorial Palace in
southern Friedrichstadt, by
Philipp Gerlach, 1734-35.
Rebuilt 1964-65 to house
the Berlin Museum

1800 to 1850

'Genesis of color and decision are one and the same. If light represents itself and objects with a general indifference and convinces us that the present is insignificant, color comes forth always as specific, characteristic, significant.'
(Goethe, Farbenlehre, 1810)
In Classicistic architecture a tonality based on off-white, pale blue and pale yellow insured that color would not compete with either the general masses of the buildings or their applied orders. Color was considered an accessory rather than a painterly value in itself.
The streets and squares of the Old Town, however, judging by paintings at least, were much livelier places in terms of color—the buildings were monochrome, but painted much brighter colors than today.

4 Leipziger Strasse in Berlin, looking west. Detail of a painting by Leopold Zielke, 1835. A companion-piece shows the view looking east

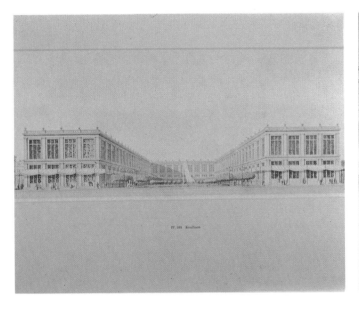

5 Design for a department store, K.F. Schinkel, 1827

6 House on Neuer Markt. Detail of "Der neue Markt mit der Marienkirche", painted by J.H. Hintze, 1828

7 Unter den Linden, with the Friedrich II Monument. Detail of a painting by Eduard Gaertner, 1852

8 Von der Heydt residence in the Tiergarten district of Berlin. Designed 1860-61 by G. Linke and built by Hermann Ende

The building activity of this period included a large number of townhouses, which were usually given monochrome rendering, apartment buildings (see below) and, with the advent of cooperative building societies towards the close of the century, large residential complexes which were unified in terms both of design and of color (see Plate 12, Bissingzeile).

Around 1860 planners began to lay out the wide streets and erect the apartment buildings that still dominate Berlin with their faded stolidity. The facades of these four- and five-storey structures are generally rendered in grey to brown tones that remind one of weathered cliffs; occasionally brownish-reds or bluish-violets or a facade with stucco decor on a brick masonry ground will enliven a block.

9 Row of facades on Seelingstrasse between Schloss and Nehringstrasse in the Charlottenburg district of Berlin. Built around 1880

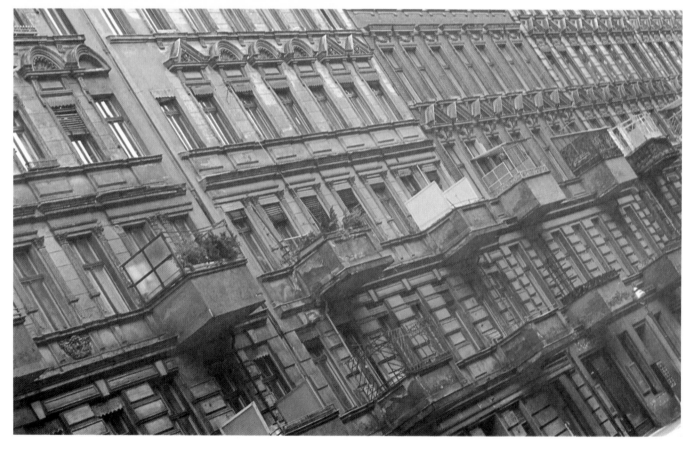

1900 to 1918

The tonality and ornament so characteristic of this period were reactions to the Revival styles of the late 19th Century and their imitated historic decor. Stylistic change was extremely rapid after 1900; from the sinuous and sallow-colored organic forms of Jugendstil architects soon turned to the stark color-planes of the Country House Style or even a polychromatic early Expressionism.

The Rheinische Viertel is a good example of the middle style, a large residential district unified by color scheme and detailing. An entry in the property register describes its color scheme, which has remained unchanged to this day: gold-ochre rendering with grey bays and top-floor window line and brown wooden trim. Roof pitch is the same on all buildings, as is the color of the tiles.

10 Detail of facade at 5 Mommsenstrasse in Charlottenburg. One of the "Yellow Houses" built in 1906-07

11 North side of Rüdesheimer Platz in the Wilmersdorf district of Berlin. "Rhine Quarter" development, by Jatzow and others, 1910-14

12 Trierer Strasse,
Berlin-Weissensee,
by Bruno Taut

Between the wars the predominant color of free-standing buildings and houses in Berlin—often cubes or combinations of cubes—was white, sometimes relieved by brick trim. Pure clinker construction was rare. As far as the city's housing developments were concerned, there was a dichotomy between monochrome (white) and polychrome schemes—'White Town' confronted 'Paintbox Settlement'. The large-area development in the suburb of Britz was also polychrome down to its last detail. In general, the rediscovery of color during this period was tied in closely with the spread of public housing, and the new, bright suburbs stood in sharp contrast to the subdued tones of the central city.

(The buildings erected in Berlin during the Third Reich were almost without exception monochrome, and their colors were usually intrinsic to the materials used rather than being applied later with paint or rendering.)

13 Row-houses in the
"Horseshoe Settlement",
Neukölln.
Bruno Taut, 1925-27

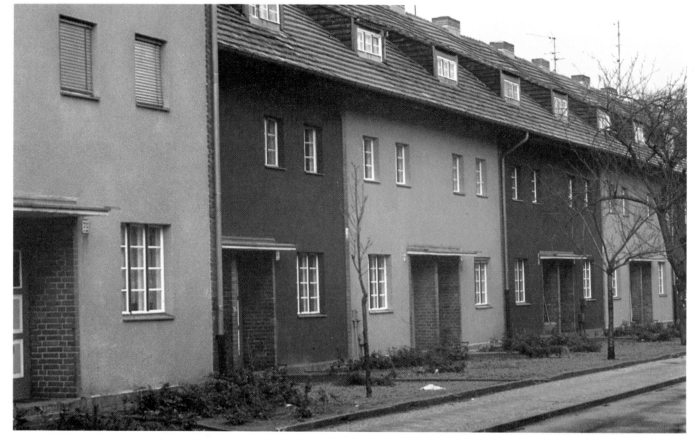

1946 to 1960

The face of postwar Berlin was shaped by necessity. On the semi-detached houses of North Charlottenburg color was used sparingly to accent natural stucco tones, and the combination of color and structural detailing was obviously meant to create a certain homey atmosphere.

For the International Building Exhibition of 1957 a number of high-rise apartment buildings were erected in the Hansa Quarter which had brightly colored detailing such as balcony and wall facings. The first historical reconstruction of old facades, those on Christstrasse in Charlottenburg, began the same year.

The first postwar building to receive full chromatic treatment in the planning stage was the studio wing of the Academy of Arts (also located in the Hansa Quarter).

14 Facade, Christstrasse in Charlottenburg. Renovated for the Interbau Exhibition, 1957

15 Studio building of the Academy of Arts, Hansa Quarter, Tiergarten. Werner Düttmann, 1960

16 Facade detail of an apartment building by Pierre Vago, at the Interbau Exhibition, 1957

17 Copper sheathing, Theatre Hall, Academy of Arts. Werner Düttmann, 1960

18 Detail of a facade in the Charlottenburg-Nord development. Hans Scharoun, 1956-61

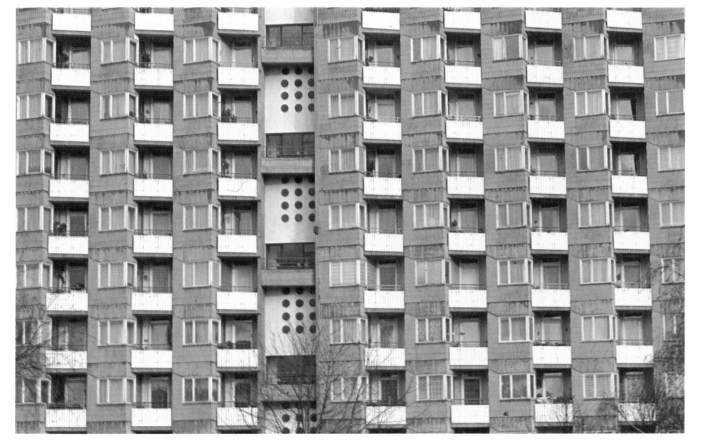

19 Institute of Nautical
Engineering in
Charlottenburg.
Ludwig Leo, 1973

Of late special-purpose buildings with unique floor-plans
and structural details have been conceived with a particular
eye to color effects, whether they are free-standing struc-
tures, integral parts of already existing complexes, or new
cities within the city.
Pleasure in color is back again, as Ludwig Leo's buildings
testify. They show an approach to architectural design and
coloring that is very personal in its combination of technical
perfection with a basically romantic attitude. The Institute of
Nautical Engineering is painted light red and blue, colors
most unusual in Berlin.

20 German Lifesaving
Association Building,
Spandau. Ludwig Leo,
1972

The 'Märkisches Viertel' is an example of design which has since become almost a trademark for the use of color in modern high-rise housing. Here exterior paint has become a building material in its own right, articulating structure and creating mosaic-like effects which are as individual as each architect's own signature.

In developments of this type color is a design element that aids orientation and provides a signpost to function and use. Here color has many different purposes: it divides blocks into separate houses, serves to enliven facades with ornamental patterns, accentuates such structural details as doors and windows, and signals special functions, such as the post office that spans the street like a yellow bridge.

from: "Farbe im Stadtbild",
Abakon Verlagsgesellschaft mbH, Berlin 1976

21 Post office spanning a street in the Märkisches Viertel development.
Ludwig Leo, 1966-67

22 Apartment building, Märkisches Viertel.
René Gagès, 1966-69

23 Spontaneous color. Children paint the fence around their playhouse

24 Apartment complex in Märkisches Viertel.
Karl Fleig, 1965-66

25 Apartment complex in Märkisches Viertel.
Müller and Heinrichs, 1967-70

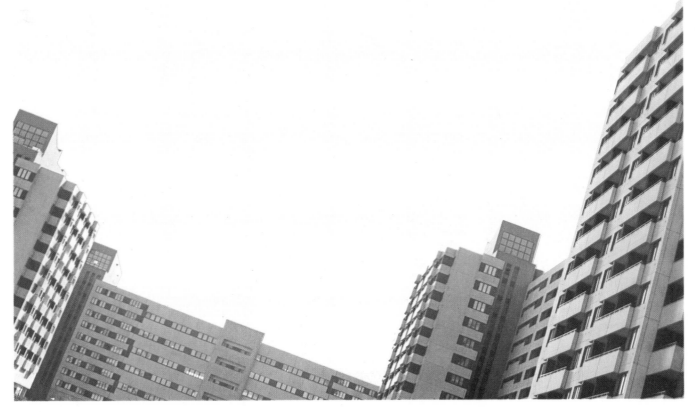

Illustrations 4 and 9 from "Erlebnis Berlin" by Hans Ludwig. Henschelverlag Kunst und Gesellschaft. Berlin 1975
Illustration 7 from the slide-series "Alt Berlin" D2, Nationalgalerie Berlin. Photo: Verlag Elsa Postel
Illustrations 20, 22, 23, 24, 25: Johannes Uhl
All other illustrations from photographs by the authors, taken in late 1975

Color in Contemporary Architecture

Designing with Color -
Creation of a chromatically unified whole; an indivisible artis-
tic unity. The application of color is always made to some-
thing limited, whether it is a surface, a body or a space. With
the desired unity in mind, including any substantive expres-
sion or aim his composition is to fulfil, the designer envis-
ages, chooses and orders his colors. Both this process of
design and its visually perceptible result are called color
composition. The colors are mixed and applied in various
ways and, taking their qualities, amounts and positions into
account, are ordered rhythmically with respect to one
another and to the whole. In this way color relations arise,
and a color context or harmony that, even if certain of the col-
ors should clash, calls forth in the viewer an impression of
balance or equilibrium. Color harmony is defined as a unity
of more or less heterogeneous, opposing colors. There are
color harmonies of a low-contrast, unstrained nature as well
as color harmonies whose high contrasts call forth a feeling
of tension. A combination of neighboring colors from sys-
tems of color notation will appear tensionless; combina-
tions of less related or completely unrelated colors high in
tension. If the colors on both sides of an actual or imaginary
vertical axis are given approximately equal visual weight, as
is often the case in early Renaissance art or in children's
paintings, then we speak of color symmetry.
Many factors are involved in designing with color. Visual per-
ception and the content of the work will influence the way in
which color is used as a means of expression. While it is diffi-
cult to make generally valid suggestions about how to de-
sign with color, a process in which both objective conditions
and the free unfolding of creative imagination play a role,
there are a few basic rules which it is advantageous to ob-
serve. The first of these concerns the dominance of one par-
ticular type of color contrast and a clear ranking of colors in
the work (i. e. differentiating between major and accessory
colors). When two colors on opposite sides of the color
wheel (e. g. blue and orange) largely determine the overall
composition, we speak of a directional color contrast (here it
is wise to have one of the two colors dominate). If the central
contrast in the composition is light-dark, however, the val-
ues of the colors used will come particularly into play and
have a great influence on the overall effect. Here, the hues
as such play a secondary role, being merely accessory to
the dominant light-dark contrast. If the composition is car-
ried out largely in one range of value (or lightness), its effects
will rest on the contrasts between pure and greyed hues. A

cold-warm contrast may also dominate, i. e. with more warm
than cold colors or vice versa. Finally, a composition may be
based on variations of a single hue (e. g. green).
Color accents are also an important tool when designing
with color, since they can be used to emphasize particular,
key parts of the composition. Even a tiny accent of color
within surroundings of a contrasting color will attract the
viewer's attention, e. g. a touch of red among shades of
green, a light among darks, pure tones among greyed ones,
cold hues in warm surroundings.
The decorative application of color is invariably carried out
with a definite aim in mind, whether aesthetic or functional;
here, colors and shapes are used to articulate, distinguish or
enliven an object (buildings, rooms, appliances, textiles,
etc.) and often to increase its commercial value.

from: "Lexikon der Kunst", Vol. 1,
VEB E. A. Seemann Verlag, Leipzig 1978, excerpted

Italy Apartments in Reggio Emilia

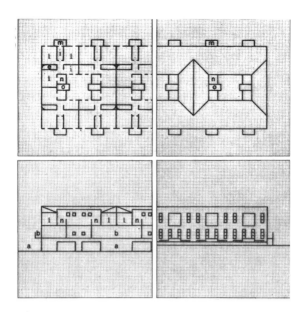

Architects:
Maurizio Belpoliti,
Arturo Perrazzi,
Sandro Silvi
Built 1975

Twelve apartments,
of three storeys each

A design that conforms to a single grid in all three dimensions, as is apparent in choice of sheathing and colors: panels in white, grey and dark grey, each 75 cm square, cover the entire building, and its aluminium windows and doors are integral parts of both grid and color scheme. Inside the doors go their own way, however, in lilac to the yellow of mailboxes and grilles.
Photos: M. Düttmann, 1980, Publication: 1978, domus 586

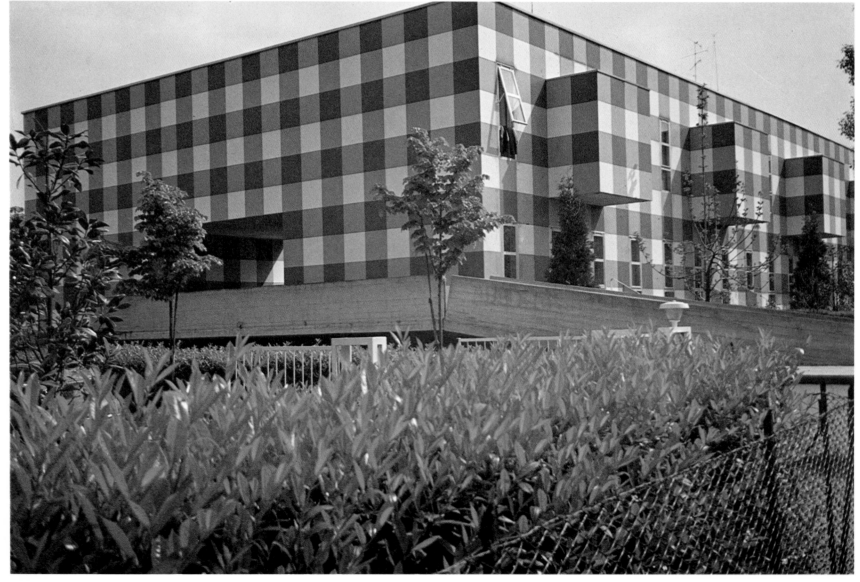

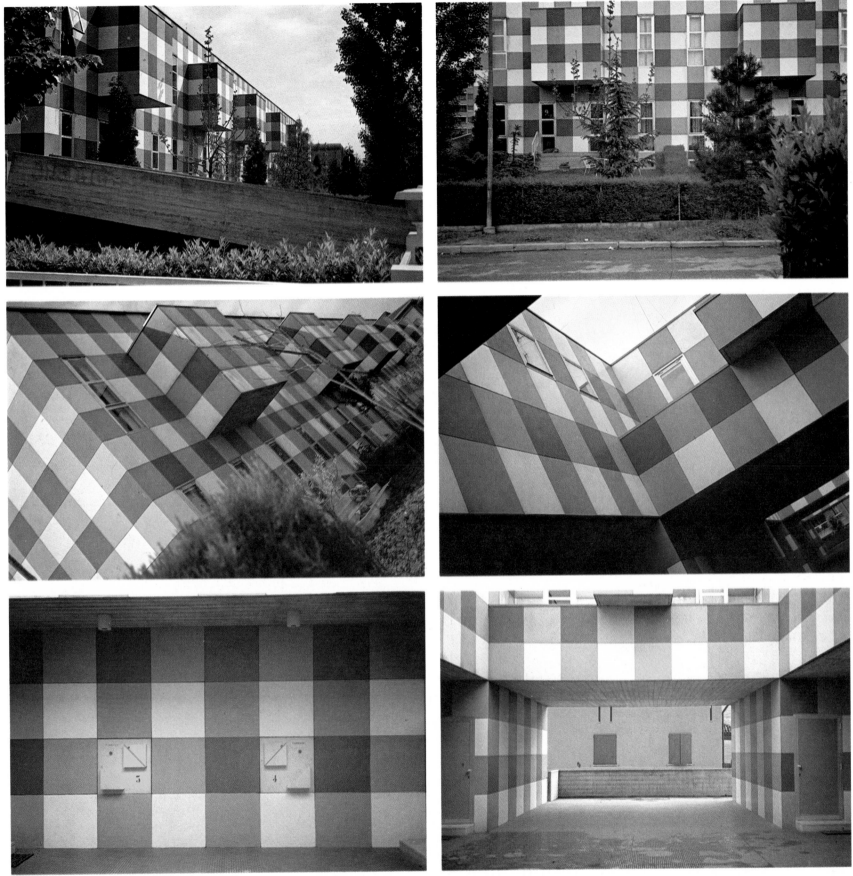

151

Spain

Walden 7, Apartment House
Near Barcelona

Architects:
Ricardo Bofill & Partners

"Taller de Arquitectura" in Barcelona is a cooperative of architects, engineers, sociologists and writers.

It stands, rather lost-looking, at a freeway exit near Barcelona, a huge red sculpture in a desert. The building's color is that of dull-surfaced tiles; reddish brown in the winter months (these photographs were taken in January, 1979), it changes to red-orange in the sun. Core of the structure is a high hall, sheathed in glossy tiles—blue, with a little pink and yellow.
Photos: Werner Düttmann, Publication: 1975, AA 182

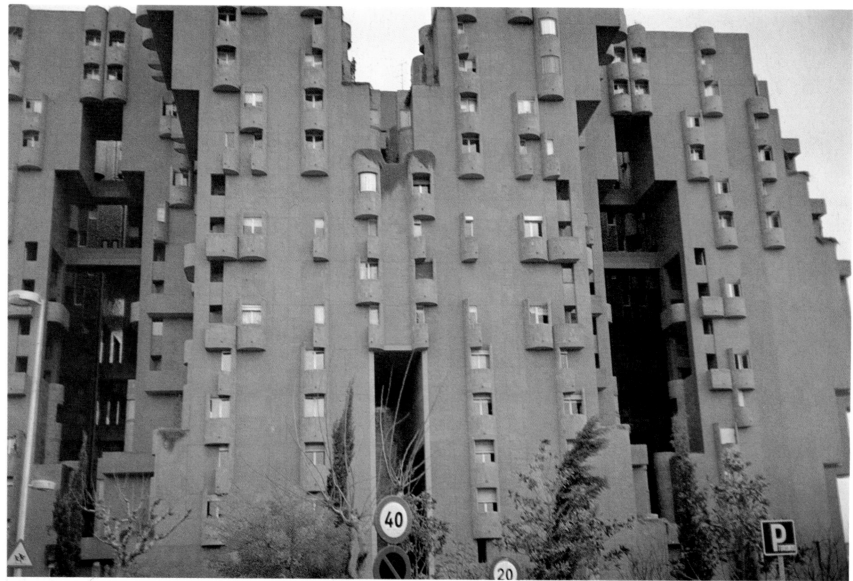

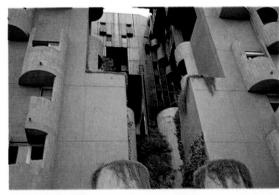
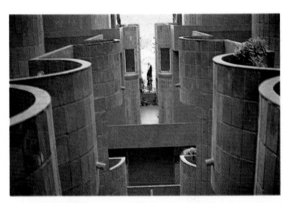
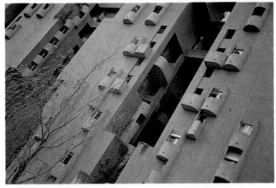
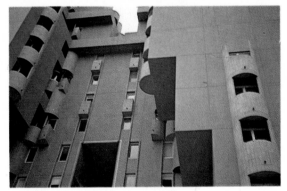
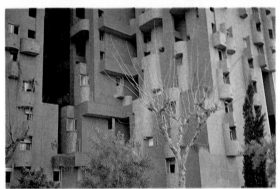

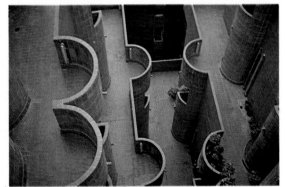

Italy

Apartment Building Outside Milan

Design of development
(plan): Carlo Aymonino
and Aldo Rossi

Architect:
Carlo Aymonino

Built 1972-74

An unusual building indeed—in an area suffering from a great
housing shortage an architect has shown the courage of his
formal convictions, creating tall partitions, austere bands of
windows, broad ramps, a voluminous courtyard; over them
all play brown, white and red, rose and yellow. The people of
the region misunderstood this architectural message, pro-
tested against it, then temporarily occupied the building by
force... Photos: P. Herms, 1975

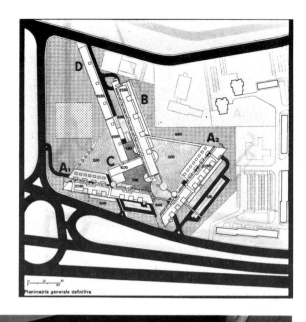

Planimetria generale definitiva

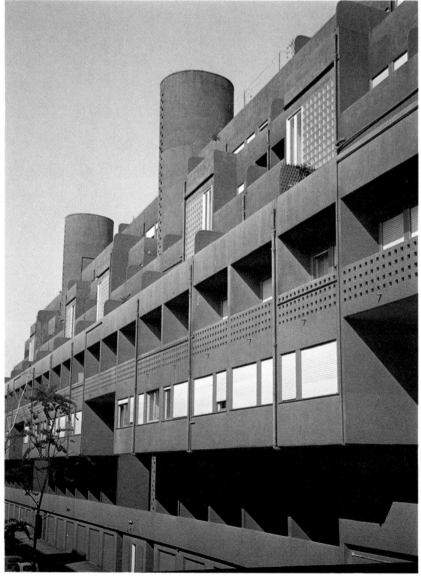

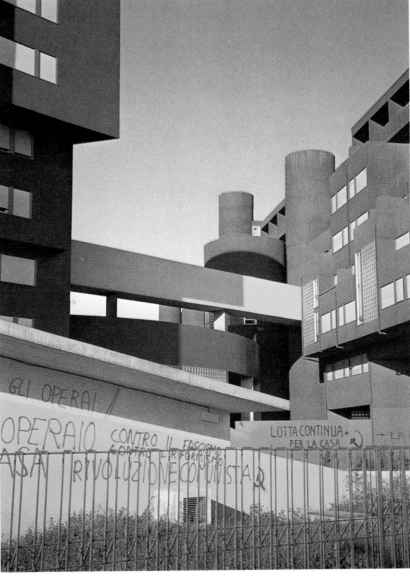

Germany

Apartments Near Charlottenburg Castle, Berlin

Architects: Uhl and Partner
(Johannes Uhl and
Michael Klewer)
Built 1974-76

About 400 apartments
for old people

Two unusual conditions shaped this project; one, the famous Charlottenburg Castle was next door, and two, a fine neo-classical frieze, designed by Friedrich Gilly and executed by Gottfried Schadow, had to be worked into the design. The facade towards the Castle was kept subdued to provide a setting for the frieze. The back shows a freer play of hues from concrete-greys through mother-of-pearl to rose-pink, a red horizontal band and a dark blue stairwell.

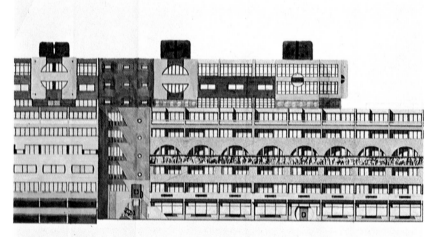

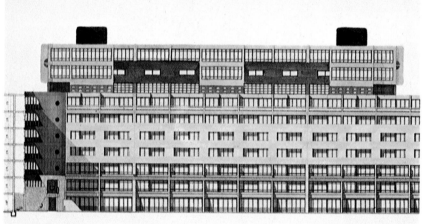

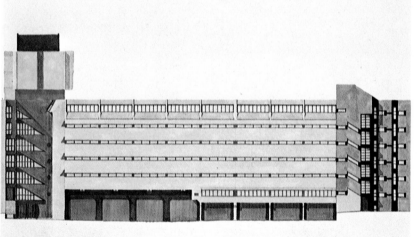

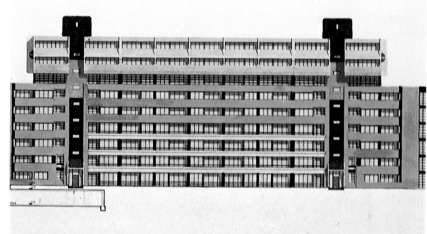

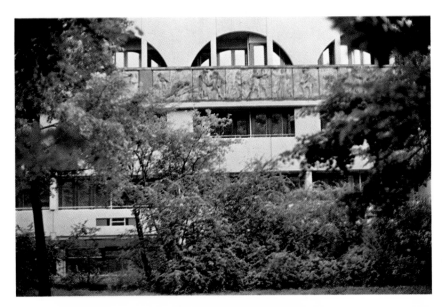

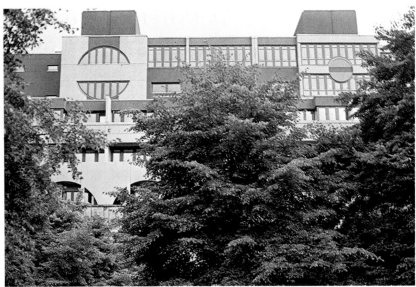

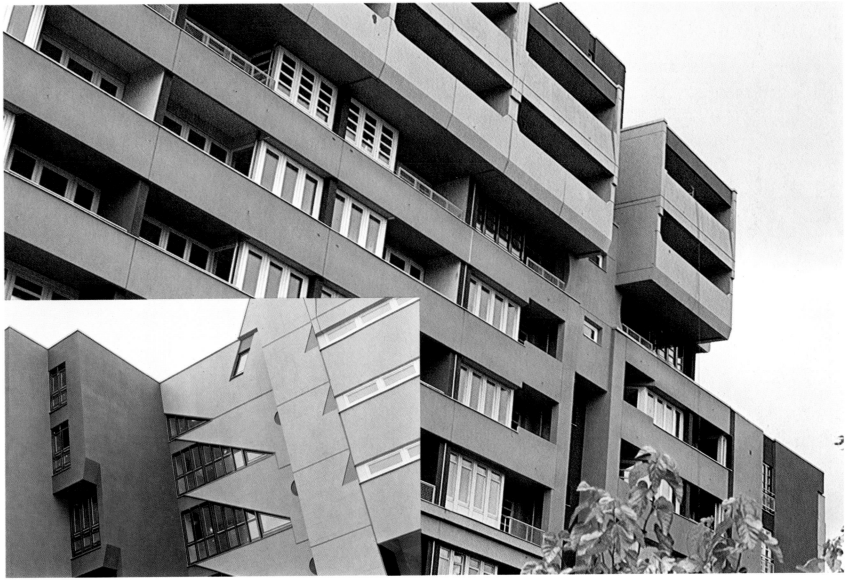

France Views of Créteil, a Nouvelle Ville Near Paris

Design coordination:
Atelier Dufau

Color scheme:
Yvaral and Vasarely

Photos:
Sikkens Archive (4),
Jan Rave (3)

Créteil is an ensemble of extremely varied types of structure and architectural form. Like the Märkische Viertel in Berlin it resembles an exhibition of modern architectural styles. Strict, geometric masses alternate with organic; round towers with leaflike balconies are set off against flat reflecting facades. The colors, however, are on the subdued side; simple patterns have been used to emphasize architectural ornament.

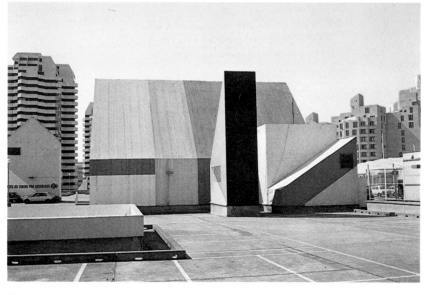

On a walk through Créteil we made two interesting discoveries: the roof of the Centre Commercial and the open plaza before the public buildings, two situations which have been completely transformed by color and patterning alone. The roof of the huge shopping center is a landscape of emergency exits and ventilators, painted in stripes of white and various blues; one thinks of the sailboats on the nearby lake, and the roof itself is like a body of water with the new city on its horizon. The plaza in front of the Chambre de Commerce is paved entirely with glossy blue and white slabs; gently undulating lines create the illusion, from near and far, of depth, of a modelled surface—water in motion. The surrounding buildings, otherwise rather unrelated to each other, seem all to float, detached from the earth.

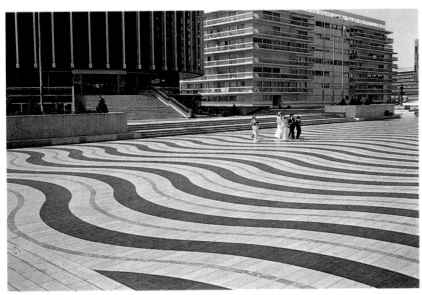
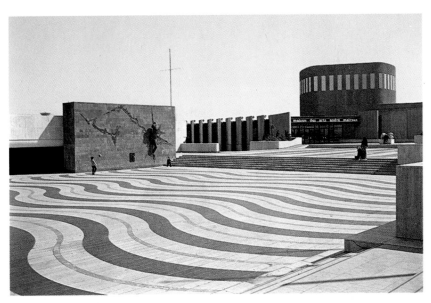

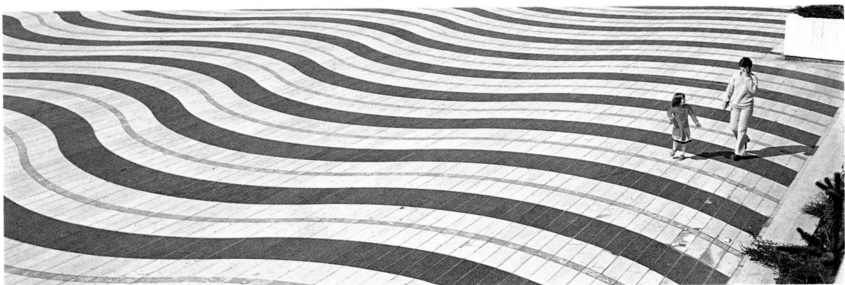

159

France　　Views of La Défense, a Nouvelle Ville Near Paris

Residences

Architect:
Emile Aillaud
Color design:
Fabio Rieti

Photos: Sikkens Archive

Aillaud's towers are variations on his well-known personal style—soft, rounded masses with flush facades and recessed windows. The towers in La Défense have chanelled surfaces, and they stand like tall straight trees in the gently undulating landscape. Their colors take up the theme, with shades of yellow and brown like shadow-tints that follow the contours of the site.

 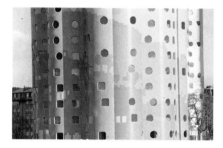

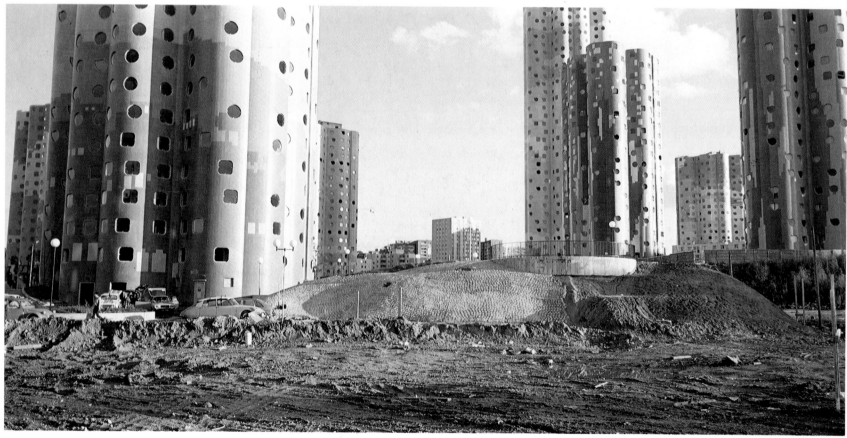

Residences

Architects:
Atelier Kalisz

Photos: Sikkens Archive

Not far from Aillaud's towers stands an ensemble of apartment buildings which, interlinked and rising one above the next, form a new horizon. Their color scheme disregards the horizontal window-bands to create diagonals parallel to an imaginary line drawn across the buildings' silhouette. Color range: rose-pink, grey-green, green, light and dark blue.

 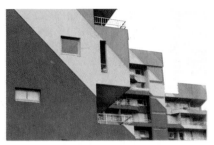

France

Views of Evry, a Nouvelle Ville Near Paris

Architects:
Michel Andrault
and Pierre Parat

Color design:
Bernard Lassus

Photos: Jan Rave

Interpenetrating masses, a series of projections and indentations, corners and steps, simultaneously redefined and unified by color. Every section of the building has a different composition: rose, red and brown catch the eye first, followed by patterned brick-red and green, blues and browns, then white.

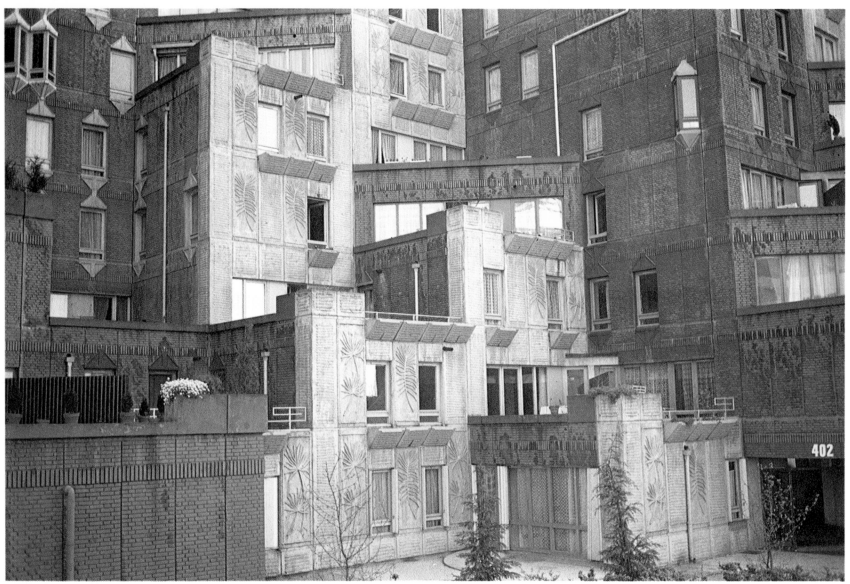

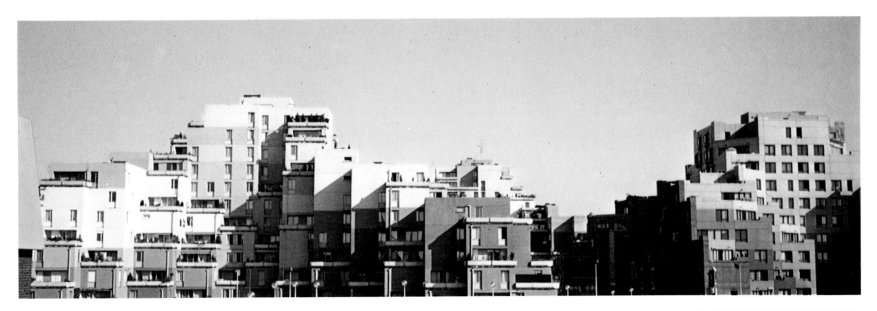

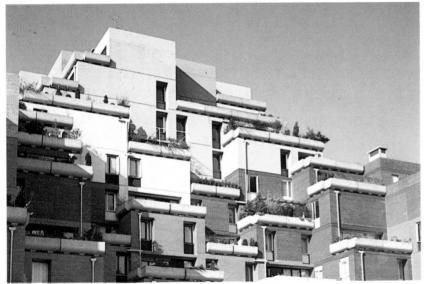

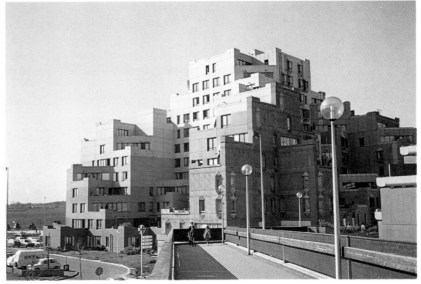

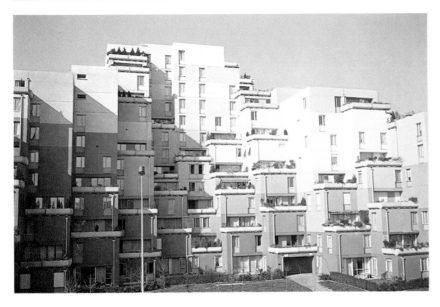

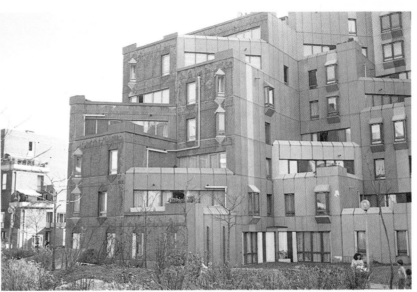

Portugal Apartment Houses in Oporto

Architect:
Alvaro Siza Vieira
Built 1977-79

These apartments in Porto were planned over a period of many years together with citizens' and tenants' groups (for a report on this project see "5 Architekten zeichnen für Berlin", Archibook, Berlin, 1979). The design itself, however, carries the architect's personal signature, and is executed in a very modern formal language that combines strict geometry and sparing ornament. The colors follow the forms of the facade—foreground white, recessed surfaces red. The sections of wall between the balconies have the effect of battlements; the entrances and windows, set axially in white surfaces, call to mind a canvas by Mondrian. The dark red band above provides a background for the facade design and pulls the building together to a unit.

Photos: Brigitte Cassirer, 1979

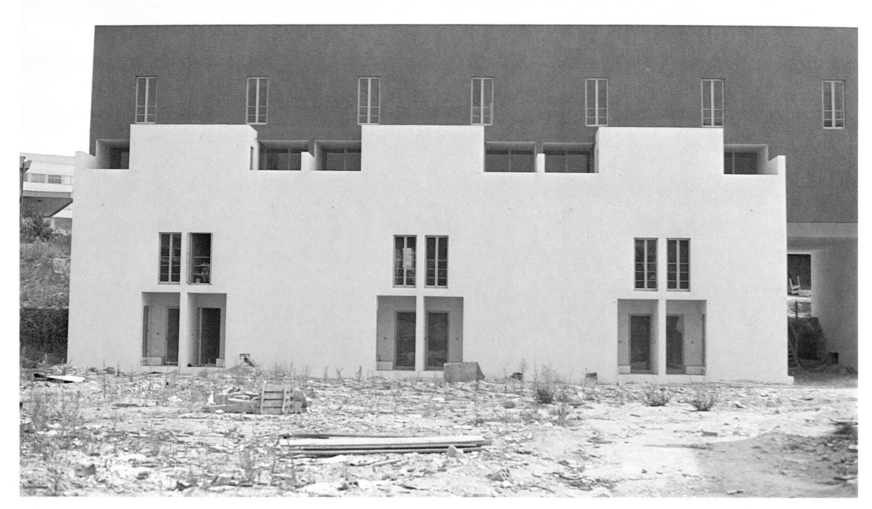

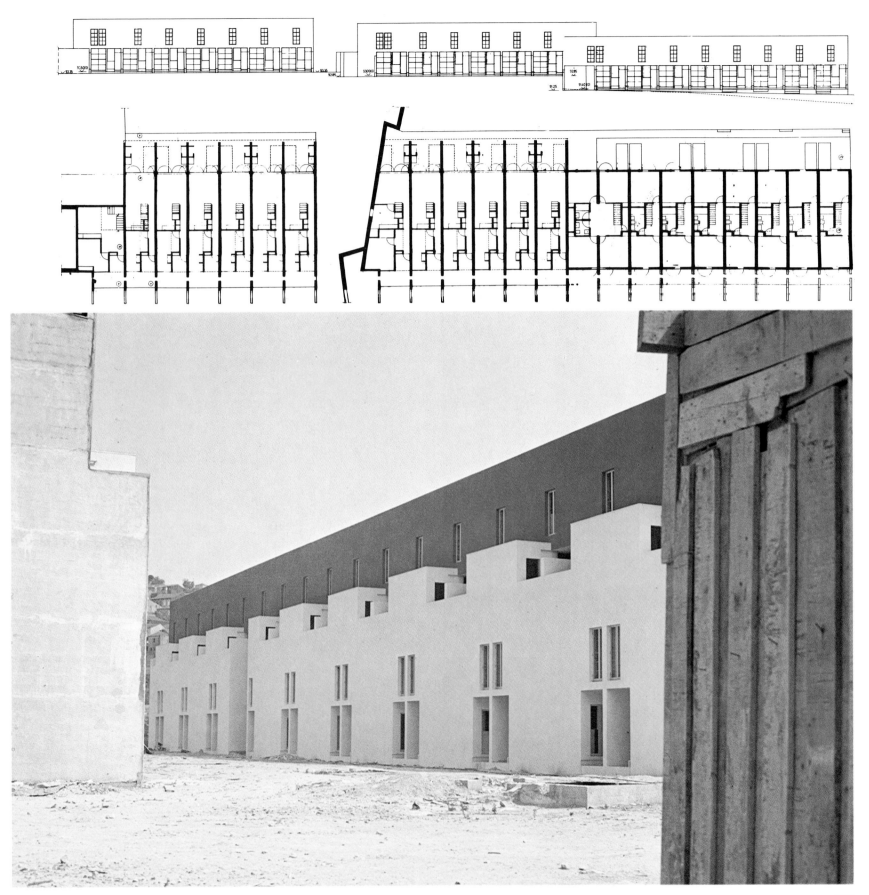

Belgium

Residences for the Department of Medicine, Brussels University

Architect:
Lucien Kroll Studio

Planned 1969,
built 1974-76

The choice of architect for this project was the students', and Kroll met with them to find out some of the things a university stands for today—change, organic growth, contradiction, improvisation, chance, openness to the outside world, self-government. The forms he found to express these ideas are only seemingly random; actually they are based on a modular system (supplied in the main by SAL of Eindhoven), yet owing to the wide variety of materials used, the interpenetrating levels and functions, an abundance of openings and imaginative landscaping, the building appears to have taken root on the site. Its colors, too, have grown out of materials and masses; each brings to the composition its own characteristic shade: wood, aluminium, white panels, grey stone, black steel, with an accent of red here and there.
Photos: A. Grossmann, Dinslaken (1);
GA Houses 3, 1977 (2)

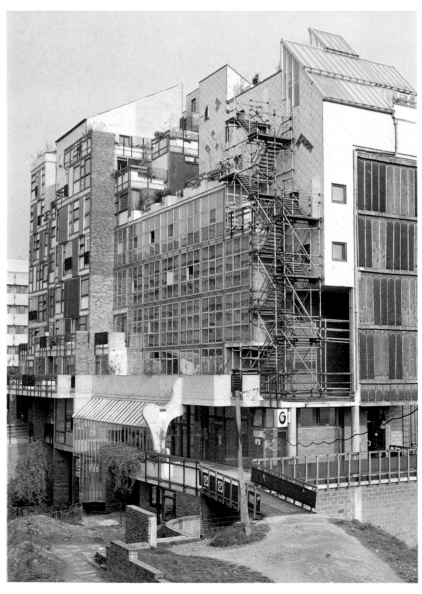
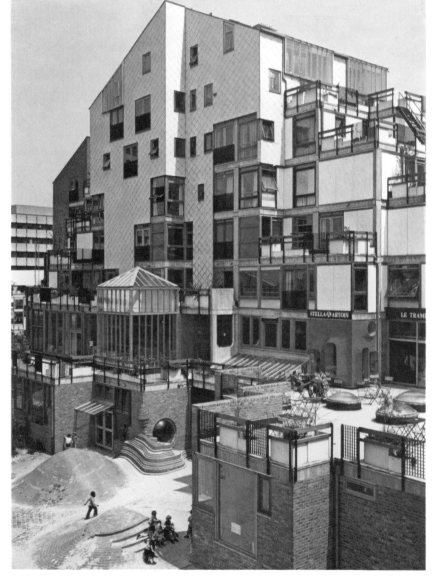

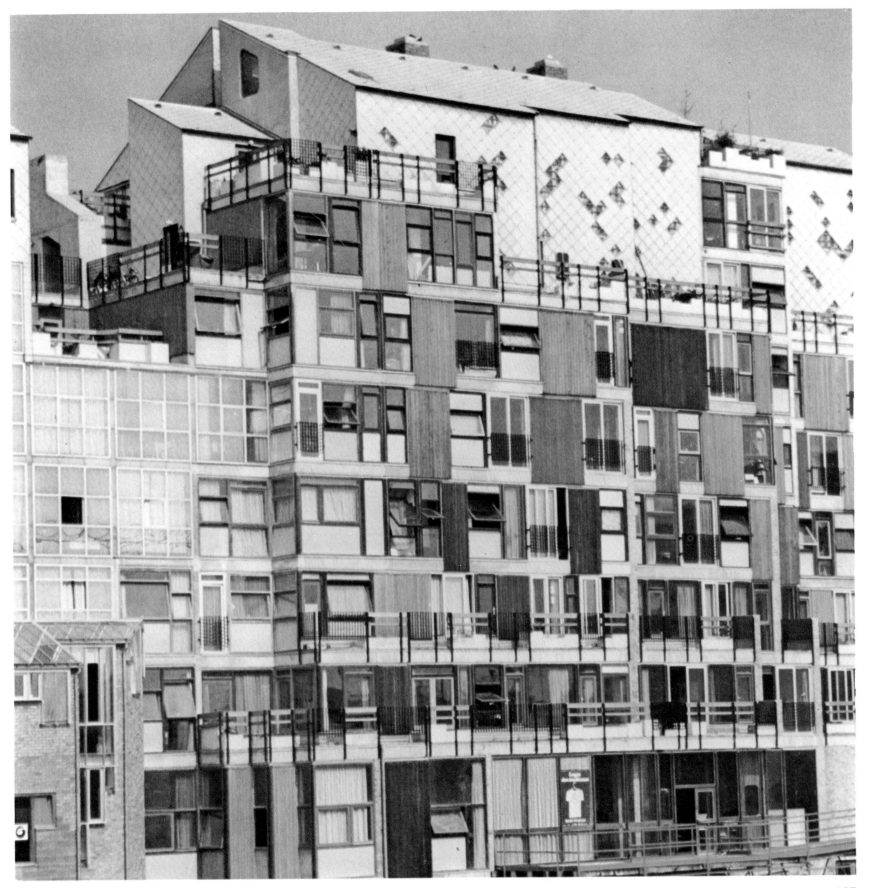

Three Projects by Charles Moore

Architects:
Charles Moore,
John Ruble, Buzz Yudell,
Tina Beebe (color adviser)
with, for Piazza d'Italia,
Auguste Perez, Malcolm
Heard, R.A. Eskew and
Ron Filson (UIG)

1 Plan view,
Piazza d'Italia
2 Isometric section,
Kwee House
3 Floor plan,
Burns House
Photos: Moore Archive
Corr.: Ingrid Bobran

The fountain has the outline of Italy; its flanking seas are executed in cobblestones, marble, slate and mirror tiles. The classical orders of its architecture are each painted differently, warm colors inside, cool outside.

Kwee House: Located at the level of the equator, this house is almost totally closed to the outside; inside, it is done in cool tones, shades of blue. The exterior scheme is warmer—pink, reddish brown, orange.

Burns House: The colors of Tuscany—ochre, orange, rose-pink, mixed on location—reverse architectonic precedence. The projections are painted in receding hues, the indentations in warm tones.

Piazza d'Italia, New Orleans 1977/78

Kwee House
for Singapore 1980

Burns House
in Santa Monica,
Los Angeles 1972

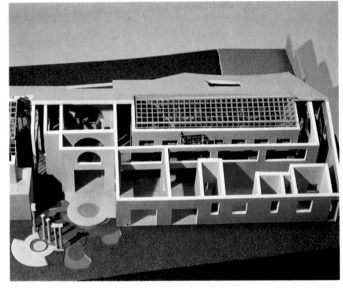

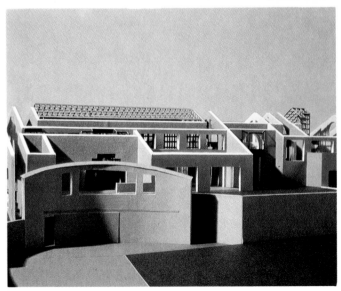

USA

Gehry Residence, Los Angeles

Architects:
Frank O. Gehry
& Associates
Built 1977-78

Interplay of colors, materials, planes and structures with an unexpected, distorted, interlocking geometry. Colors are rose, light green, white, supplemented by wood and metal tones.
From: GA Houses 6, 1979

WEST ELEVATION

EAST ELEVATION

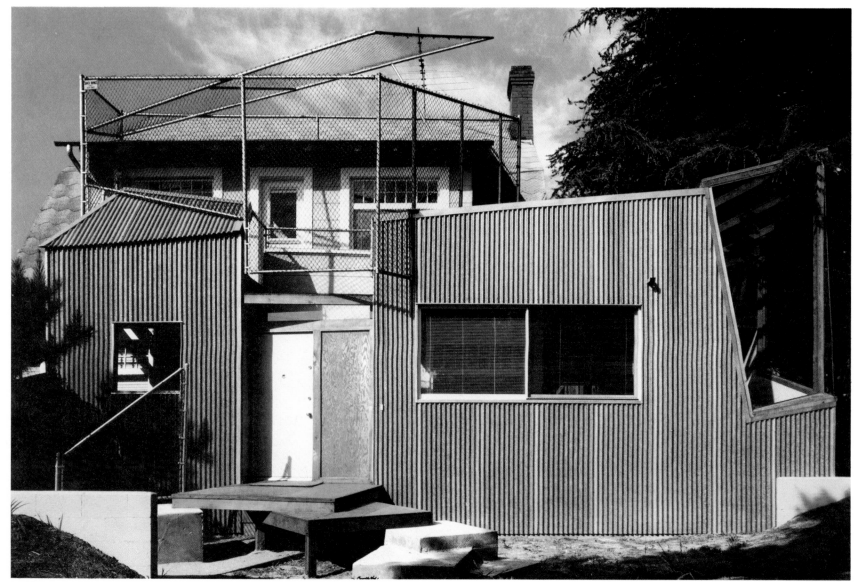

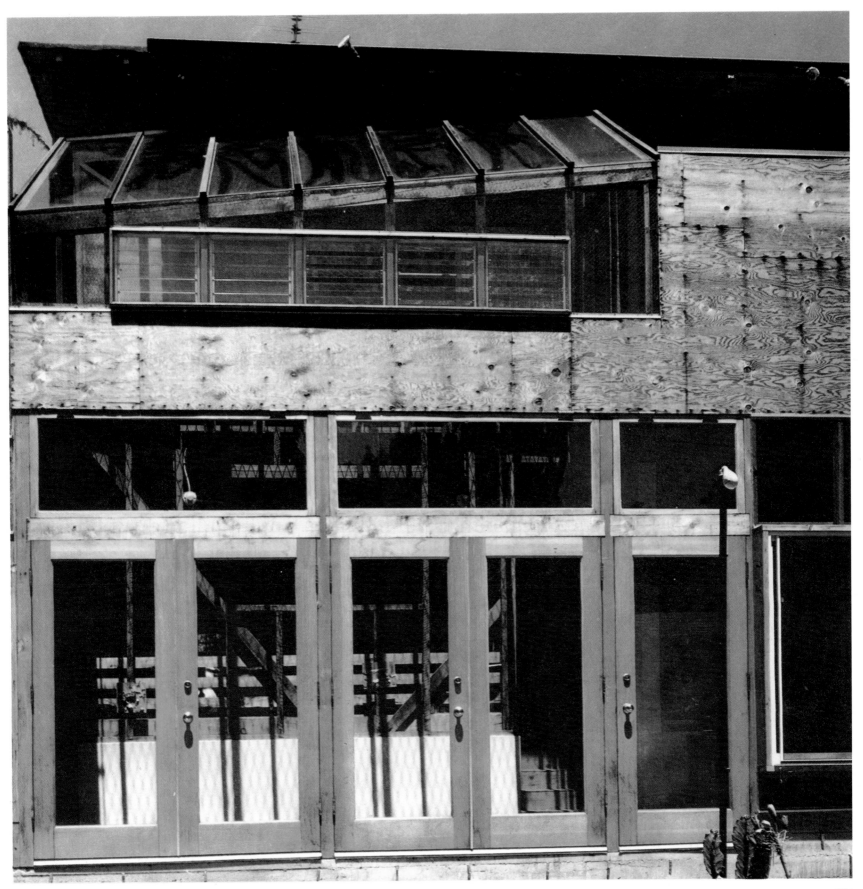

Italy

Three Vacation Houses on Sardinia

Single-Family House in Ligornetto

Architect:
Umberto Riva
Built 1972
Earth-colored walls, bright hues limited to roofs—fields of red and blue-grey glazed terracotta tiles.
From: GA Houses 6, 1979

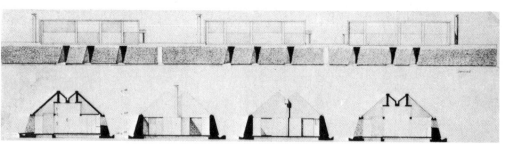

Architect: Mario Botta
with Martin Boesch
Built 1975-76
A cubic mass, geometrically austere; color scheme grey and red concrete blocks in striped effect.
From: GA Houses 3, 1977

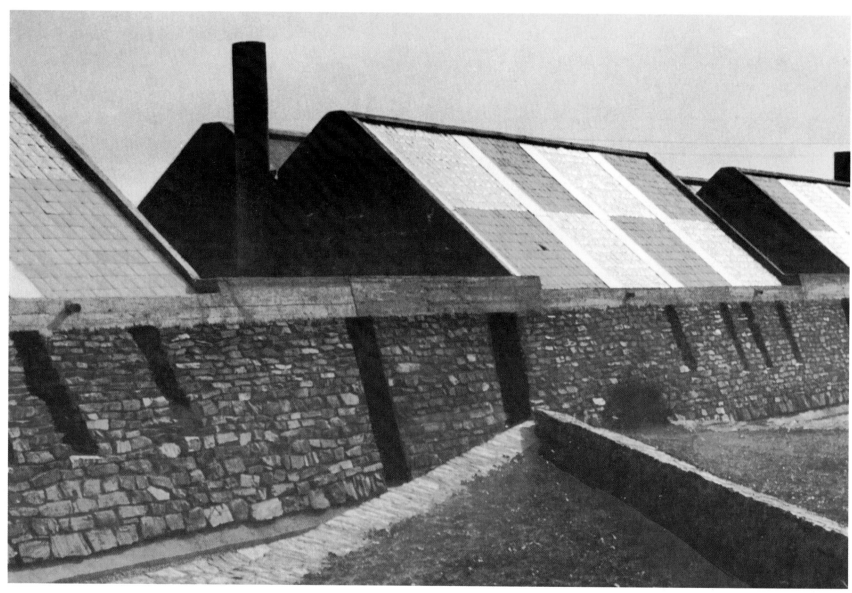

France

Solmer Steel Works, Fos-Sur-Mer

Color design:
Jean Philippe Lenclos
Photos: J. P. Lenclos

Project: Color scheme for a steel mill.
The composition isolates machine parts, obscures their true scale, uncovers a hidden romantic element in the functional, changes the work atmosphere.

France

Centre Pompidou, Paris

Architects:
Renzo Piano and
Richard Rogers
Built: 1972-77

A loud, garish, mechanical, romantic and very "Parisian" building. An odd note, but not a destructive one; it puts a new bright frame around the old familiar picture of Paris streets.

Photos: Werner Düttmann, Johannes Uhl, 1978
Published: 1977, AA 189

France

Facade Design for Le Vaudreuil

Color design:
Jean Philippe Lenclos
Architect: H. Beauclair
Photos: J.P. Lenclos

A color scheme derived consciously from the atmosphere of a place and the architecture that is part of it.
Step 1: Collection of samples and materials
Step 2: Selection of color range from charts
Step 3: Composition (color harmonies)
Step 4: Color samples for new facades
Step 5: Compositions for new facades

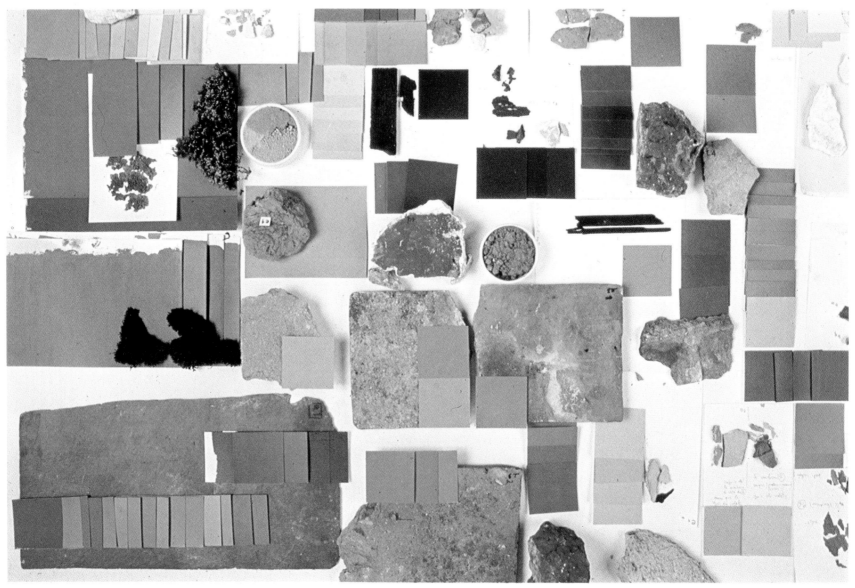

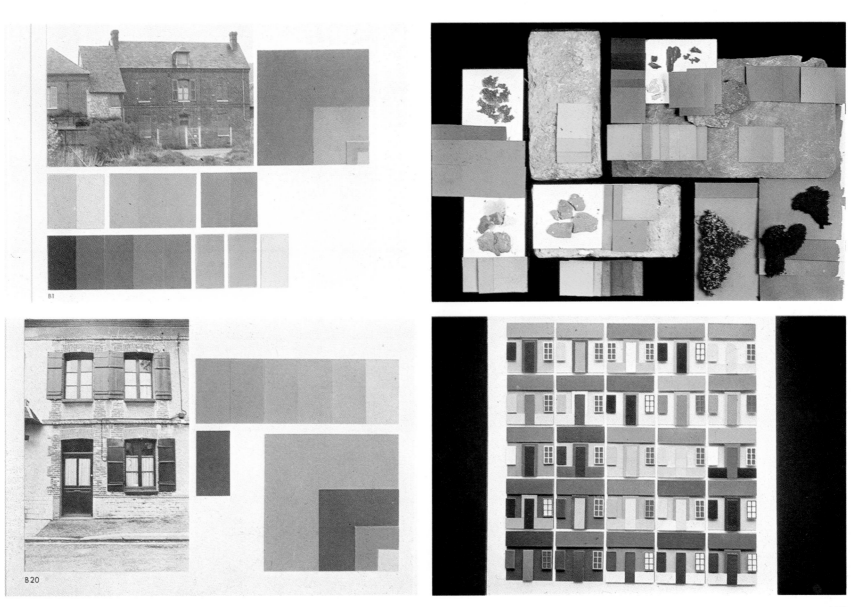

USA Pacific Design Center, Los Angeles

Architects:
Cesar Pelli
and Associates
Built 1975-76

A center for exhibitions on the design market—products models, prototypes—this building is itself an exhibit. Surrounded by low, temporary-looking structures, the mammoth blue mass, completely mirror-surfaced, stands alone against the sky, its elevation, like its plan, of imposing simplicity.
Photos: P. Stürzebecher (1), C. Pelli (4), J. Uhl (2), 1978

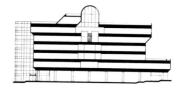

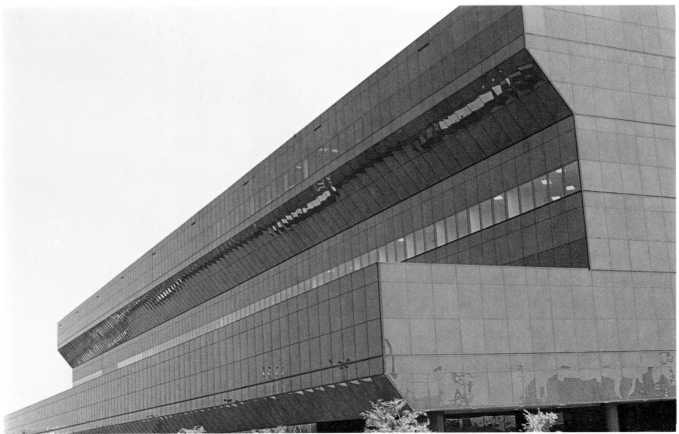

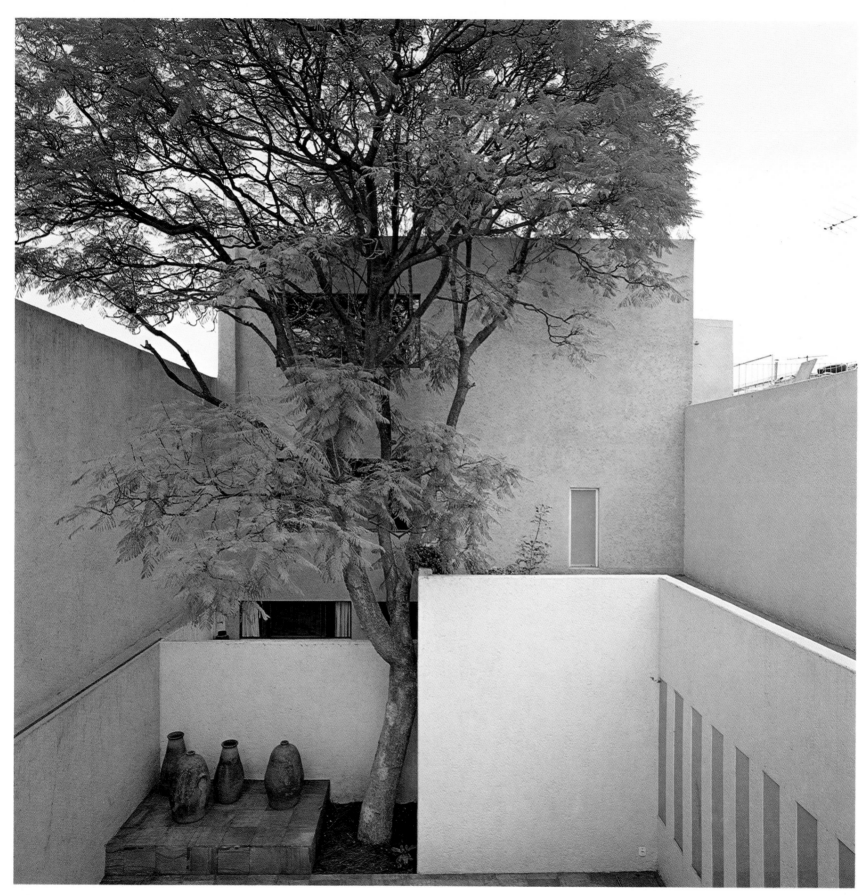

Germany Infill on Fulda Street, Berlin

Architect:
Johannes Uhl
Built 1979

Apartment house with
twenty-one flats

Neighboring building is by Bruno Taut, 1927-28. The color scheme divides the building into horizontal sections, an allusion to the stripes so popular in the Twenties: four brick cubes on set-back roofline, green band above trees, below that a band of brick, followed by light green rendering, a prefabricated concrete section bordered in brick, then ground floor on brick foundation. Trim in black steel.

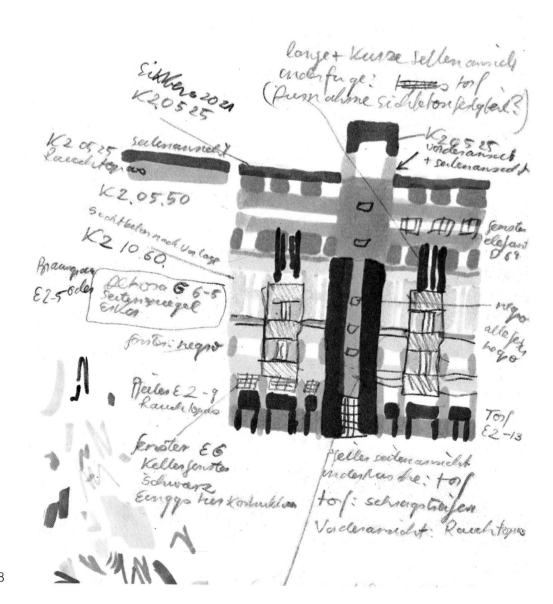

Pages 182-183:

M. Francisco Gilardi
Residence, Mexico City
Architect: Luis Barragan
Photos: Alain Dovifat and
Brigitte Baert, Paris
Publication: 1980, AA 208

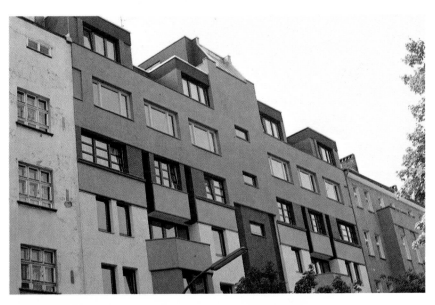

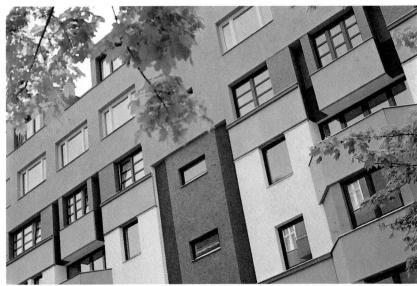

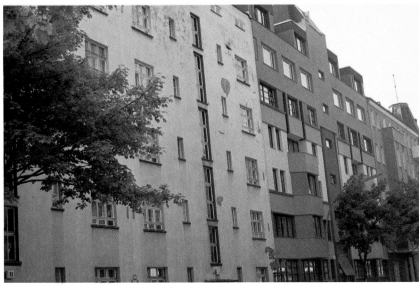

USA

Snyderman House, Fort Wayne

Architect:
Michael Graves

Single-family house
Built 1972

Photos: Michael Graves

A house surrounded by an illusionary white frame. Walls have been separated from frame in two ways: in terms of their form, which is soft and undulating; by means of color, ranging from pink to light blue.

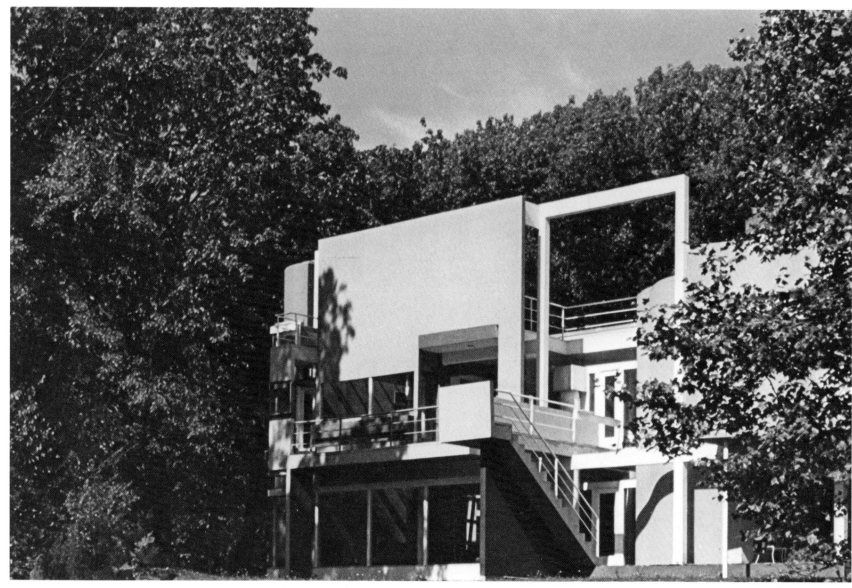

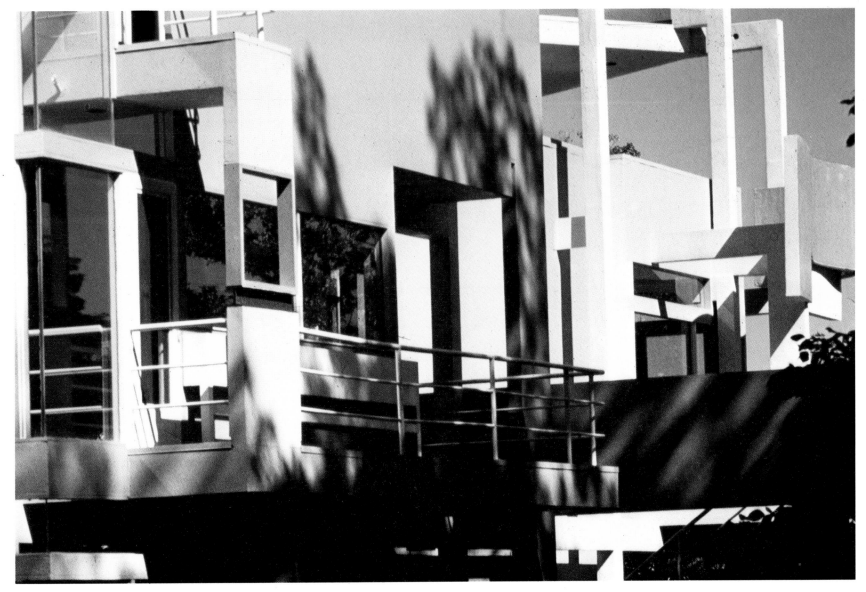

USA

Residence of the Architect, Los Angeles

Architect:
Charles Eames
Built 1948
Photos: J. Uhl

Like a composition by Mondrian, like the House of Cards (Charles and Ray Eames, 1952), like the Toy Doll House (1958), this house is a stage, a backdrop, a plaything to live in.

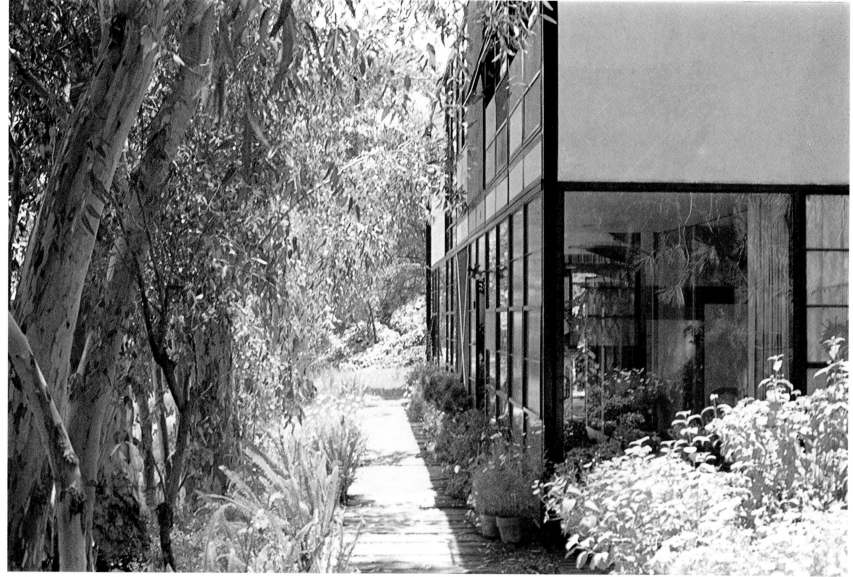

USA

Architectural Drawings

Architect:
Michael Graves

From: Michael Graves,
Academy Editions, 1979

1972:
Architectural renderings
for conversion of a
department store into
private residences in
Princeton, New Jersey.

1978:
Architectural renderings
for additional multi-car
garage for automobile
collection: Kalko House,
Green Brook, New Jersey.